'Guy Morrow goes well beyond truisms such as "an artist is a start-up business" because he knows that such truisms don't sustain the various phases of any artistic career. Instead, his focus is on the value of agility amidst increasing complexity. Managers in every industry can learn from this.'
– *Catherine Moore, PhD*, Adjunct Professor, University of Toronto, Canada

'Guy Morrow has had a fascinating career as an artist management "pracademic" (i.e. both a practitioner and academic). This makes his work of particular relevance and interest to those of us seeking to bridge theory and practice.'
– *Paul Saintilan*, CEO, Collarts and Macleay Colleges, Australia. Co-author of *Managing Organizations in the Creative Economy: Organizational Behaviour for the Cultural Sector*

'Artist Management offers a timely understanding of the manifold ways in which contemporary creative producers need to deal with uncertainty and career development. Incorporating the experiences of practitioners and the insights of contemporary scholarly work, Guy Morrow has crafted a highly engaging book.'
– *Dr. Erik Hitters*, Associate Professor of Media and Creative Industries, Managing Director of the Erasmus Research Centre for Media, Communication and Culture, Erasmus University Rotterdam, Netherlands

'This book opens up key concerns for theory and practice: how do contemporary practices such as agile management, lean start up and crowd-funding relate to the big questions of what are the arts and how should they be managed.'
– *Doris Ruth Eikhof*, CAMEo Research Institute, University of Leicester, UK

ARTIST MANAGEMENT

Artists are creative workers who drive growth in the creative and cultural industries. Managing artistic talent is a unique challenge, and this concise book introduces and analyses its key characteristics.

Artist Management: Agility in the Creative and Cultural Industries makes a major contribution to our understanding of the creative and cultural industries, of artistic and managerial creativities, and of social and cultural change in this sector. The book undertakes an extensive exploration of the increasingly pivotal role of artist managers in the creative and cultural industries and argues that agile management strategies are useful in this context. This book provides a comprehensive and accessible account of the artist–artist manager relationship in the twenty-first century. Drawing from research interviews conducted with artist managers and self-managed artists in five cities (New York, London, Toronto, Sydney and Melbourne), this book makes an original contribution to knowledge. Nation-specific case studies are highlighted as a means of illuminating various thematic concerns.

This unique book is a major piece of research and a valuable study aid for both undergraduate and postgraduate students of subjects including arts management, creative and cultural industries studies, arts entrepreneurship, business and management studies and media and communications.

Guy Morrow is Lecturer in Arts and Cultural Management at the University of Melbourne, Australia. He is co-author of *The New Music Industries*. His research interests include the use of agile management strategies within the creative and cultural industries.

MASTERING MANAGEMENT IN THE CREATIVE AND CULTURAL INDUSTRIES

Edited by Ruth Rentschler

Creative and cultural industries account for a significant share of the global economy and working in these sectors is proving increasingly popular for graduates across a wide array of educational institutions. Business and management skills are a vital part of the future of these sectors, and there are a growing number of degree schemes reflecting this.

This series provides a range of relatively short textbooks covering all the key business and management themes of interest within the creative and cultural industries. With consistent production quality, pedagogical features and writing style, each book provides essential reading for a core unit of any arts/cultural management or creative industries degree and the series as a whole provides a comprehensive resource for those studying in this field.

Entrepreneurship for the Creative and Cultural Industries
Bonita M. Kolb

Marketing Strategy for the Creative and Cultural Industries
Bonita M. Kolb

Strategic Analysis
A Creative and Cultural Industries Perspective
Jonathan Gander

Managing Organizations in the Creative Economy
Organizational Behaviour for the Cultural Sector
Paul Saintilan, David Schreiber

Visual Arts Management
Jeffrey Taylor

Artist Management
Agility in the Creative and Cultural Industries
Guy Morrow

Arts Leadership
Creating Sustainable Arts Organizations
Kenneth Foster

ARTIST MANAGEMENT

Agility in the Creative and Cultural Industries

Guy Morrow

LONDON AND NEW YORK

First published 2018
by Routledge
2 Park Square, Milton Park, Abingdon, Oxon OX14 4RN

and by Routledge
711 Third Avenue, New York, NY 10017

Routledge is an imprint of the Taylor & Francis Group, an informa business

© 2018 Guy Morrow

The right of Guy Morrow to be identified as author of this work has been asserted by him in accordance with sections 77 and 78 of the Copyright, Designs and Patents Act 1988.

All rights reserved. No part of this book may be reprinted or reproduced or utilised in any form or by any electronic, mechanical, or other means, now known or hereafter invented, including photocopying and recording, or in any information storage or retrieval system, without permission in writing from the publishers.

Trademark notice: Product or corporate names may be trademarks or registered trademarks, and are used only for identification and explanation without intent to infringe.

British Library Cataloguing-in-Publication Data
A catalogue record for this book is available from the British Library

Library of Congress Cataloging-in-Publication Data
Names: Morrow, Guy, author.
Title: Artist management : agility in the creative and cultural industries / Guy Morrow.
Description: New York : Routledge, 2018. | Includes bibliographical references and index.
Identifiers: LCCN 2017048349 | ISBN 9781138697652 (hardback) | ISBN 9781138697669 (pbk.) | ISBN 9781315520896 (ebook)
Subjects: LCSH: Arts--Management. | Arts--Marketing. | Artists' representatives. | Concert agents. | Theatrical agents.
Classification: LCC NX760 .M67 2018 | DDC 706--dc23
LC record available at https://lccn.loc.gov/2017048349

ISBN: 978-1-138-69765-2 (hbk)
ISBN: 978-1-138-69766-9 (pbk)
ISBN: 978-1-315-52089-6 (ebk)

Typeset in Bembo
by Taylor & Francis Books

Visit the companion website: http://www.routledgetextbooks.com/textbooks/MMCCI/

For Zara Yasmin Morrow

CONTENTS

List of illustrations xi
Acknowledgements xii

1 **Introduction: Artist management in the creative and cultural industries** 1
 1.1 The agile movement 2
 1.2 Collaboration has a lifespan 4
 1.3 Managing artistic contributions 5
 1.4 What is artist management? Is it creative? 8
 1.5 The artist–artist manager relationship 9

2 **Research design** 15
 2.1 Selection of industries, cases and participants 15
 2.2 Methods 19
 2.3 Outline of the book 21

3 **The artist's career as startup: Lean startup and effectuation methods for the arts** 26
 3.1 Extreme uncertainty: What is art? 26
 3.2 Extreme uncertainty: Shaping a future for yourself 31
 3.3 Conclusion: What good are the arts? How can we sell art? 38

4 **Agile management strategies** 44
 4.1 Artist management and the agile movement 44
 4.2 Agility on individual and group levels 48

4.3 Case study: Agility in the dance sector 50
4.4 Case study: Agility in the film sector 55
4.5 Conclusion 61

5 Storytelling in the creative and cultural industries: Where is creativity? Creative cities and artist management — 66
5.1 Storytelling in the creative and cultural industries 66
5.2 Sporting analogies 67
5.3 An artist manager's checklist 68
5.4 Moving people to action 70
5.5 B2C and B2B storytelling 71
5.6 Storytelling etiquette 73
5.7 Case study: SXSW favours the storytellers 76
5.8 Destroying through narrative 78
5.9 Conclusion 82

6 The artist–artist manager relationship: Agile by default — 86
6.1 The specificity of artist management labour 86
6.2 An informal approach to management 87
6.3 They found me with a gun in my hand 88
6.4 Double dipping 93
6.5 The bank account 97
6.6 Conclusion 101

7 Conclusions: The future of artist management: Artist's voice, manager's voice — 104
7.1 The rapid escalation of complexity 104
7.2 Creativity: The key leadership competency for the future 105
7.3 Music case study 1: The Featured Artists' Coalition 106
7.4 Music case study 2: The International Music Managers' Forum 108
7.5 Judas Goat 109
7.6 Dance case study: GoSeeDo and Book a Flash Mob 111
7.7 Creative and cultural industries case study: Culture Counts 115
7.8 Big data, automation and the future of work 117

Appendix A: The interviews 124
Appendix B: Association of Artist Managers Code of Conduct 125
Appendix C: Code of Conduct of MMF Australia 127
Index 129

ILLUSTRATIONS

Figures

1.1	Artist management	10
2.1	The concentric circles model of the creative and cultural industries	16
4.1	Agility on two levels	48

Table

A.1	The Interviews	124

ACKNOWLEDGEMENTS

This research was funded by a Macquarie University New Staff Grant that was awarded to me in 2010 to 2011. This grant funded the travel required to conduct the research interviews in New York, London and Toronto. The time required to conduct this research was made possible by a period of Outside Studies Program (OSP) leave from Macquarie University to work as a visiting scholar at New York University (NYU) from January to July 2010, and then again from December 2010 to March 2011. Thanks to Professor Catherine Moore of the University of Toronto, who was then at NYU, for organising to host me during this time. Thanks to Macquarie University, and various administrative staff, for making such grants and periods of study leave possible. Thanks also to the University of Melbourne Faculty of Arts Internal Grants scheme for funding copyediting and indexing.

Material from Chapter 5 has previously appeared elsewhere as:

Morrow, G. (2008) 'Creative Process as Strategic Alliance', *International Journal of Arts Management*, 11, 1: 4–15.

I am grateful to the editor of this journal for permission to use the material. I would also like to thank Nathan Brenner at the Music Managers' Forum (MMF) Australia and the International Music Managers' Forum (IMMF) for granting permission to use the MMF code of conduct and for organising permission for me to use material from the IMMF website. Thanks also to Leanne de Souza at the Association of Artist Managers (AAM) for organising permission for me to use the AAM code of conduct. Thank you to Georgia Moore at Culture Counts, Chris Elam at GoSeeDo and Jordan Statham at the Featured Artists' Coalition for granting permission for me to use material from your respective websites. Thanks also to Taylor & Francis for granting me a licence to use Figure 2.1 in the book.

I would like to thank the following people for their comments on ideas and topics that shaped this book. Two new colleagues at the University of Melbourne, Dr Beth Driscoll and Dr Christiaan de Beukelaer, provided extremely valuable

feedback during the final stages of writing this book. Thanks also to Kate Leeson for copyediting the book and for providing editorial suggestions. This book has also benefited enormously from various conversations with artist managers and self-managed artists in the field, including: Rowan Brand, Gregg Donovan, John Watson, Catherine Haridy, Julie-Anne Long and Jefferton James. This research project was initially suggested by Australian-Canadian artist manager Michael McMartin, who subsequently provided many useful research interview leads. The book also benefited from comments made by audience members at various conferences and seminars where I presented these ideas, and from undergraduate and postgraduate students in classes at the University of Melbourne, the Sydney Opera House, Macquarie University and New York University.

I am very grateful to all the people who agreed to be interviewed for the book. Thanks to the various members of the IMMF who provided interview leads within the music sector of the creative and cultural industries, and to Emily Gilfillan and Julie-Anne Long for knowledge about the dance sector. Thanks also to Peter Maple and Catherine Fargher for generously sharing their knowledge about the film sector.

Thanks to the family and friends who sustain me during my work. While too numerous to name here individually, you know who you are. Thank you so much for supporting me and keeping me going during all the years of researching and writing this book. Thanks to Jefferton James and Dimity Kennedy for all the fun times on set producing music videos. Thanks to Armin Sayyadi and Mon Sayyadi for making our move to Melbourne from Sydney during the writing of this book much easier than it might otherwise have been. Thanks to Mum and Dad for their love and support, and especially to my wife Anna Morrow for her 'unrelenting' positive attitude, love and support and for largely carrying the burden of organising our move to Melbourne while I finished writing this book.

I would like to dedicate this book to Zara Yasmin Morrow, who was born during the writing of this book and who is the most amazing thing I have ever helped to create.

<div style="text-align: right;">
Guy Morrow, Melbourne, Victoria

October 2017
</div>

1

INTRODUCTION

Artist management in the creative and cultural industries

Why would you want to be an artist manager? Throughout the numerous research interviews I conducted for this book in New York, London, Toronto, Sydney and Melbourne, I experienced many poignant moments when my role as a researcher seemingly morphed into that of a therapist for the artist managers and self-managed artists I was interviewing. Artist management can be a thankless and difficult task. So why do it?

My own rationalisation for being involved in artist management is that I want to be helping to create content that I think is amazing. I am driven to manage artists because I am chasing the 'five minutes of magic' that is sometimes generated by this activity. This is a subjective type of magic that may take the form of a song that is recorded in a studio or a live performance or video. And it is subjective: it involves helping to create something that is amazing to *me* and that can be defined as such by *me*. Then – hopefully – many other people will also find the content to be amazing, and they will become fascinated enough to spend money attending performances, listening to recordings and contributing to crowdfunding campaigns, thus helping to build a client's career. This is what motivates me and draws me towards working with people who amaze me. This perspective was shared by some of the participants in this research project. The artist managers interviewed were often fascinated by the talent of their clients, what their clients can do, how career building works and how they could help realise the potential of their client's art, or their own art if they were self-managed.

I became involved in artist management through working as a musician, performing in bands that I was managing myself. I fell into the role by default, self-managing primarily because I was in bands that no one else gave a damn about. I then started to think about how I could progress 'our band', a band that we were, with hindsight perhaps inappropriately, obsessed with. This passion for musical creativities then led to an interest in management in and of itself and in how artists

in other sectors of the creative and cultural industries, such as dance and film, are managed or self-manage. In particular, I am interested in thinking about how artists are, and can be, managed using agile methods. Within the field of organisational and business management literature (OBM), I am influenced by the lean startup movement (Ries, 2011) and the agile movement (Highsmith, 2010; Medinilla, 2012).

This book examines the extent to which the methods stemming from these movements can be used to address uncertainty relating to artistically creative products and career development in the creative and cultural industries. The aim of this book is to capture an aspect of the creative and cultural industries – artist management – as it is experienced, and interpreted, by the participants in this project. There has been, and will arguably continue to be, a rapid escalation of complexity within the creative and cultural industries due to the digitisation of aspects of these industries. Furthermore, these industries will increasingly interface with the data economy. In this book, I argue that this rapid escalation of complexity is the biggest challenge facing artists and artist managers and that agile methods are useful for facing an uncertain and increasingly complex future.

Artist management is organic, adaptable and diverse. It contrasts with other forms of management that emphasise linearity, conformity and standardisation. In this book, I argue that the uniqueness of artist management stems from its subordination to artistic creativities and the fact that such symbolic creativities are artistically/aesthetically autonomous and 'cannot be reduced to set rules or procedures' (Hesmondhalgh and Baker, 2011: 84). I also argue that partly due to the autonomy of what they are managing, as well as the fact that there are no professional qualifications required to become an artist manager, artist managers are extremely professionally autonomous in their roles. This is why, I argue, agile methods are useful in this context. This book engages with literature relating to these methods rather than other works within the field of OBM. In turn, the arts have much to offer the agile movement.

1.1 The agile movement

This book therefore locates artist management practices in the creative and cultural industries within the agile movement. Agile project management (APM) originated for the purposes of developing software to better meet users' needs. While originating in the software industries, the agile movement has now become mainstream, with the ideas stemming from this approach to innovation being deployed in many industries and even by governments.[1] APM is characterised by the close monitoring of customer feedback, and each iteration of the developing product is designed to obtain and test such feedback. In this way, product development is not informed by assumptions about what customers want, but what they actually need. This approach therefore reduces the risk involved in product development, and within the context of the creative and cultural industries, it potentially has an impact on the artistic/aesthetic autonomy of the artist.

APM enables participants to respond to change rather than follow a rigid plan, often in small teams that work autonomously, with managers managing for goals rather than micromanaging processes. This is because APM involves understanding that, as software engineer and author Highsmith (2010) put it, 'ultimate customer value is delivered at the point-of-sale, not the point-of-plan' (8). APM has largely been enabled by 'the plunging cost of experimentation' (5) in many industries, which has been made possible by the digitisation of aspects of these industries. This is true of the arts; for example, the music industries. In my earlier co-written work (Hughes, Evans, Morrow and Keith, 2016) examining career development in music, we discussed a similar approach to APM, the lean startup method (LSM) (see Ries, 2011). My co-authors and I noted that:

> Due to the ambiguity surrounding the term 'novel' in definitions of hard artistic creativity, some artists are operating in circumstances of extreme uncertainty. … The uncertainty and ambiguity surrounding the novelty of hard artistic creativities, and the question of who decides what is creative in the digital ecology, means that startup methodologies for addressing uncertainty in relation to both hard artistic creativity, and the business/es around it, are applicable.
>
> (Hughes et al., 2016: 37–8)

Due to the plunging cost of experimentation, we (Hughes et al.) also argued that musicians can very cheaply release recorded music as a minimum viable product (MVP) (Robinson, 2001, and Ries, 2011, cited in Hughes et al., 2016: 38) in order to manage the risk associated with what we identified as a new circular career development model (see p. 30). In music, for example, promoting an artist to gatekeepers in the industries involves releasing a 'demo', or a 'demonstration', of a song as a recording. Nowadays, through social media, a demo can be released early as an MVP. This involves bringing the audience into the process of record production early and fascinating them in the same way that an artist manager may be fascinated. This can lead to 'demoitis' whereby the fan, or the person in the creative and cultural industries listening to the demo, becomes attached to an early recording. This is often because the demo is 'loose' and has a rough beauty to it that is subsequently polished off when the song is re-recorded at great expense in a professional studio. While this is often done with the best of intentions, the end product that is then released to a (hopefully) mass audience lacks something the raw demo had. I am not sure whether this is because one becomes attached to the original sound of the demo or whether there was something captured in the performance that cannot be captured again. Nevertheless, in the digital age, the timing of *when* an audience can be engaged has been brought forward in the creative process. Indeed, there has been a shift from summative to formative feedback from audiences and critics.

This book focuses on APM more than LSM. A startup is only a temporary organisation, ultimately seeking to move on from the startup phase; and in the

context of the arts, startup methods are primarily useful for managing hard artistic creativities. In contrast, as I will explain, APM is applicable to managing the whole spectrum of hard to weak creativities (Madden and Bloom, 2001) and is useful during any startup phase, as well as post such a phase, in addition to facilitating innovation in businesses that are not entirely new.

1.2 Collaboration has a lifespan

As an artist manager I have contributed to the creation of music and design works, and also to the founding of numerous creative and cultural industries startups. I have worked with many of Australia's best-known musicians within various popular music scenes through direct artist management as well as through music and design work. During the time frame of the research for this book, I was the founding co-manager of the bands Boy & Bear and Movement and I managed graphic designer and videographer Jefferton James. In this capacity I worked with Australian and international artists such as Passenger, Josh Pyke, Missy Higgins, Dustin Tebbutt, Emma Louise, Sheppard, The Paper Kites, The Griswolds, Oh Mercy, Tim Rogers, Kasey Chambers, Patrick James, and Husky. This involved working with Universal Music Group/Republic in New York, Creative Artists Agency in Los Angeles, International Talent Booking in London, Universal Music Australia, Warner Music Australia, Sony Music Australia, ABC Music, EMI, Chugg Entertainment, Eleven Music, i.e. Music, Wonderlick Entertainment, Select Music, Central Station Records, MGM, Inertia, and Nettwerk Music Group.

Interestingly, however, this list of artists with whom I am associated, and that I 'name-drop' here in an attempt to claim credibility in writing about artist management, is also, with the exception of Jefferton James, a list of the artists whom *I no longer manage* or for whom *we no longer produce* visual content. In this book, I define artist management as a form of group creativity, and therefore the nuances of group creativity are relevant here. One particular nuance that shone through in the research interviews is that creativity naturally leads to disloyalty within groups because any collaboration has a lifespan (see Chapter 3).

In this book, agility therefore also pertains to the process of relationships forming and dissolving. This form of agility can be understood in relation to group flow. Through his studies of jazz music groups, improv theatre groups and business teams, Sawyer (2007, 2012), who is a psychologist, found that while familiarity with each other is a requirement for a team to achieve group flow:

> After two or three years, members of groups can become too familiar with each other and their effectiveness starts to decrease. Close listening becomes less necessary because everything is shared; no surprises are left. When group flow fades away, the group usually breaks up because its members want to find new challenges elsewhere.

(Sawyer, 2007: 52)

Sawyer's findings are relevant to the artist management group in a multitude of ways. While the collaboration between the artist and the artist manager may itself have a natural lifespan, the artist may also be involved in an artistically creative group that has a lifespan, a group with which they collaborate until the interaction is no longer challenging. This causes angst for the artist manager her/himself and also within the groups they are managing. This is because the rhythm of group creativity often naturally ends with a break-up which is taken personally and interpreted as an act of disloyalty when, in fact, it is often not personal. This issue is arguably more pronounced in some sectors of the creative and cultural industries than others.

Within the music industries for example, it is common for artists and bands to sign with a record label for one album, with a firm release commitment, and then options for subsequent albums – options that are exercisable by the record label. If the first album is commercially successful, there is an expectation that the band will stay together for the release of multiple albums. Each album is typically released within a two-year cycle. The nature of group creativity over such a long time frame means that bands and their managers necessarily attempt to resist the natural transitions in the lifespan of such creative groups. The dance, film and theatrical industries arguably operate on a more project-by-project basis, and therefore groups within these sectors naturally form and dissolve more rapidly. An extreme example of this is improv theatre: 'Chicago improv ensembles rarely continue performing together for more than three months, and many shows last for much less than that before the members move on and form new combinations with actors likewise freed from other mature groups' (Sawyer, 2007: 52).

Understanding that the rapid forming and dissolving of groups within the creative and cultural industries is natural, because such collaborations have lifespans, can help managers deal with perceptions of disloyalty amongst the groups they are managing. Such feelings of betrayal no doubt become more difficult to deal with however when an artist manager is dealing with the lifespan of their own collaboration with a client.

1.3 Managing artistic contributions

This research-based book therefore conceptualises the artist–artist manager partnership as a form of group creativity. Because artists contribute to society in a complex variety of ways, so too do artist managers. While artistic creativity can serve useful, benevolent purposes that enrich our world, there is also a dark side to artistic creativity; the divisive tendencies of the arts can lead to tension, violence and fanaticism,[2] and creative thinkers can be more dishonest.[3] Furthermore, many of the activities that are required to sustain artistic careers, such as the flying involved with international touring, are very carbon intensive and therefore have an environmental impact. A full understanding of artistic contributions is therefore needed when examining the topic of artist management. What exactly are artists, and their managers, managing?

Artistic contributions are often understood in one of two ways. First, artistic creativity can be seen as beneficial *in and of itself*. This understanding of the 'intrinsic' value of the arts is often referred to as 'art for art's sake'. Second, artistic creativity is believed to generate *instrumental*[4] benefits (see Belfiore and Bennett, 2008: 7). Within the arts advocacy and funding discourse that emanates from the creative and cultural industries, there has been a shift from considering the arts to be a 'loss leader'[5] for the public good, one that should be subsidised using taxpayers' money, toward arguments that there are a wide range of instrumental benefits that can be derived from artistic creativities.[6] Within the creative and cultural industries, 'economic' benefits are arguably predominant in such instrumental arguments. However, such arguments also feature the impact school students' participation in artistic creativities can have on their performance in other subjects, and the ways in which the arts can strengthen democracy (Madden and Bloom, 2001: 411). The creative and cultural industries literature itself is therefore divided due to its tendency to rely on such instrumental arguments, particularly when it comes to a consideration of which art forms can be lent to the mass market and those which cannot so readily be. This tension also plays out in policy debates when there is an attempt to distinguish between 'high' art[7] and mass or popular art (see Gilfillan and Morrow, 2016). The complexity of artistic contributions, and how these contributions are managed, therefore derives from binaries such as these, and also from the uncertainty surrounding creativity itself.

Following Madden and Bloom (2001), two broad conceptual forms of creativity can be used here to analyse this complexity and uncertainty: 'hard' creativity and 'weak' creativity.[8] The differences between these two forms pivot on the concept of 'newness'. For them, '"Hard" creativity represents the creation of something that is "brand new" in the sense that it is unprecedented (creation as invention). "Weak" creativity represents something merely being "brought into being" (creation simply as production)' (412). For Madden and Bloom (2001), these two forms of creativity are located at opposite ends of a spectrum. These categories are therefore not distinct but, rather, creativity involves various blends of hardness and weakness. A particular challenge for artists, and their managers, is that while weak creativity is perhaps the predominant form of artistic creativity (Madden and Bloom, 2001: 414), the focus of arts advocates, policymakers, and often the media[9] on innovation and 'hard' artistic creativities means that what most artists are creating the majority of the time falls outside the scope of many of the support structures within the creative and cultural industries.

The research problem explored in this book then is: How do artists and their managers make headway in such complex conditions of uncertainty? I explore this problem by drawing upon original research that I conducted in three sectors of the creative and cultural industries: music, dance and film.[10] The research questions informing this study emphasise the subjective experiences of artist managers and self-managed artist entrepreneurs. What is it like to manage an artist? Or, if you are a self-managed artist entrepreneur, what is it like to manage your own career? Can agile methods[11] be used to manage artists within the creative and cultural industries?

The contributions of artists, both in terms of artistic creativity that is beneficial *in and of itself* and artistic creativity that generates *instrumental* benefits, drive the creative and cultural industries as part of the super-creative core of these industries (Florida, 2002, 2017). This book focuses on how artists are managed. In doing so it aims to advance our understanding of the generative relationship between artists and their managers, and those between self-managed artist entrepreneurs and the people with whom they interact in order to create their careers.

This book builds on a growing body of research concerning creative labour by focusing on the key role artist managers have in managing the endemic features of this type of labour: overidentification, fragility, portfolio careers, low and sometimes non-existent wages, low emotional resilience, gendered constraints, and intense competition leading to high failure rates (Hesmondhalgh and Baker, 2011; Throsby and Zednik, 2010; Bridgstock, 2011, 2013; Stahl, 2012). And because artist management itself is a form of creative labour, this book also examines how artist managers sustain their own livelihoods and mental health. The growing body of literature on creative labour has examined these issues as well as the positive aspects of artistic careers such as intrinsic motivation, the joy of creating and self-realisation – aspects that have also been addressed in the field of creativity research more broadly (Amabile, 1997; Csikszentmihalyi, 1997; Sawyer, 2012). However, comparatively little attention has been paid to how artists are managed within the creative and cultural industries[12] and, specifically, whether agile management approaches can help to address issues such as career fragility.

The paucity of research into artist management is striking given that in the arts sector in Australia, for example, 77 per cent of *all artists* and 87 per cent of *visual artists* identify as freelancers/self-employed artists (Throsby and Zednik, 2010: 53). Given these percentages, and the fact that the largest amount of funding allocated by the Australia Council during the 2013–14 financial year went to major performing arts organisations and key organisations[13] (Australia Council for the Arts, 2014: 20–1), artists and artist managers are often left to their own devices in Australia. The situation is similar in the UK in that, as Jones (2015) noted,

> Since 2008/9, self-employed earnings have dropped by 22%. The typical self-employed person now earns 40% less than their employed counterpart. ... [In] the publicly-funded visual arts – in which self-employment stands at around 50% ... the salaries of arts employees increased during the recession, while freelance fee rates went down.
>
> *(1)*

Artist management (including self-management) involves helping artists to sustain livelihoods in contexts in which they are primarily left to their own devices. As Csikszentmihalyi (1996), an influential positive psychologist, stated:

> Although all creative persons, in breaking new ground, must create careers for themselves, this is especially true for artists, musicians, and writers. They are

often left to their own devices, exposed to the vagaries of market forces and changing tastes, without being able to rely on the protection of institutions. ... Those who persevere and succeed must be creative not only in the manipulation of symbols but perhaps even more in shaping a future for themselves.

(199)

This book therefore focuses on the ways in which artists, self-managed artist entrepreneurs and artist managers shape futures for themselves. This is particularly important given that, as Segers, Schramme and Devriendt (2010) observed, there is a paradox relating to arts policy: 'although the arts have been largely embedded within organizational and management structures, the situation of individual artists has become more vulnerable' (58).

1.4 What is artist management? Is it creative?

There is a debate within creative and cultural industries literature as to whether the manager's role is a creative one. While authors such as Bilton and Leary (2002), Bilton (2007) and Robinson (2012) have argued that it is, Banks (2007), McGuigan (2009) and Hesmondhalgh and Baker (2011) have argued that the conflation of 'creative' and 'management' is problematic because it divests artistically creative work of its privileges. Burnard's (2012) notion of 'creativities' can be used to aid conceptual clarity here. Pluralising creativity enables us to understand that artistic creativity and managerial creativity are different types of creativity that interact with one another in sometimes combustible and conflicting ways and at other times in generative ones. This also enables artistic creativity to remain unique. The fact that the artist manager is managing the 'concrete and named labour of the artist' (Ryan, 1992: 41) means that there is a direct connection between the person/artist and the product – to the extent that the artist may even overidentify with their work. Whilst artist management is arguably creative, the artist's labour is different in this way. In fact, arts marketers, artist managers and publicists play on these differences to convince audiences that their client is different from them, is special, is unique and is a gifted genius, so that they will buy concert tickets and other products (whether they themselves buy into this positioning of the artist or not). There is also an affective element to artistic creativity that is not as evident in managerial creativity, the latter focusing on problem-solving, negotiating solutions and strategising.

An engagement with the three main streams of creativity research identified by Weisberg (2010), a cognitive psychologist, enables us to understand the origins of the colonisation by artists of the term 'creative' while simultaneously moving beyond this colonisation in our understanding of artist management as a creative function. For Weisberg (2010), the first stream of creativity research lies

> outside ordinary conscious thought: one possible source is *madness*. ... The second stream – *psychometrics of creativity* – centers on measuring the particular

thinking abilities and personality characteristics that contribute to creativity ... *divergent thinking*. ... The third stream, the *cognitive view*, rejects the notion of genius.

(236)

Weisberg (2010) labelled the first stream 'out of one's mind'. This stream is otherwise known as the 'romantic view' of creativity, whereby creative works are understood to be produced by mysteriously gifted geniuses – geniuses who just (problematically) happen to be predominantly male, white and middle to upper middle class. This stream therefore obviously features a divide between a tiny percentage of 'creative' people and the many 'non-creative' people. Interestingly, the second stream, what Weisberg (2010) termed the 'psychometrics of creativity', also features a divide between 'creative' and 'non-creative' people. Stemming from psychology and social psychology, this stream is inclusive of more people, though it too implies that creative people are special because they are either naturally predisposed to think in more divergent, lateral and open ways, or they have been able to learn how to do this. Weisberg's (2010) final stream, 'the cognitive view', stems from cognitive science and the ability to generate fMRI and PET scans of the human brain. Scientists in this field argue that there are no differences in thinking between the people sampled and, therefore, creativity is an ordinary thinking process.

Arguments about whether creativity is manageable, whether artist management is creative, and the extent to which 'creativity' and 'management' can be conflated, typically stem from one of these particular streams. There is a spectrum of thinking about creativity in the field of creativity research. At one end it is extraordinary, while at the other, it is ordinary. While the practices of artist managers may, for marketing purposes, perpetuate the view that artists are *out of their minds* (and the conditions of work of creative labourers may mean that this is a self-fulfilling prophecy), when considering the psychometrics of creativity in conjunction with the cognitive view, one can argue that there are no differences in thinking processes (how the brain actually works) between so-called 'creative' artists and so-called 'non-creative' managers. Artist management can therefore be defined as a form of group creativity that involves the interaction between artistic creativities and managerial creativities. Defining artist management in this way enables us to pluralise this form of creativity and to conceptualise it as a dialectic between these two clusters of creativities – creativities that are at times in conflict and at other times in harmony.

1.5 The artist–artist manager relationship

Within the context of OBM, artist management within the creative and cultural industries is unique because quite often managers work *for* their artists. While in other fields managers are employed by capitalists to efficiently run their interests for them, with the staff hired under the manager being subordinate to the manager, artists employ artist managers to build and guide their own careers. Artists are often

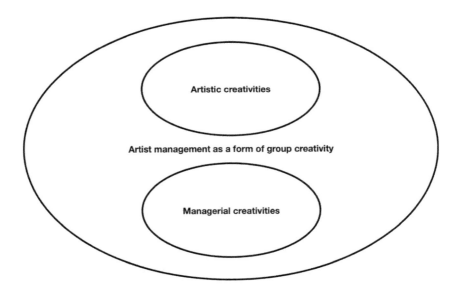

FIGURE 1.1 Artist management

the capitalists, the product and the equivalent of the staff being managed all in one, and generally speaking artists both own and sell the products of their labour. Despite the common rhetoric that artists are ripped off by managers,[14] in many cases artists themselves are the capitalists who exploit the labour of managers. Therefore, whilst artist management can be defined as a form of group creativity, the managerial creativities within this 'group' are for the most part subordinate to the artistic creativities, and to the artist.

The balance of power in the relationship between artist and manager is unique as the artist manager works for the artist, while at the same time the artist is often following the artist manager's lead. Throughout an artist's career trajectory, this balance of power tends to shift as success[15] accumulates. A rise in the level of success will see the power balance shift in the artist's favour. However, in the period before success and after a decline in success, the power balance will be in the artist manager's favour, and this has consequences for dealmaking between the two parties. There are also more nuanced and day-to-day power shifts between the two parties.

In order to further conceptualise this shifting power dynamic within the artist and manager group, Gilfillan's (2016) work concerning dance-making is useful. Gilfillan's work is situated at the intersection of psychological and organisational behaviour research into group creativity and dance studies and focuses on the exchanges of power that occur between dance-makers and dancers. She further develops Sawyer's (1999, 2000, 2003) theory of collaborative emergence to frame collaboration as 'the moment-to-moment creative developments that occur when dancers/creatives and dance-makers are negotiating concepts, tasks and movement sequences' (Gilfillan, 2016: 6). This theory is useful for a consideration of artist management as a form of group creativity as it creates the space for understanding

artist managers' contributions to creative work in the arts. Arguments that virtually all creative work in the arts is collaborative have shifted the field of dance studies from notions of individual authorship toward a focus on democratic collaboration. However, 'rejecting one type for another creates a binary and overshadows the shifts in power between a dance-maker and dancers during a process' (Gilfillan, 2016: 7). Instead, the theory of moment-to-moment collaboration involves understanding that there are moment-to-moment power fluctuations and active and passive power exchanges between dancers and dance-makers. This theory is relevant here for understanding the nuances of the collaborative relationship between artistic 'creatives' and managerial 'creatives' in the artist management group. Both the artist and the artist manager, on a moment-to-moment basis, contribute to each other's creativities, and in this way, artists' careers collaboratively emerge over time.

Drawing from research interviews conducted with artist managers and self-managed artists in five cities – New York, London, Toronto, Sydney and Melbourne – this book makes an original contribution to knowledge. Nation-specific case studies are highlighted as a means of illuminating various thematic concerns, such as the conditions and experiences of artists and artist managers, the tensions between commerce and creativity, artist advocacy, artist manager advocacy, exploitation, self-exploitation, self-realisation, best practices and codes of conduct. The book undertakes an extensive exploration of the increasingly pivotal role of artist managers in the creative and cultural industries and argues that agile management strategies are useful in this context.

Notes

1 For example, in Australia Prime Minister Malcolm Turnbull often used the term 'agile' to describe elements of his approach after he succeeded Tony Abbott as Prime Minister in 2015.
2 For an examination of the topic of popular music and violence, see Johnson and Cloonan (2009).
3 For evidence concerning creativity and dishonesty, see Gino and Ariely (2012) and Ariely (2013).
4 In this context, 'instrumentalism' involves considering artistic activity to be an 'instrument' or tool for a practical purpose rather than in more absolute or ideal terms as an end in and of itself (art for art's sake).
5 A loss leader is usually a product that is sold at a loss to attract customers to purchase another product that will generate a profit. The term is being used here to suggest that the arts are funded at a loss in order to generate benefits pertaining to the 'public good'.
6 See Cunningham (2009) for an outline of the various ways in which creative industries discourse has recast the traditional arts in a positive economic light around the world. While some couch this in terms of a problematic adherence to the market fundamentalism of the neo-liberal agenda (McGuigan, 2009), others have argued that 'the concept of neo-liberalism only partly explains this shift towards instrumentalism' (Hesmondhalgh, Nisbett, Oakley and Lee, 2015: 108).
7 Carey (2005) noted that 'cultural commentators distinguish "high" art (classical music, "serious" literature, old-master painting, etc.) from mass or popular art, and generally assume its superiority' (32). He argued that there are no rational grounds for this binary however.

8 The word 'weak' is not used by Madden and Bloom (2001) in a derogatory way; it simply refers to something that is brought into being, and in terms of their spectrum, it provides a contrast with 'hard' creativity.
9 For example, within the music industries, Chicago-based Pitchfork Media (see Sinkovich, Ravanas and Brindisi, 2013) and the Australian Broadcasting Corporation's (ABC's) youth broadcaster triple j aim to facilitate invention and innovation in contemporary music, with triple j's governing statute officially requiring it to do so by law.
10 See Acknowledgements for more details concerning the funding for and length of this research, and see Chapter 2 for the research design and methods.
11 Agile methods respond to unpredictability and uncertainty through the iterative and incremental development of projects. Such methods are informed by the empirical feedback derived from various experiments rather than traditional project management, which has been critiqued by the agile movement because it relies on too many assumptions.
12 Some of the exceptions to this are considered in Chapters 3 and 4. One particular exception is a book I co-authored concerning the new music industries (Hughes, Evans, Morrow and Keith, 2016).
13 Australia's major performing arts companies operate in the areas of dance, theatre, opera, circus, chamber music and orchestral music, while key organisations are small and medium-sized organisations that are recognised for their leadership in artistic vibrancy and sector development. See Australia Council for the Arts (2014: 20–1).
14 Rogan (1988) was one of the first to deconstruct what he believed to be the most prevalent stereotype of an artist manager within the field of music – the familiar caricature of a cigar-smoking hustler who takes advantage of star-struck adolescents. He attempted to do this by providing a list of 13 categories of managerial types.
15 The term 'success' is being used here to refer to both an artist's creative and commercial success. For a discussion of the various reconceptualisations of success within the music industries that have occurred during the digital age, see Hughes et al. (2013) and Smith (2013).

References

Amabile, T. (1997) 'Motivating Creativity in Organizations: On Doing What You Love and Loving What You Do', *California Management Review*, 40, 1: 39–58.
Ariely, D. (2013) *The Honest Truth About Dishonesty: How We Lie to Everyone – Especially Ourselves*, New York: Harper Perennial.
Australia Council for the Arts (2014) *Annual Report: 2013–2014*, Strawberry Hills, NSW: Australia Council for the Arts.
Banks, M. (2007) *The Politics of Cultural Work*, Basingstoke: Palgrave Macmillan.
Belfiore, E. and Bennett, O. (2008) *The Social Impact of the Arts: An Intellectual History*, Basingstoke: Palgrave Macmillan.
Bilton, C. (2007) *Management and Creativity: From Creative Industries to Creative Management*, Malden, MA: Blackwell.
Bilton, C. and Leary, R. (2002) 'What Can Managers Do for Creativity? Brokering Creativity in the Creative Industries', *International Journal of Cultural Policy*, 8, 1: 49–64.
Bridgstock, R. (2011) 'Making it Creatively: Building Sustainable Careers in the Arts and Creative Industries', *Australian Career Practitioner Magazine*, 22, 2: 11–13.
Bridgstock, R. (2013) 'Professional Capabilities for Twenty-First Century Creative Careers: Lessons from Outstandingly Successful Australian Artists and Designers', *International Journal of Art and Design Education*, 32, 2: 176–189.
Burnard, P. (2012) *Musical Creativities in Practice*, Oxford: Oxford University Press.
Carey, J. (2005) *What Good Are the Arts?* London: Faber.

Csikszentmihalyi, M. (1996) *Creativity: Flow and the Psychology of Discovery and Invention*, New York: HarperCollins.
Csikszentmihalyi, M. (1997) *Finding Flow: The Psychology of Engagement with Everyday Life*, New York: Basic Books (MasterMinds).
Cunningham, S. (2009) 'Trojan Horse or Rorschach Blot? Creative Industries Discourse Around the World', *International Journal of Cultural Policy*, 15, 4: 375–386.
Florida, R. (2002) *The Rise of the Creative Class: And How It's Transforming Work, Leisure, Community and Everyday Life*, New York: Basic Books.
Florida, R. (2017) *The New Urban Crisis: How Our Cities Are Increasing Inequality, Deepening Segregation, and Failing the Middle Class – and What We Can Do About It*, New York: Basic Books.
Gilfillan, E. (2016) *Dance-Making: Moment-to-Moment Collaboration in Contemporary Dance Practices*, PhD thesis, Macquarie University, Sydney.
Gilfillan, E. and Morrow, G. (2016) 'Sustaining Artistic Practices Post George Brandis's Controversial Australia Council Arts Funding Changes: Cultural Policy and Visual Artists' Careers in Australia', *International Journal of Cultural Policy*, online before print: 1–19.
Gino, F. and Ariely, D. (2012) 'The Dark Side of Creativity: Original Thinkers Can Be More Dishonest', *Journal of Personality and Social Psychology*, 102, 3: 445–459.
Hesmondhalgh, D. and Baker, S. (2011) *Creative Labour: Media Work in Three Cultural Industries*, Abingdon; New York: Routledge.
Hesmondhalgh, D., Nisbett, M., Oakley, K. and Lee, D. (2015) 'Were New Labour's Cultural Policies Neo-liberal?', *International Journal of Cultural Policy*, 21, 1: 97–114.
Highsmith, J. (2010) *Agile Project Management: Creating Innovative Products*, 2nd ed., Upper Saddle River, NJ: Addison-Wesley.
Hughes, D., Keith, S., Morrow, G., Evans, M. and Crowdy, D. (2013) 'What Constitutes Artist Success in the Australian Music Industries?' *International Journal of Music Business Research*, 2, 2: 61–80.
Hughes, D., Evans, M., Morrow, G. and Keith, S. (2016) *The New Music Industries: Disruption and Discovery*, Cham, Switzerland: Palgrave Macmillan.
Johnson, B. and Cloonan, M. (2009) *Dark Side of the Tune: Popular Music and Violence*, Abingdon; New York: Routledge.
Jones, S. (2015) 'Self-employed in the Arts: The Good, the Bad and the Future', *The Guardian*, 23 April. Online: <www.theguardian.com/culture-professionals-network/2015/apr/23/self-employed-arts-freelance-susan-jones> Accessed 28 September 2017.
Madden, C. and Bloom, T. (2001) 'Advocating Creativity', *International Journal of Cultural Policy*, 7, 3: 409–436.
McGuigan, J. (2009) 'Doing a Florida Thing: The Creative Class Thesis and Cultural Policy', *International Journal of Cultural Policy*, 15, 3: 291–300.
Medinilla, Á. (2012) *Agile Management: Leadership in an Agile Environment*. Berlin: Springer.
Ries, E. (2011) *The Lean Startup: How Today's Entrepreneurs Use Continuous Innovation to Create Radically Successful Businesses*, New York: Crown Business.
Robinson, K. (2012) *Out of Our Minds: Learning to be Creative*, Hoboken, NJ: John Wiley & Sons.
Rogan, J. (1988) *Starmakers and Svengalis: The History of British Pop Management*, London: Macdonald.
Ryan, B. (1992) *Making Capital from Culture: The Corporate Form of Capitalist Cultural Production*, Berlin; New York: Walter de Gruyter.
Sawyer, K. (1999) 'The Emergence of Creativity', *Philosophical Psychology*, 19, 4: 447–469.
Sawyer, K. (2000) 'Improvisational Cultures: Collaborative Emergence and Creativity in Improvisation', *Mind, Culture, and Activity*, 7, 3: 180–185.
Sawyer, K. (2003) *Group Creativity: Music, Theater, Collaboration*, Mahwah, NJ: Lawrence Erlbaum Associates.

Sawyer, K. (2007) *Group Genius: The Creative Power of Collaboration*, New York: Basic Books.
Sawyer, K. (2012) *Explaining Creativity: The Science of Human Innovation*, 2nd ed., New York: Oxford University Press.
Segers, K., Schramme, A. and Devriendt, R. (2010) 'Do Artists Benefit from Arts Policy? The Position of Performing Artists in Flanders (2001–2008)', *Journal of Arts Management, Law, and Society*, 40, 1: 58–75.
Sinkovich, J., Ravanas, P. and Brindisi, J. (2013) 'Company Profile: Pitchfork: Birth of an Indie Music Megabrand', *International Journal of Arts Management*, 15, 2: 73–81.
Smith, G. (2013) 'Seeking "Success" in Popular Music', *Music Education Research International*, 6: 26–37.
Stahl, M. (2012) *Unfree Masters: Popular Music and the Politics of Work*, Durham, NC; London: Duke University Press.
Throsby, D. and Zednik, A. (2010) *Do You Really Expect to Get Paid? An Economic Study of Professional Artists in Australia*, Surry Hills, NSW: Australia Council for the Arts.
Weisberg, R. (2010) 'The Study of Creativity: From Genius to Cognitive Science', *International Journal of Cultural Policy*, 16, 3: 235–253.

2
RESEARCH DESIGN

2.1 Selection of industries, cases and participants

The research reported in this book was carried out in New York, London, Toronto, Sydney and Melbourne between 2009 and 2017. I conducted semi-structured interviews with 22 artist managers and self-managed artists across three sectors of the creative and cultural industries: music, dance and film. This method was supplemented by analysis of the trade press associated with each industry and textual analysis of key products. I selected these three industries because they involve two of the different circles that constitute Throsby's (2008) seminal concentric circles model of the creative and cultural industries. Throsby's concentric circles model has four layers or circles that are used to classify the industries that produce cultural goods and services:

Core creative arts

- Literature
- Music
- Performing arts
- Visual arts

Other core cultural industries

- Film
- Museums, galleries, libraries
- Photography

Wider cultural industries

- Heritage services
- Publishing and print media

16 Research design

- Sound recording
- Television and radio
- Video and computer games

Related industries

- Advertising
- Architecture
- Design
- Fashion

(Throsby, 2008: 149)

This research project primarily concerned the core creative arts and, through a consideration of artist management strategies, the relationship between this core and the outer circles of this model. I selected the music industries and the dance industries because they form part of the core layer of this model, while I selected the film industries because they represent the second layer of this model. Using these categories is an effective way to ensure a spread of examples of artist management practices within the cultural and creative industries that encompass different relationships to live performance and to the mass production of the cultural artefacts produced by the artists being managed.

In this research project I employed a qualitative approach. As outlined in the introduction, the aim was to capture an aspect of the creative and cultural industries – artist management – as it is experienced, and interpreted, by the participants in this project. To this end, I employed an 'intensive' rather than an 'extensive' (Harré,

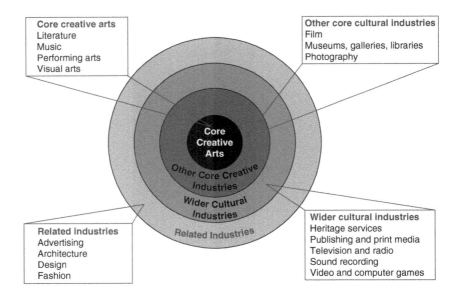

FIGURE 2.1 The concentric circles model of the creative and cultural industries (Reproduced under licence with Taylor & Francis)

1979) research design. I investigated how artist management practices work in a small number of cases in order to generate explanations of the development of artists' careers and of the experiences involved in artist–artist manager relationships. I took measures to ensure a degree of representativeness, in terms of the interviewees involved, so that as wide as possible a range of experiences were examined within the scope of this project and its limitations.

This project began with an examination of the extent to which the international music industries have decentralised and whether this has shifted commercial control from monopoly companies, such as major record labels, to smaller artist–artist manager teams. The scope of this project was then broadened to include self-managed artists and artist managers working within the film and dance industries. This was done in order to advance knowledge and understanding of artistically and managerially creative work within the cultural and creative industries at large through an examination of artist management practices across a number of these industries and some genres within them. Most other studies have tended to be confined to one cultural industry. The primary research questions for this project then became: What is it like to manage artists in the creative and cultural industries? Or if you are a self-managed artist, what is it like to manage your own career? Are agile management strategies used within the creative and cultural industries? Can agile methods be used for managing artists within the creative and cultural industries?

This project employed an innovative approach by putting a number of different analytical fields into mutual dialogue. The creative and cultural industries have most often been theorised and studied within media, communication and cultural studies, and this project also used this lens. A particular focus within this field is the body of literature relating to creative labour (Cloonan, 2014; Eikhof and Haunschild, 2006; Ellmeier, 2003; Gill and Pratt, 2008; Hausmann, 2010; Hesmondhalgh and Baker, 2011; Jones, 2003; McGuigan, 2010; Scott, 2012; Stahl, 2012; Tams, 2002; Taylor and Littleton, 2008; Throsby and Zednik, 2010). The second field of concern here was creativity research; I critically applied theories of artistic creativity and group creativity that stem from the field of psychology (Amabile and Pillemer, 2012; Catmull, 2008, 2014; DeZutter, 2011; Kurtzberg and Amabile, 2001; Kurtzberg, 2005; Weisberg, 2010; Sawyer and DeZutter, 2009; Sawyer, 2012). In particular, I used the notion of how group creativity emerges from, and is therefore a characteristic of, the group, rather than the individuals involved, to analyse the artist management 'group'. Furthermore, artistic processes are considered to be non-linear, dynamic, intuitive and contextually dependent, and therefore theories relating to these processes were linked to a third analytical field: organisational, business and management studies (Anderson, 2006; 2012; Eisenmann, Ries and Dillard, 2012; Highsmith, 2010; Ries, 2011). Specifically, I turned to literature relating to agile project management, hypothesis-driven entrepreneurship and startups in order to develop an understanding of how artistic creativity, and the careers stemming from it, are managed.

Subsequently, the research sub-questions became: Does artist co-management involve 'distributed agility'? What is the nature of the relationship between artist

startups and cultural intermediaries within the creative industries? Can a new project within an existing arts organisation be considered a startup? Is artist management more 'creative' than management jobs in other sectors? What is the difference between waterfall,[1] agile and integrated project management within the context of the creative and cultural industries? Does working in an agile way require a different mindset to that currently dominant within the creative industries? Have artists and artist managers within the creative industries always worked in an agile way due to the nature of artistic creativity?

Therefore this project advances knowledge and understanding of artistically and managerially creative work in a number of ways. In addition to examining artist management practices across a number of cultural industries and genres by focusing on artists' and artist managers' reports of their subjective experience of managing, these 'subjective' data are contextualised through an examination of the organisational, political, economic and cultural dimensions that have an impact on such experiences. In doing so, this research achieves a cross-disciplinary engagement of creative arts and business management discourses concerning creativity. It addresses the paucity of research regarding artist management practices as collaborative creativity in order to extend current understandings of both collaborative creativity and management, and this will be of benefit to the wider community. Through a qualitative, case study approach, I aimed to capture the nature of such processes in an in-depth fashion, addressing some of the shortcomings concerning the usually quantitative methods employed within organisational research and psychological studies of group creativity. I did not aim to supplant previous research, but rather to bring awareness to the assumptions underpinning that research through an investigation of an under-researched area.

When selecting interviewees in each industry, I made an effort to achieve a balance between male and female participants. However, an even split between the two sexes was not achievable due to the fact that the sector that was the initial focus of this project, the music industries, is still male dominated. In terms of the creative and cultural industries overall, Henry (2009) found that 'the same gender-related barriers that exist within other industry sectors are just as prevalent, if not more so, within the creative sector' (143). Henry highlighted the need for empirical research concerning this issue across the various sectors that constitute the creative and cultural industries; however, this goes beyond the scope of this project. In total, 4 females and 18 males were interviewed for this study. Balance was also sought in terms of the following dimensions: those well established in their industries, newcomers and mid-career workers; older and younger participants; participants working for larger artist management companies and those working on a freelance basis; those working in New York City and London, two central areas for Western cultural production, and those working outside of these cities. The recruitment of interviewees was guided by these efforts. However, I also made the most of serendipitous opportunities for interview leads provided by some of the participants.

2.2 Methods

This project used a qualitative approach. It involved intensive interviewing, which is a method that enabled interviewees to outline their experiences of artist management and self-management, including what happens to them and/or their clients, and their rationales for why the creative and cultural industries operate in the way they articulated. There are however some potential, and well-known, limitations to interviewing as a method. These limitations include interviewers asking leading questions and interviewees making definite statements about phenomena without clear evidence to support the statements made. There are also limitations relating to the analysis of interview data. Recent concerns about disciplined methods of analysis (see Hesmondhalgh and Baker, 2011: 16) are reflected in the following commentary from 38 years ago:

> The most serious and central difficulty in the use of qualitative data is that methods of analysis are not well formulated. For quantitative data, there are clear conventions the researcher can use. But the analyst faced with a bank of qualitative data has very few guidelines for protection against self-delusion, let alone the presentation of unreliable or invalid conclusions to scientific or policy-making audiences. How can we be sure that an 'earthy', 'undeniable', 'serendipitous' finding is not, in fact, wrong?
>
> (Miles, 1979, cited in Punch, 2014: 169)

In the light of such a critique of qualitative methods, Punch (2014) noted that methods for the analysis of data need to be systematic, disciplined, transparent and described. If this is achieved and if enough care is applied when analysing the interview transcripts, then they can provide relevant knowledge concerning the topic and issues that the interviewer and interviewee are attempting to address (Hesmondhalgh and Baker, 2011: 16).

I adopted a number of strategies to address the potential pitfalls of qualitative research methods. I continuously evaluated the interviews while they were in process, and the interviewing processes were guided by the following criteria: '1. *Nondirection*. 2. *Specificity*: subjects' definition of the situation should find full and specific expression. 3. *Range*: the interview should maximise the range of evocative stimuli and responses reported by the subject. 4. *Depth and personal context*' (Merton and Kendall, 1946: 545, emphasis added). In addition to adhering to these guidelines, a number of the participants within the different industries studied were working within the same cultural 'world', and this increased the chance that the interviewees' accounts could be checked against one another. Furthermore, in order to help detect evasions and equivocations, I collected as much information as I could about the people being interviewed and, if relevant, their clients. Finally, I coded the data using the Miles and Huberman (1994) approach. While the early labels were merely descriptive, the second round of coding involved inferential (or pattern) codes. These later codes were more interpretive and required some degree

of inference beyond the data, and it was at this stage that confirmations and challenges of the understandings evident in previous studies were uncovered.[2]

Participant observation was not used as a method in this study. Although, as discussed in the introduction to this book, I have been involved in the creative and cultural industries as an artist manager, the purpose of this next section is to address any perceptions of bias towards the artist manager's point of view. The research was conducted independently of my involvement in the creative and cultural industries as an artist manager. However, as Landry, Saïhi, Amara and Ouimet (2010) noted, the way in which academics manage their knowledge transfer activities is a matter of debate. This is a debate that concerns different understandings of knowledge itself as well as the ways in which knowledge can be transferred and, interestingly, resisted. This debate requires some attention here.

Landry et al. (2010: 1396) used a multivariate path model to examine the ways in which academics undertake multiple knowledge transfer activities. Their study explored whether the six knowledge transfer activities they identified – namely, publishing, teaching, informal knowledge transfer, being granted patents, engaging in spin-off formation and providing consulting services – exhibit complementarity, substitution or independence effects. These authors concluded: 'the results of this study suggest that publications, patenting, spin-off creation, consulting and informal knowledge transfer are complementary' (ibid.). My argument here therefore is that my involvement in artist management and consulting as well as academic research publishing involves two 'mutually reinforcing knowledge transfer activities that lead to an enhanced performance in the knowledge transfer of academics' (ibid.). While Landry et al.'s (2010) study primarily concerned academics focusing on engineering and technology, one can extrapolate their findings to academics focused on creative and cultural industries.

Another study that engaged with the debate concerning the interrelationship between the knowledge transfer activities of academics was conducted by Williamson, Cloonan and Frith (2011). While these authors are themselves engaged in both music policy research and music business activities, they examined the ways in which traditional academic values of impartiality and concern with research methodology can conflict with the instrumentalist agendas and industrial lobbying efforts that in part inform the sector-wide push for academic research to have more of an 'impact'. They noted that knowledge itself is a disputed concept, and therefore knowledge cannot be transferred in any simple way. In addition to noting that participants in the music industries put a premium on 'experiential knowledge', as opposed to knowledge obtained through academic research, they observed that disputes can arise about what knowledge is for; music industries workers' responses to academic knowledge can manifest as 'knowledge resistance' rather than the openness required for 'knowledge transfer'. This is particularly the case when the knowledge is 'uncomfortable' and does not reinforce their particular world view. According to Williamson et al. (2011),

> Music industries lobby groups tend to start from a desired policy outcome and then seek (and shape) the evidence that will justify that outcome. ... Academic

researchers are expected, rather ... to gather and assess evidence on its own terms, [and] its value is related to an ideal of methodological rigor.

(461)

Therefore when conducting the research for this book, I have not used participant observation as a method and have instead maintained the independence of my role as an academic researcher. While the mutually reinforcing knowledge transfer activities with which I have been engaged have, and will, lead to enhanced performance in terms of my portfolio of knowledge transfer activities, I have been very careful to maintain the independence of this study and to pursue knowledge concerning artist management practices within the creative and cultural industries through the use of a rigorous methodological process that has produced knowledge which is valuable in its own right.

2.3 Outline of the book

In the book, Chapters 3 and 4 concern lean startup and agile project management methods respectively. The interrelationships between these types of methods that develop as artists move through different stages throughout their careers are also outlined. Chapter 3 focuses on the startup phase of career development in the creative and cultural industries and considers the uncertainty artists face on two fronts: (1) the arts – what any one particular artist is trying to achieve through their artistic creativities can be uncertain; and (2) creative labour – issues associated with creative labour such as career fragility, and the managerial creativities required to manage this latter form of uncertainty, are addressed. In addition to Ries' (2011) lean startup method (LSM), this chapter engages with Sarasvathy's (2008) effectuation method (EM) (see also Read et al., 2011). Like the LSM, effectuation is a method that serves entrepreneurs in starting businesses and, thus, their attempts to control a future that is inherently uncertain and unpredictable.

Chapter 4 then focuses on agile project management (APM), rather than the LSM or EM, because a startup is only a temporary organisation that is ultimately seeking to move on from the startup phase. Furthermore, in the context of the creative and cultural industries, startup methods are primarily useful for managing hard artistic creativities due to the uncertainty and unpredictability associated with original invention. In contrast, APM is applicable to managing the whole spectrum of hard to weak creativities (Madden and Bloom, 2001) and is therefore useful during any startup phase, as well as post such a phase, in addition to facilitating innovation in businesses that are not entirely new or that are not dealing with original and inventive content. Chapter 4 examines agility within the creative and cultural industries on two levels: (1) the individual level – divergent thinking and motivation are examined in relation to APM; and (2) group creativity – the notion that diversity in a group's constitution increases the probability of the lateral associations (Kurtzberg and Amabile, 2001; Kurtzberg, 2005) required for APM is examined with particular attention given to the negotiations that occur within such

groups, and between such groups and the other stakeholders and partners that are required for the co-creation of artistic ventures. Attention is also paid to the topic of freelancing and agility and the question of whether freelance careers are more agile by their very nature.

In Chapter 5, the context for the examination of artist management processes is broadened through a consideration of the role of geographic location(s) in these processes and therefore in career development in the creative and cultural industries. The work of Csikszentmihalyi (1996, 2014) is relevant here as he shifted the base question concerning creativity to 'where is creativity?'. In this way, he came to envisage creativity as operating within a system that involves the interrelationship of three component parts: the person, the domain and the field. Therefore geographic location(s) and storytelling creativities relating to it are fundamental for accessing the domain and the field for both artistic and managerial creativities in this model.

Chapter 6 then examines the specificity of artist management labour by outlining the ways in which the principle of artistic/aesthetic autonomy[3] structures the artist–artist manager relationship. It also questions the professional autonomy of the artist manager from an ethical perspective. As discussed in the introduction, artist management can be defined as a form of group creativity that involves the interaction between artistic creativities and managerial creativities. Defining artist management in this way enables us to pluralise this form of creativity and to conceptualise it as a dialectic between these two clusters of creativities – creativities that are at times in conflict and at other times in harmony. While the uniqueness of artist management stems from its subordination to artistic creativities and the fact that such symbolic creativities are not bound to set rules, managerial creativity and the 'professional autonomy' stemming from this type of creativity *should* perhaps be *more* bound to set rules and procedures.

This book concludes by addressing the questions: What is it like to manage an artist? Is artist management more 'creative' than management jobs in other sectors? To answer these questions, Chapter 7 summarises key issues, such as tensions between commerce and creativity, the labour conditions and experiences of artists and artist managers, artist advocacy, artist manager advocacy, exploitation, self-exploitation, self-realisation, duties of care and best practices and codes of conduct in the context of artist startups. I argue that the future of artist management needs to be discussed in relation to the opportunities and threats relating to automation of the workforce and, indeed, in relation to the potentially changing concept of 'work' itself. Within the time period this book was written, the progress of big data and its associated 'data economy' has often been coupled with discussion of automation and resultant job losses. Therefore, in Chapter 7, I present case studies concerning agile management strategies within the context of the arts, and in doing so I attempt to provide a preliminary sketch of the role of the artist, the artist manager, the arts and the creative and cultural industries in the future.

Notes

1 A waterfall management style involves a linear trickle down from different, and often isolated, project stages. Integrated project management involves a mixture of waterfall and agile approaches.
2 See Appendix A for a list of the interviewees and the pseudonyms used in this study.
3 For a further discussion of various arguments for and against the principle of artistic/aesthetic autonomy, see Bourdieu (1984, 1993, 1996), Williams (1981) and Hesmondhalgh and Baker (2011).

References

Amabile, T. and Pillemer, J. (2012) 'Perspectives on the Social Psychology of Creativity', *Journal of Creative Behaviour*, 46, 1: 3–15.
Anderson, C. (2006) *The Long Tail*, New York: Hyperion.
Anderson, C. (2012) *Makers: The New Industrial Revolution*, New York: Crown Business.
Bourdieu, P. (1984) *Distinction: A Social Critique of the Judgement of Taste*, Abingdon; New York: Routledge.
Bourdieu, P. (1993) *The Field of Cultural Production: Essays on Art and Literature*, Cambridge: Polity.
Bourdieu, P. (1996) *The Rules of Art: Genesis and Structure of the Literary Field*, Cambridge: Polity.
Catmull, E. (2008) 'How Pixar Fosters Collective Creativity', *Harvard Business Review*, Sept. Online: <https://hbr.org/2008/09/how-pixar-fosters-collective-creativity> Accessed 30 August 2017.
Catmull, E. (2014) *Creativity, Inc.: Overcoming the Unseen Forces that Stand in the Way of True Inspiration*, New York: Random House.
Cloonan, M. (2014) 'Musicians as Workers: Putting the UK Musicians' Union into Context', *MusiCultures*, 41, 1: 10–29.
Csikszentmihalyi, M. (1996) *Creativity: Flow and the Psychology of Discovery and Invention*, New York: HarperCollins.
Csikszentmihalyi, M. (2014) *The Systems Model of Creativity: The Collected Works of Mihaly Csikszentmihalyi*, Dordrecht; Heidelberg; New York; London: Springer.
DeZutter, S. (2011) 'Performing Groups as Distributed Creative Systems: A Case Study', in C. Lobman and B. O'Neill (eds.), *Play and Performance: Play and Culture Studies*, Lanham, MD: University Press of America, pp. 237–259.
Eikhof, D. and Haunschild, A. (2006) 'Lifestyle Meets Market: Bohemian Entrepreneurs in Creative Industries', *Creativity and Innovation Management*, 15, 3: 234–241.
Eisenmann, T., Ries, E. and Dillard, S. (2012) *Hypothesis-Driven Entrepreneurship: The Lean Startup*, Harvard Business School Background Note 812-095. Online: <www.hbs.edu/faculty/Pages/item.aspx?num=41302> Accessed 31 August 2017.
Ellmeier, A. (2003) 'Cultural Entrepreneurialism: On the Changing Relationship Between the Arts, Culture and Employment', *International Journal of Cultural Policy*, 9, 1: 3–16.
Gill, R. and Pratt, A. (2008) 'In the Social Factory? Immaterial Labour, Precariousness and Cultural Work', *Theory, Culture & Society*, 25, 7–8: 1–30.
Harré, R. (1979) *Social Being: A Theory for Social Psychology*, Oxford: Blackwell.
Hausmann, A. (2010) 'German Artists Between Bohemian Idealism and Entrepreneurial Dynamics: Reflections on Cultural Entrepreneurship and the Need for Start-Up Management', *International Journal of Arts Management*, 12, 2: 17–29.

Henry, C. (2009) 'Women and the Creative Industries: Exploring the Popular Appeal', *Creative Industries Journal*, 2, 2: 143–160.

Hesmondhalgh, D. and Baker, S. (2011) *Creative Labour: Media Work in Three Cultural Industries*, Abingdon; New York: Routledge.

Highsmith, J. A. (2010) *Agile Project Management: Creating Innovative Products*, 2nd ed., Upper Saddle River, NJ: Addison-Wesley.

Jones, M. (2003) 'The Music Industry as Workplace: An Approach to Analysis', in A. Beck (ed.), *Cultural Work: Understanding the Cultural Industries*, Abingdon; New York: Routledge, pp. 147–156.

Kurtzberg, T. (2005) 'Feeling Creative, Being Creative: An Empirical Study of Diversity and Creativity in Teams', *Creativity Research Journal*, 17, 1: 51–65.

Kurtzberg, T. and Amabile, T. (2001) 'From Guilford to Creative Synergy: Opening the Black Box of Team-Level Creativity', *Creativity Research Journal*, 13, 3–4: 285–294.

Landry, R., Saïhi, M., Amara, N. and Ouimet, M. (2010) 'Evidence on How Academics Manage Their Portfolio of Knowledge Transfer Activities', *Research Policy*, 39, 10: 1387–1403.

Madden, C. and Bloom, T. (2001) 'Advocating Creativity', *International Journal of Cultural Policy*, 7, 3: 409–436.

McGuigan, J. (2010) 'Creative Labour, Cultural Work and Individualisation', *International Journal of Cultural Policy*, 16, 3: 323–335.

Merton, R. and Kendall, P. (1946) 'The Focused Interview', *American Journal of Sociology*, 51, 6: 541–557.

Miles, M. and Huberman, A. (1994) *Qualitative Data Analysis*, 3rd ed., Thousand Oaks, CA: Sage.

Punch, K. (2014) *Introduction to Social Research: Quantitative & Qualitative Approaches*, 3rd ed., Los Angeles, CA: Sage.

Read, S., Sarasvathy, S., Dew, N., Wiltbank, R. and Ohlsson, A. (2011) *Effectual Entrepreneurship*, Abingdon; New York: Routledge.

Ries, E. (2011) *The Lean Startup: How Today's Entrepreneurs Use Continuous Innovation to Create Radically Successful Businesses*, New York: Crown Business.

Sarasvathy, S. D. (2008) *Effectuation: Elements of Entrepreneurial Expertise*, Cheltenham; Northampton, MA: Edward Elgar.

Sawyer, R. K. (2012) *Explaining Creativity: The Science of Human Innovation*, 2nd ed., New York: Oxford University Press.

Sawyer, K. and DeZutter, S. (2009) 'Distributed Creativity: How Collective Creations Emerge from Collaboration', *Psychology of Aesthetics, Creativity, and the Arts*, 3, 2: 81–92.

Scott, M. (2012) 'Cultural Entrepreneurs, Cultural Entrepreneurship: Music Producers Mobilising and Converting Bourdieu's Alternative Capitals', *Poetics*, 40, 3: 237–255.

Stahl, M. (2012) *Unfree Masters: Popular Music and the Politics of Work*, Durham, NC; London: Duke University Press.

Tams, E. (2002) 'Creating Divisions: Creativity, Entrepreneurship and Gendered Inequality – A Sheffield Case Study', *City*, 6, 3: 393–402.

Taylor, S. and Littleton, K. (2008) 'Art Work or Money: Conflicts in the Construction of a Creative Identity', *Sociological Review*, 56, 2: 275–292.

Throsby, D. (2008) 'The Concentric Circles Model of the Cultural Industries', *Cultural Trends*, 17, 3: 147–164.

Throsby, D. and Zednik, A. (2010) *Do You Really Expect to Get Paid? An Economic Study of Professional Artists in Australia*. Surry Hills, NSW: Australia Council for the Arts.

Weisberg, R. (2010) 'The Study of Creativity: From Genius to Cognitive Science', *International Journal of Cultural Policy*, 16, 3: 235–253.

Williams, R. (1981) *Culture*, London: Fontana.

Williamson, J., Cloonan, M. and Frith, S. (2011) 'Having an Impact? Academics, the Music Industries and the Problem of Knowledge', *International Journal of Cultural Policy*, 17, 5: 459–474.

3

THE ARTIST'S CAREER AS STARTUP

Lean startup and effectuation methods for the arts

3.1 Extreme uncertainty: What is art?

Effectual logic is a thinking framework used by entrepreneurs to shape an uncertain and unpredictable future. Instead of pursuing preset goals and opportunities, conducting competitive analyses and using 'causal rationality', effectual logic

> does not begin with a specific goal. Instead, it begins with a given set of means and allows goals to emerge contingently over time from the varied imaginations and diverse aspirations of the founders and the people with whom they interact.
>
> (Sarasvathy, 2008: 73)

It involves entrepreneurs asking the questions: 'Who am I?', 'What do I know?' and 'Who do I know?'

Within the context of the creative and cultural industries, a seminal example of a band in recent times that identified the means they had available to them by asking these questions was Radiohead with the release of their album *In Rainbows* on 10 October 2007 as a digital download for which consumers chose their own price, beginning at nothing. In an earlier work (Morrow, 2009), I explored the issue of whether this strategy of Radiohead's presented a model for other artists to bypass established record labels; however, what became evident was that this was simply an example of effectual logic being used. Thom Yorke, Radiohead's lead singer, made the following comment concerning their unorthodox approach:

> It's not supposed to be a model for anything else. It was simply a response to a situation. We're out of contract. We have our own studio. We have this new server. What the hell else would we do? ... But it only works for us because of where we are.
>
> (Yorke, quoted in Morrow, 2009: 163)

This strategy arguably only worked for Radiohead because of who they were, what they knew and whom they knew. It was also largely dependent on who knew them; namely, a massive audience that had been built in part by EMI's investments in the band over a 16-year period to that point.

As stated in the introduction to this book, artist management is organic, adaptable and diverse; it contrasts with other forms of management that emphasise linearity, conformity and standardisation. Therefore in addition to effectuation, this chapter is also concerned with the lean startup method because these logics resonated with some of the artists interviewed for this project. A number of participants noted that they do not use traditional planning and that the perceived tension between 'management' and 'artistic creativity' is partly due to the fact that, from their perspectives, management is trying to generate a rigid plan for something that is quite fluid and free-spirited. One Sydney-based and self-managed contemporary dancer, Anne, noted:

> I'm starting this new work, and I know what some of the initial things are that I'm interested in, but I don't know what it is or what it adds up to … I look for and respond to invitations and opportunities. I look for opportunities and go 'oh yeah, I can do something for that'. And by saying that, it forces me to focus in and pull something together. So hopefully it will accumulate over the next couple of years so that I will be clearer in knowing what it is. So looking for any performance opportunities and especially low-key ones, to test out ideas, to try images, and to see what the response is.
>
> *(Interview 21)*

Therefore rather than using more traditional project management approaches by pursuing preset goals or opportunities and assembling means after a goal is set, artists such as Anne work in ways that are more in line with the early-stage management strategies that the lean startup method (LSM) and the effectuation method (EM) can facilitate. The LSM and the EM are a better fit for the work autonomy and aesthetic autonomy that are required for some forms of artistic creativity.

Therefore in this chapter I argue that the lean startup (Ries, 2011) and effectuation (Sarasvathy, 2008) methods for startups are useful within the context of the arts. They are particularly useful for addressing the complexity and uncertainty that stems from attempts to answer questions related to career development and arts investment: What is art? What is art for? What good are the arts? How can we sell art? Both methods eschew more traditional business planning and provide a way to control a future that is inherently unpredictable and extremely uncertain. Artists and artist managers face uncertainty on two fronts. First, the arts – what any one particular artist is trying to achieve through their artistic creativities can be uncertain. Second, artists and artist managers face uncertainty about whether they will be able to shape a future for themselves within the creative and cultural industries. This chapter focuses on the startup phase of career development in the creative and cultural industries. It acknowledges that the lean startup method and effectual

logic/effectuation[1] are like first and second gears: they are useful for starting artistic enterprises and careers, though eventually managers and artists shift away from these logics. So if these approaches are useful for working in the arts, what, exactly, is the lean startup method? What is effectual logic?

Most startups fail (Blank, 2013), and in the creative and cultural industries, market failure is the norm (Madden and Bloom, 2001). Both the LSM and EM help to manage the risks associated with startup management in a way that resonates with Anne's approach to working as an artist (quoted above). Both approaches focus on experimentation and are responsive to consumer/audience feedback. The LSM tests assumptions about how a product will perform through the generation of hypotheses that are then proven or disproven through a build-measure-learn feedback loop facilitated by the early release of minimum viable products (MVP) (Robinson, 2001; Ries, 2011: 93). It is therefore designed to help address the underlying issues stemming from the tendency for market failure. While it does not address the fact that in the creative and cultural industries supply is much larger than demand, this method involves attempting to generate demand *during* the creative processes involved in *supplying* artistic content. Ultimately, the lean startup method serves startups in their search for scalable and repeatable business models in contexts in which there are no pre-existing business models to emulate.

The LSM serves the founders of startups in addressing the extreme uncertainty that comes with starting a brand new venture in a new industry, or a new sector of an existing industry, that is without precedent. The question of whether an artist's career can be considered to be a startup has been partly addressed by Hughes, Evans, Morrow and Keith (2016). My co-authors and I argued that, for example, while a band operating in the music industries is not an entirely new structure or concept, in the case of Madden and Bloom's (2001) definition of 'hard artistic creativity' (artistic creativity that is groundbreaking, innovative and inventive), some bands/artists[2] are operating in conditions of extreme uncertainty, and therefore the LSM is useful in this context.

The LSM is being used in this chapter in conjunction with EM simply because the latter adds additional, and useful, logics that can be applied by artists and artist managers during the startup phase. Sarasvathy (2008), who is a leading scholar/researcher within the field of business administration and specialises in entrepreneurship, studied the work of expert entrepreneurs and noted that many of the most interesting ventures are by definition operating in a context in which the future is unknown, and unknowable. In analysing how entrepreneurs shape unpredictable, or unknowable, futures, Sarasvathy identified the 'future shaping' techniques entrepreneurs use and their underlying 'effectual logic'.

The principles of effectuation are as follows. As discussed above, for Sarasvathy, expert entrepreneurs start with their means, rather than preset goals or opportunities, and as exemplified by the case of Radiohead's release of their album *In Rainbows*, entrepreneurs pursue the possibilities that arise from the means they identify by asking the questions 'who am I?', 'what do I know?' and 'who do I know?'[3] Next is one of the most useful principles of effectual logic for the purposes

of this book. It concerns the notion of 'affordable loss', and it can be used to expand understandings of how founders of startups approach the risk associated with the experimentation required for Ries' (2011) LSM. Sarasvathy (2008: 81) noted that through understanding what they can afford to lose at each step, expert entrepreneurs limit risk by choosing goals and actions that will progress the project in a positive way, even if at this incremental step they incur some form of loss. This principle is related to another effectual concept that features the lemonade metaphor in the following bromide: 'when life gives you lemons, make lemonade' (90); by inviting the surprise factor, expert entrepreneurs use 'bad news' as a cue for creating a new market or product.

Expert entrepreneurs pursue partnerships with 'self-selecting' stakeholders: 'Effectual entrepreneurs focus their efforts on the image of the future coalescing out of a dynamic series of stakeholder interactions rather than crafting a vision up front and then attempting to force it or "sell" it to targeted stakeholders' (89). Finally, the pilot-in-the-plane principle concerns the non-predictive control that is facilitated by the belief that the future is 'made' rather than 'found' or 'predicted'; by focusing on activities that are within their control, expert entrepreneurs are piloting the plane. Effectual logic is therefore useful for expanding the use of the LSM in this book, and for managing careers and startup enterprises that necessarily have to address the uncertainty and unpredictability stemming from 'art'.

The argument here – that the LSM and the EM are useful within the context of career development in the creative and cultural industries because some forms of artistic creativity are open-ended and are therefore uncertain and unpredictable – relates to the questions: What is art? What is art for? What good are the arts? How can we sell art? Interestingly, according to Carey (2005), who is a literary critic, these are all modern questions that could not have been asked prior to the late eighteenth century, as:

> Most pre-industrial societies did not even have a word for art as an independent concept, and the term 'work of art' as we use it would have been baffling to all previous cultures, including the civilizations of Greece and Rome and of Western Europe in the medieval period.
>
> *(7)*

Following this, in most previous societies, artist management, arts management and the creative and cultural industries would not have existed conceptually, because art was not produced by a separate caste of people labelled 'artists' who needed 'managing', but was spread throughout any particular community as a universal human practice (see Dissanayake, 1988).

Even when the label 'artist' emerged for a separate caste of, usually (problematically only) male and privileged, people in the West, the question of whether these special people could be 'managed' was moot because, according to the influential philosopher Kant, artistic genius 'discovers the new, and by a means that cannot be learnt or explained' (Kant cited in Carey, 2005: 11). In addition to this, the paradigm shift

from essentialism to relativism that occurred within Western thought post Kant further complicates attempts to answer the aforementioned questions and also, therefore, efforts to facilitate artists' careers as startups. The influence of the work of Kant is relevant here for an understanding of the basic aesthetic assumptions that informed the separate concepts of 'art' and 'artist' that arose over the last 200 years in the West.

Essentialism in this context refers to the belief that there is a universal or absolute 'essence' to a work of art (and, in the case of Kant, beauty) which is informed by the logic that everyone will agree with us when we call something a work of art or refer to an object's beauty.[4] In terms of artist management, this initially appears to simplify the process of managing an artist's work and career; whether their work is art would not be uncertain, but would instead be universally understood. However, when one considers that Kant believed there is a 'mysterious realm of truth, which he called the supersensible substrate of nature' (Carey, 2005: 9) where such essences, universals and absolutes reside, attempts to define art remain uncertain because, according to Kant, it is 'mysterious'.

In contrast to essentialism, relativism involves the belief that deciding whether something is a work of art is 'relative' to one's individual perspective, societal positioning, class, race, gender and any other factor that may influence one's understanding of the work of art and the context in which it is located. Associated with postmodernism, the 'new' humanities and deconstructionism, relativism arose partly out of a deep distrust of essentialism, which in the first half of the twentieth century still informed the modernist paradigm. This 'distrust' arose partly in response to the many horrors of the twentieth century – two world wars and the Holocaust amongst many other horrific events – and the way in which some of the ideologies that informed these events had, at their core, a belief in universal, absolute and 'essential' meaning(s). In this context, Gibson-Graham[5] (2006) preferred the term 'anti-essentialist' as opposed to 'relativist' or 'non-essentialist'. They noted that this signals 'the impossibility of fully transcending essentialism, or even of wishing to. Anti-essentialism is a motive rather than an achievement, and even as a motive it cannot exist as a universal value or unmitigated good' (29). Gibson-Graham also engaged with the work of Fuss (1989), who argued that an attempt to overthrow the strictures of essentialist thought in favour of relativism and social constructionism runs the risk of allowing anti-essentialism to become an 'essence' itself within the context of contemporary social theory (for further discussion of this topic, see Gibson-Graham, 2006: 24).

The notion of relativism, or anti-essentialism, highlights the extreme uncertainty surrounding the artistic creativities that an artist manager is helping to facilitate and manage. This is because, in this paradigm, what makes something a work of art is simply that someone *thinks* that it is a work of art. Carey's (2005) answer to the question 'what is a work of art?' is particularly salient here: 'A work of art is anything that anyone has ever considered a work of art, though it may be a work of art only for that one person' (29). Therefore managing careers within the creative and cultural industries – industries in which the core product is defined in this way – is an extremely uncertain process indeed.

Having addressed the question 'what is a work of art?', we can now turn our attention to the other key questions that will help us to understand the applicability of the LSM and the EM in an arts context: What is art for? What good are the arts? How can we sell art? As mentioned in the introduction to this book, artistic contributions are often understood in one of two ways: first, that artistic creativity is beneficial *in and of itself* (otherwise known as 'art for art's sake'); second, that artistic creativity generates *instrumental* benefits. When trying to understand what art is 'for', we can therefore surmise here that sometimes it is simply *for* itself, and at other times it is *for* making money, helping school students perform better in other subjects, strengthening democracy and increasing productivity in workplaces, amongst the many other instrumental benefits that can be derived from participation in the arts.

The understanding that artistic creativity generates instrumental benefits can be further expanded here through a consideration of sociologist Bourdieu's (1984) notion of 'cultural capital'. In modern societies, art is often used by individuals to differentiate themselves from others, and Bourdieu's cultural capital, which includes knowledge about art, influences which class in a society gets to determine the dominant 'cultural taste' within that society. One's cultural taste then in turn comes to signify class membership and other types of social positioning. The reason why cultural taste/capital is being couched here in terms of its 'instrumental' benefit is that for Bourdieu, cultural capital is often defined by its ability to be converted into economic capital. Furthermore, the arts constitute a means to access social capital because they can help to facilitate social mobility. As a consequence, the practices of artist management, arts management and arts marketing facilitate, and even exacerbate, the socially and culturally divisive impact of the arts within contemporary societies. While divisiveness of this kind is clearly inherent in notions of high art (as it is 'high' in comparison to low, popular or mass art), youth and popular culture has a divisive equivalent, what Thornton (2006) has labelled 'subcultural capital'. Subcultural capital is a subspecies of cultural capital and is most commonly understood through the vernacular of youth culture in terms such as 'coolness' or 'hipness'. Indeed, even the notion of 'art for art's sake' can be understood through the lens provided by the work of Bourdieu; the knowledge that is required to argue that a particular artwork is beneficial *in and of itself* requires a certain amount of cultural capital – that is, knowledge about the art form. In terms of popular culture, it may be 'cool' and 'hip' to say that a particular artwork or song is beneficial *in and of itself*.[6] In this way the notion of artistic/aesthetic autonomy becomes complicated by the social context in which the art is being produced.

3.2 Extreme uncertainty: Shaping a future for yourself

According to Gratton (2017), 'Childlessness is often regarded as a necessary sacrifice for a creative career, especially for women.' This speaks to the extreme uncertainty and difficulty artists and artist managers face in their attempts to shape futures for

themselves within the creative and cultural industries and the impact of this on their ability to support children if they choose to have them. Other authors have made points similar to Gratton's regarding the way in which the time, money and energy required for parenting is often allocated instead to sustaining an artistically creative career, particularly for women (see Corbin Sicoli, 1995; Reis, 2002), and others such as Hesmondhalgh and Baker (2011) have discovered that there is often a career exodus from the creative and cultural industries by women in their mid-thirties.[7]

Better understanding of artist management practices, and artist self-management practices, is important in this context. Career development in some sectors of the creative and cultural industries is non-linear and slow growing, and therefore the startup phase can last a long time, as writer and director Kim Ramsay noted: 'In Australia I look at some of the film-makers I admire and it took them between eight to ten years to get their first feature film up – and that's a long time' (Ramsay cited in Gratton, 2017). A participant in this project, Sydney-based and self-managed scriptwriter, director and actor Peter Maple,[8] observed:

> I've probably toiled in the fringes of trying to bang on the ceiling of the industry to get in for about ten years now, I would say, at least. Yes, ten years professionally, and so I've got to the point of really having to develop my own work for screen as well, as an actor. I was doing that for theatre but then I realised the world is changing – we've now got much more outlets to tell stories, we've got online and so forth, and to film things is so much easier now ... That's led to me trying to create my own content, and in recent years I've even started producing and writing features.
>
> *(Interview 19)*

The length of the startup phase is one of the reasons why many artists delay having children or choose not to have them. Kim Ramsay discussed this in relation to artists who are in the mid-thirties age bracket in particular:

> A lot of us are questioning if we will ever be able to buy a house in our lifetime, can we afford to stay in Sydney and what on earth can you potentially do if you want to start a family?
>
> *(Ramsay cited in Gratton, 2017)*

The tendency for artists and other creative labourers (such as artist managers) to develop portfolio careers has been well researched (see Throsby and Zednik, 2010; Bridgstock, 2011). A portfolio career simply involves the 'portfolio' of commercial activities and resultant (multiple) income streams artists and artist managers develop in order to support their creative work.[9] During the startup phase, artists and artist managers therefore often live a double life (hence the lack of time for parenting in some cases), and it is in this context that the 'startup phase' for artists needs to be considered pluralistically; that is, artists, and their managers if they have them, have

to 'startup' multiple careers of sorts in order to establish the multiple income-generating activities that constitute their portfolio career.

The notion of a portfolio career is relevant to artists during the startup phase, and also to artist managers during this phase of their client's career as well as in their own career as a manager. As one highly successful New York-based artist manager in popular music, Daniel, noted in relation to the impact that one particular attempt to licence artist managers[10] would have on this startup phase:

> 99 out of 100 new artists can't incentivise someone like me and people with smaller businesses to spend a year of their life managing a brand new artist and making almost no money. That's something you need young, inexperienced, but hopefully very smart people to do and that's how a lot of managers get started, and that's how a lot of artists get started ... and therefore managers who are, you know, working out of their apartment on their cell phone and don't have any staff ... if you start having economic costs to do that, then you're just going to eliminate services that no one else is going to provide.
>
> *(Interview 14)*

Artist managers speculatively invest time into artist startups. Because they are investing, as Daniel stated, 'a year of their life managing a brand new artist and making almost no money', they often need to develop a portfolio of other income-generating activities in order to sustain themselves during this phase and then juggle these activities as best as they can.

The risk relating to the artist manager's investment therefore most often concerns the loss of time, and this is where effectual logic and Sarasvathy's (2008) notion of 'affordable loss' is useful. Entry-level artist managers need to limit risk by choosing goals and actions that will progress the career of the artist they are managing in a positive way while, at the same time, keeping an eye on the progress of their own career. As highly successful British artist manager in music Peter Jenner[11] said:

> Expect to get fired. Don't worry about it. It you're doing your job well and the artist fucks you off, that's their problem! Nothing is forever, it's just a business relationship and not a marriage, and you should see losing an act as part of your development as a manager. ... I would suggest that there are more good artists than there are good managers.
>
> *(2002, 3–1)*

This sense of the impending and inevitable end to their relationship with a client pervaded the interviews conducted for this project with artist managers in music. This poignant aspect of artist management in popular music was discussed by Toronto-based senior artist manager Ben:

> I mean every artist and manager relationship ends, it's just whether it is in ten days' time or in ten years' time. I often joke with the artists I've worked with

over the years, saying that 'well one day you'll fire me, it's just a matter of when'. This is because eventually something comes between you. It's rare for a situation to be like Peter Jenner and Billy Bragg where two parties can get along for something like 20 years. That's a rare situation to be in. Normally something comes between you.

(Interview 5)

In this context, the notion of affordable loss is different for the artist manager than it is for the artist. This is because the artist typically only has one attempt, or to use the industry vernacular, one 'shot', at breaking out of the startup phase and establishing a career, whereas any one artist manager has multiple shots because they can move on to manage a new artist, using the social capital they acquired through their previous investment of time in developing a different client's career. Metaphorically speaking, any single artist's career becomes a stepping stone for the manager in their attempts to develop their own career.

In terms of an artist manager's career, then, each client they manage can be considered an incremental step in the building of their own career, and at each step they may incur some form of loss. As the power balance between the artist and the artist manager shifts with commercial success, the irony of artist management is that the better an artist manager is at helping their client build a career, the worse the negotiating position they themselves end up in with their own client. They also become more vulnerable to a more established artist manager or artist management firm swooping in to take over the management of the client post the startup phase.[12] Discussing this dynamic, and the issues that arise when external regulators do not understand it properly, London-based senior artist manager in popular music Harry noted:

With external regulators you just need to be careful, because people get preconceptions. And this is driven by television and movies where the manager is always the bad guy. But it's not necessarily always the case. Artists can be very shrewd, and there are countless examples of where the artist has effectively ripped off the manager, and this may be that the manager has done all of the work and the artist just walks away. Particularly at the starting out level where a young manager will get the artist as far as a record deal and then the record company encourages the artist to take on a more experienced manager, and the young manager has done all the hard graft and is then left with nothing.

(Interview 12)

In terms of effectual logic, it can be argued here that, though painful, this scenario does not necessarily leave the entry-level artist manager with nothing. If the entry-level artist manager can get over the heartbreak of this happening, they will often find that through this process of managing an artist startup 'as far as a record deal', they have accrued social, cultural, subcultural and (hopefully some) economic capital. They can use these to pursue new possibilities that arise from the new

means they identify by asking the questions 'who am I?', 'what do I know?' and 'who do I know?' The portfolio career also becomes relevant here for entry-level artist managers. By working on the side for an entity that is involved in the creative and cultural industries, entry-level artist managers may also use their arts-related work to build social capital that they can then use to better answer the aforementioned questions.

In relation to the LSM, from the artist manager's long-term perspective, each artist's career can be viewed as minimal viable product, and they can build their own career through the build-measure-learn feedback loop that the process of signing new clients enables. They can also use 'bad news' (for example, being dumped by their client in order to be replaced by a more experienced manager or management firm) as a cue to create new opportunities. However, to do this effectively they need to invest a sufficient amount of time and effort into each client's career; otherwise, they risk reputational damage. As Daniel (New York-based senior artist manager in music) stated:

> The biggest problem is a lack of effort. People take on too many artists and can't do a good job for everyone, and the old cliché is to throw things against a wall and see what sticks. And if you're one of the artists that didn't stick to the wall, you feel 'gee they said that they loved me, and now I never hear from them'. You know, 'if I'd known they weren't going to work hard, I would've found somebody different to represent me'. That's the kind of thing that doesn't lend itself to legal remedy; it's just a function of judgement and reputation.
>
> *(Interview 14)*

Therefore artists and artist managers often attempt to shape futures for themselves in different ways, and this affects the relationship between the artist and the manager, and also the relationships they form, through collaboration with each other, with self-selecting partners. For instance, because artist managers can have multiple attempts or 'shots' at breaking out of the startup phase, they may go easier in a negotiation than an artist who only has one shot; they want to maintain the relationship with the entity with which they are negotiating so that they can approach this entity again in the future, on favourable terms, with one of their new potential signings. As the artist typically only has one attempt or shot, they are often more anxious and emotional than their manager about such negotiations. Discussing the multiple attempts an artist manager has, the intrinsic motivation they need to keep going, and the risk they take in their attempts to break themselves and/or their client out of the startup phase, Ben (Toronto-based senior artist manager in popular music) observed:

> If you are passionate about it and you believe in an artist, then you are willing to take that chance. And honestly nine times out of ten it usually ends poorly in the sense that usually you don't get what you are expecting or what you put into it. But there's always that hope that one time you will.
>
> *(Interview 5)*

Some of the senior managers interviewed for this project pursue relationships with 'self-selecting' stakeholders; their attempts reflect the effectual logic described earlier in this chapter. Within the music industries, for example, the traditional management model involves crafting a vision in collaboration with the artist upfront and then attempting to sell this vision to targeted stakeholders such as record labels. In the digital age, however, many of the potential stakeholders have become 'self-selecting'; they can become more 'reactive' by only signing artists who can already demonstrate a direct connection with an audience and exponential growth in terms of audience interest, which can be measured digitally in various ways (see Hughes et al., 2016). As a consequence, a number of different artist management business models are increasingly coalescing out of new patterns of stakeholder interactions in the music industries, rather than just the aforementioned 'traditional' one, as Harry (London-based senior artist manager) noted:

> All managers are looking at different business models … There are still some people who are using the traditional management model, and there are others who are effectively going out to business angels to get the money in to effectively act as the record label. There are other people who are assuming the role of the record company on behalf of the artist without going out to a third-party investor; they are instead just growing the business that way, and so they are performing the record company functions but without the private investor, or without the private equity stakeholder. Because as soon as there is an outside investor, the returns you are going to make are going to be different. It means that the amount of money the manager is going to take or share with the artist is going to be different.
>
> *(Interview 12)*

Decisions as to which business model to pursue are often informed by effectual logic in this sector of the creative and cultural industries. The potential downside of effectual logic during the startup phase of an artist's career, however, is that it can lead to a dilemma relating to who controls their intellectual property/copyright. This dilemma concerns how much an artist is willing to give away in order to attract partners and investors during the startup phase, and it involves two factors. First, during the startup phase the artist often does not have money to pay a fee to the people they need to help them grow their business into an ongoing concern, and these people, who are usually service providers such as managers, do not want to work for nothing. Second, in order to motivate the people they need to help them grow, the artist is willing to licence or to assign their intellectual property/copyright to these people (who would otherwise simply be service providers). This can also lead to a conflict of interest for the artist manager because they are then acting as the manager *and* the song publisher, record label or any other entity that has a relationship to the artist's intellectual property/copyright.

The conflict of interest arises in relation to the question of whose interests the artist manager[13] is going to represent. For example, in their role as an artist

manager, do they represent the artist's interests in a negotiation with the song publisher (also them)? Or do they represent the song publisher's interests, which are also their own interests? This type of conflict of interest can also provide the artist manager with the opportunity to 'double dip'.[14] Double dipping in this scenario would involve the artist manager receiving income as the song publisher[15] while also commissioning the artist's share of the song publishing income as the artist manager.[16] Discussing this type of conflict, Daniel (New York-based senior artist manager in music) said:

> The only time there are potential conflicts of interest in my experience, other than people who are just idiots, is relatively new artists who need/want somebody to handle them and that person says, 'How am I going to make any money out of this? If I can't make any money now, at least let me be your partner in the following areas.' You know, as a co-publisher. Occasionally that happens ... And in that kind of a situation the obligation should be to fully disclose it and to make sure that the artist has an independent attorney, who doesn't have a conflict of interest, to explain to them what it is they're committing to.
>
> *(Interview 14)*

This dilemma arises during the startup phase of an artist's career because the artist is trying to motivate someone to invest time into the development of their career on the promise of future compensation. The principle of deferred compensation – when combined with the irony of artist management being such that the better an artist manager is at fulfilling their role, the more vulnerable they are to being ousted by the artist[17] – means that the artist will sometimes agree to licence or assign their intellectual property/copyright to the artist manager with whom they are working during the startup phase. From the artist manager's perspective, this helps to appease anxiety relating to the longevity, or lack thereof, of their relationship with the client. As Daniel continued:

> If you're going to try to get people to work for you, you've got to find a way of compensating them. If you can't pay them cash, you've got to give them some promise of future income, which sometimes involves contracts. So I think if you can't incentivise people, you are not going to be able to motivate them. So that's a dilemma for new and developing artists – they get services that they can't really pay cash for. If they get paid cash, no one's going to ask you to sign anything. That's the dilemma.
>
> *(Interview 14)*

From the perspective of the artist manager, this desire to partner with the artist during the startup phase is understandable. They want to be a co-owner or licensor of the intellectual property that will exist in the future and which they help to create. This is because the future for an artist manager or artist is not 'found' or

'predicted', but is instead 'made', 'shaped' and 'created'. The dilemma therefore exists primarily from the artist's perspective (not the artist manager's); during the startup phase they may need a particular manager to help shape their future, though if they can get to this future, they may feel that a better option than their current manager may/will exist there.

3.3 Conclusion: What good are the arts? How can we sell art?

When it comes to the startup phase of an artist's career, artist management and artist self-management involve attempts to address uncertainty on two fronts: first, the arts – what any one particular artist is trying to achieve through their artistic creativities can be uncertain; and second, artists and artist managers face uncertainty about whether they will be able to shape a future for themselves within the creative and cultural industries. The argument in this chapter – that the uncertainty stemming from artistic creativity is derived from the fact that it is subjectively defined – evokes the art versus science debate. Regarding this debate, Robinson (2011), who is an author and international advisor on creativity and education, noted:

> It is as legitimate to talk about the objective processes of making and understanding art as it is about anything. To assume that artistic judgments are simply personal opinion is as mistaken as assuming all scientific opinion is undisputed fact. Meaning and interpretation are at the heart of all creative processes.
>
> *(194)*

The best way to elaborate on this seemingly contradictory quotation (within the context of this chapter) is to consider that there is a spectrum of uncertainty stemming from artistic creativity. As I discussed in the introduction to this book, the complexity of artistic contributions, and how these contributions are managed, derives from the complexity of creativity itself. A useful frame for this spectrum of uncertainty involves Madden and Bloom's (2001) 'hard' creativity and 'weak' creativity. On one end of the spectrum, weak creativity concerns creativity simply as production, something merely brought into being. This can involve replication of tradition, and it is therefore less uncertain than hard creativity. This is because hard creativity involves innovation in the sense that the work is a brand new and unprecedented invention. On this latter end of the spectrum, managing 'hard' artistic creativities is extremely uncertain.

While weak creativity is arguably the predominant form of artistic creativity (Madden and Bloom, 2001: 414), attempts to use brain science to measure the affective impact of specific artworks or the experience of engaging with, viewing and listening to the arts, or to prove that two people have an identical experience of an artwork, have fallen short (see Carey, 2005).[18] Therefore instead of turning to science to address the uncertainty, and sometimes extreme uncertainty, stemming from artistic creativity, I argue that the lean startup method and the effectuation method, when combined, are useful for framing the ways in which artists and artist

managers experiment with artistic ideas, minimum viable artistic products, ongoing innovation, and iterative sprints in their attempts to create art that will have an impact. Lean startup and effectuation methods for the arts therefore involve generating experiments that can test artists', and artist managers', assumptions about what a work of art *is* and/or can be, what the work(s) of art they are creating is *for*, what *good* their and their artworks' impact on the world is, and how they can articulate this 'impact' to audiences and potential investors. Furthermore, and perhaps most importantly from the perspective of the artist manager, these methods are useful for testing assumptions regarding how, in their attempts to break out of the difficult startup phase of an artistic career or arts-related enterprise, they can *sell* art in order to build a scalable and repeatable business around it.

Lean startup and effectuation methods for the arts can also help to address the uncertainty stemming from the question of whether the arts make us better and the extent to which the arts contribute to the public good. This is because through their work, artist managers help to *make something art*, to articulate *what good the arts are*, and *what art is for*. Artist managers then help to sell the resultant understandings and beliefs. In this sense, artist management involves processes that aim to intricately connect the answers to the questions addressed in this chapter in attempts to build sustainable businesses around art. These answers, understandings and beliefs help to motivate audiences to buy artistic products, and in turn they also help to motivate artists and artist managers to do their work. There are many assumptions that inform the work of artist managers in relation to these questions that would benefit from being 'tested' in the ways that the lean startup and effectuation methods for the arts allow.

For example, the arguments that the arts have a 'civilising' impact on participants and are therefore of benefit to the public good are highly debatable and often problematic (see Carey, 2005: 96). Yet an understanding that by helping to manage artists, artist managers are making a broad contribution to the public good permeated the interviews for this project; participants were motivated by the belief that in grinding through the challenges of the startup phase of career and project development, they are doing something important by helping to address the career fragility of artists, whose work greatly contributes to the public good. Furthermore, they tended to note that if their efforts did not lead to them 'selling art', at least they will have helped to contribute something that speaks to the broader question of what good the arts are (even when clear answers to this question remain elusive).

While a number of the participants in this project espoused such outward-looking justifications for doing the work they do, inward-looking justifications were even more common. Many of the artist managers and self-managed artists interviewed for this project discussed, in various ways, being intrinsically motivated to do their work. For example, as Ben (Toronto-based artist manager in popular music) noted, belief in an artist increases willingness to take risks (Interview 5). Regarding one of the dance sector's equivalents to an artist manager in popular music, the 'producer', Anne (Sydney-based and self-managed contemporary dancer) noted:

I think in the dance sector the producers that I know of are genuinely committed to the art form, and they're genuinely interested in the artists they work with. They're not going to choose to support an artist whose work they're not interested in. So that connection is very genuine.

(Interview 21)

In this sense artist managers are intrinsically motivated to assist in and to facilitate the behavioural tendency of 'making special' (Dissanayake, 1988: 74) to help create something that they find amazing and that the audience will hopefully find amazing, and special, as well. Artist managers are therefore helping to manage something that is very powerful in a primordial sense. Participating in the creative and cultural industries as an artist manager or self-managed artist therefore offers, as Hesmondhalgh and Baker (2011) argued, a tantalising potential to achieve self-realisation/self-actualisation, and this is another motivation to keep going through the difficult startup phase of an artistic career or project. Personal motivation of the intrinsic variety is a glue that holds the creative and cultural industries together, a dense glue that often belies some of the realities of this type of creative labour, such as self-exploitation, overidentification with creative work and overwork (see Hesmondhalgh and Baker, 2011: 139).

Notes

1 Note that 'effectual logic' and 'effectuation' are used throughout this chapter as synonyms.
2 Note that my previous co-written study (Hughes et al., 2016) was solely focused on what we called the 'new music industries', whereas this book concerns the broader creative and cultural industries in addition to the music industries.
3 For Sarasvathy (2005, 2008), causal reasoning contrasts with effectual reasoning because it works in the inverse way by assembling the means to achieve a preset goal(s).
4 This is a belief that is still implicit today in some attempts to justify decisions related to arts funding; see Gilfillan and Morrow (2016).
5 J.K. Gibson-Graham is a pen name shared by feminist economic geographers Julie Graham and Katherine Gibson.
6 Interestingly, divisiveness of this kind is aberrant when viewed through the lens of human evolution. For Dissanayake (1988, 2008), the divisive tendencies of both high art and popular/youth culture would have been alien to members of early human societies whose art forms, which included skin painting and weapon decoration, were communal and therefore had the effect of reinforcing the group's cohesion. This behaviour thus helped to assure the group's survival by giving it selective value.
7 Through their participant observations and interviews within the creative and cultural industries, Hesmondhalgh and Baker (2011) found 'a distinct absence of women in their mid-thirties to late forties' (147) in television production companies in London.
8 Maple features in a case study in Chapter 4. Unlike the other participants in this chapter who were interviewed on conditions of anonymity, Maple gave consent for his identity to be disclosed.
9 According to Throsby and Zednik (2010), this portfolio often includes a mixture of core creative work that may generate some income, arts-related work, such as teaching the art form or managing another artist, and non-arts-related work, which could literally include any income-generating activity, though the most clichéd examples involve waiting tables in a cafe or restaurant or driving a taxi or nowadays perhaps an Uber.

10 Daniel was referring to the old Entertainment Industry Act 1989 (NSW). Morrow (2013: 10) noted that 'A key feature of the Act is that agents, managers and venue consultants must obtain a license from the Office of Industrial Relations (OIR) to work in the state of NSW. This license requires compliance with a set of laws governing operations, including the maximum fees that can be charged and how money held on behalf of performers must be handled.' This licensing requirement has been repealed by the new Entertainment Industry Act 2013 (NSW).
11 Throughout his career as an artist manager, Jenner worked with artists such as Pink Floyd, The Clash, Billy Bragg, Eddi Reader, and many others.
12 This is commonly known as 'poaching' and can take a number of forms. An explicit version involves an artist being approached directly, and unethically, by another, often more senior, manager. An implicit and more subtle form of poaching involves senior managers (because they are the ones who can afford to) waiving commissions on tours in order to build a reputation for doing this so that they will attract more clients. One of the first writers to examine this aspect of artist management was Rogan (1988).
13 Traditionally, artist managers in music have functioned as service providers to their clients and have received a percentage commission of their client's income across five different areas: record sales, song publishing royalties, merchandise sales, live performance fees and revenue from sponsorship. They typically have not licensed, or had assigned to them, their client's intellectual property/copyright in the way that a record label or song publisher traditionally has.
14 The problem of double dipping is discussed at more length in Chapter 6.
15 Song publishing income is typically split between the songwriter and the publisher on splits that range between 85/15 (songwriter's way) for an 'administration only' deal to 75/25 (songwriter's way) for an agreement whereby the song publisher will do more than simply administer the copyright. Within any single agreement, these splits can vary depending on the stream. For example, the 'performance copyright' and 'mechanical copyright' streams/royalties may be 75/25 (songwriter's way); for 'synchronisation income', the splits may be 70/30 (songwriter's way) if the publisher secures the synchronisation opportunity (because the publisher has to do more work placing the songs in TV, film and advertising-related visual products) or 75/25 (songwriter's way) if the songwriter secures the synchronisation opportunity. For more information on the specifics of song publishing, see Simpson and Munro (2012).
16 Artist managers in music typically receive commission between 15% and 20% of net income, or of 'adjusted gross' income. Adjusted gross means that there are some amounts (particularly expenses relating to live performance) deducted from the commissionable income before the manager takes a commission. In other instances, savvy lawyers define 'net income' in a way that involves these deductions anyway (so in some agreements, 'net income' is the same thing as 'adjusted gross income'). For more information on the specifics of artist management agreements, see Simpson and Munro (2012).
17 Or alternatively, as previously discussed, the artist manager during the startup phase may be trumped by a more senior artist manager who can better articulate their own effectual logic of 'who they are', 'what they know' and 'who they know'.
18 To make this argument, Carey (2005) engaged with the work of researchers who have posited various theories relating to scientific 'tests' for art, including Ramachandran and Hirstein (1999), Wilson (1998) and Zeki (1999) (all cited in Carey, 2005: 65).

References

Blank, S. (2013) 'Why the Lean Startup Changes Everything', *Harvard Business Review*, May. Online: <https://hbr.org/2013/05/why-the-lean-start-up-changes-everything> Accessed 25 February 2016.

Bourdieu, P. (1984) *Distinction: A Social Critique of the Judgement of Taste*, Abingdon; New York: Routledge.
Bridgstock, R. (2011) 'Making it Creatively: Building Sustainable Careers in the Arts and Creative Industries', *Australian Career Practitioner Magazine*, 22, 2: 11–13.
Carey, J. (2005) *What Good Are the Arts?* London: Faber.
Corbin Sicoli, M. (1995) 'Life Factors Common to Women Who Write Popular Songs', *Creativity Research Journal*, 8, 3: 265–276.
Dissanayake, E. (1988) *What is Art For?* Seattle, WA: University of Washington Press.
Dissanayake, E. (2008) 'The Arts after Darwin: Does Art Have an Origin and Adaptive Function?', in K. Zijlmans and W. van Damme (eds), *World Art Studies: Exploring Concepts and Approaches*, Amsterdam: Valiz, pp. 241–263.
Fuss, D. (1989) *Essentially Speaking: Feminism, Nature and Difference*, New York; London: Routledge.
Gibson-Graham, J. (2006) *The End of Capitalism (As We Knew It): A Feminist Critique of Political Economy*, Minneapolis, MN: University of Minnesota Press.
Gilfillan, E. and Morrow, G. (2016) 'Sustaining Artistic Practices Post George Brandis's Controversial Australia Council Arts Funding Changes: Cultural Policy and Visual Artists' Careers in Australia', *International Journal of Cultural Policy*, online before print: 1–19.
Gratton, E. (2017) 'Why Artists Don't Have Kids', *ArtsHub*, 5 April. Online: <www.artshub.com.au/news-article/opinions-and-analysis/trends-and-analysis/emma-clark-gratton/why-artists-dont-have-kids-253482> Accessed 4 September 2017.
Hesmondhalgh, D. and Baker, S. (2011) *Creative Labour: Media Work in Three Cultural Industries*, Abingdon; New York: Routledge.
Hughes, D., Evans, M., Morrow, G. and Keith, S. (2016) *The New Music Industries: Disruption and Discovery*, Cham, Switzerland: Palgrave Macmillan.
Jenner, P. (2002) 'The Noble Art of Management', in M. McMartin, S. Eliezer and S. Quintrell (eds), *The MMF Music Manager's Manual*, Sydney: Music Managers Forum (Australia), 3–1.
Madden, C. and Bloom, T. (2001) 'Advocating Creativity', *International Journal of Cultural Policy*, 7, 3: 409–436.
Morrow, G. (2009) 'Radiohead's Managerial Creativity', *Convergence: The International Journal of Research into New Media Technologies*, 15, 2: 161–176.
Morrow, G. (2013) 'Regulating Artist Managers: An Insider's Perspective', *International Journal of Music Business Research*, 1, 4: 9–35.
Reis, S. (2002) 'Toward a Theory of Creativity in Diverse Creative Women', *Creativity Research Journal*, 14, 3–4: 305–316.
Ries, E. (2011) *The Lean Startup: How Today's Entrepreneurs Use Continuous Innovation to Create Radically Successful Businesses*, New York: Crown Business.
Robinson, F. (2001) 'MVP: A Proven Methodology to Maximize Return on Risk', *SyncDev*. Online: <www.syncdev.com/minimum-viableproduct/> Accessed 24 February 2016.
Robinson, K. (2011) *Out of Our Minds: Learning to Be Creative*, Chichester: Capstone Publishing.
Rogan, J. (1988) *Starmakers and Svengalis: The History of British Pop Management*, London: Macdonald.
Sarasvathy, S. (2005) *What is Effectuation?* Online: <www.effectuation.org/sites/default/files/documents/effectuation-3-pager.pdf> Accessed 4 September 2017.
Sarasvathy, S. (2008) *Effectuation: Elements of Entrepreneurial Expertise.* Cheltenham; Northampton, MA: Edward Elgar.

Simpson, S. and Munro, J. (2012) *Music Business: A Musician's Guide to the Australian Music Industry by Top Australian Lawyers and Deal Makers*, Sydney; London: Omnibus Press.

Thornton, S. (2006) 'Understanding Hipness: "Subcultural Capital" as Feminist Tool', in A. Bennett, B. Shank and J. Toynbee (eds), *The Popular Music Studies Reader*, Abingdon; New York: Routledge, pp. 99–105.

Throsby, D. and Zednik, A. (2010) *Do You Really Expect to Get Paid? An Economic Study of Professional Artists in Australia*, Surry Hills, NSW: Australia Council for the Arts.

4

AGILE MANAGEMENT STRATEGIES

4.1 Artist management and the agile movement

This chapter provides a descriptive and prescriptive analysis of artist management practices within two sectors of the creative and cultural industries: dance and film. It is descriptive to the extent that it describes how artist management and career development in the creative and cultural industries correlates with the agile paradigm, even though for the most part this is not how the participants in these sectors conceptualise how they are managed, or how they self-manage. For example, regarding the field of dance, one interviewee, Nashville-based Australian dancer and dance researcher Emma, noted that there is agility built into one of the broader structures surrounding this field in Australia: the Australian funding system for dance.

> I think that there is a sense of agility in the way the funding system works in Australia because you rarely get funded for the entirety of your project; you usually get funded for a stage of it, and at the end of that stage you have to have some sort of outcome that can be viewed in some way. It could be a showing ... and the question of whether it gets funded again depends on that. So there is that testing of it. OK, it's not being received well – going back, trying something new, coming back later with a new approach to the same idea, or you might scrap the project altogether.
>
> *(Interview 22)*

Therefore in Australia an agile build-measure-learn feedback loop of sorts is built into the funding system for dance, and as the empirical data in the chapter demonstrates, there is also evidence of moment-to-moment agility within group creative processes. This chapter therefore addresses the following research

questions: What is it like to manage artists in the creative and cultural industries? Or if you are a self-managed artist, what is it like to manage your own career? Are agile management strategies used within the creative and cultural industries? Can agile methods be used for managing artists within these industries? What is the difference between waterfall, agile and integrated project management within the context of these industries? Does working in an agile way require a different mindset to that currently dominant within these industries? Have artists and artist managers within the creative and cultural industries always worked in an agile way due to the nature of artistic creativity?

In response to these questions, this chapter is also prescriptive as I argue that the agile lens is useful for progressing artist management. The agile movement has a lot to offer when considering how artists are managed, as well as how they could be managed, within the creative and cultural industries. This chapter therefore focuses on agile management (AM) rather than the lean startup method (LSM) or the effectuation methods (EM). This is because a startup, which was the focus of Chapter 3, is only a temporary organisation that is ultimately seeking to move on from the startup phase. Furthermore, in the context of the creative and cultural industries, as discussed in Chapter 3, startup methods are primarily useful for managing hard artistic creativities (creation as invention), as opposed to weak ones (creation simply as production or reproduction), due to the uncertainty and unpredictability associated with original invention. In contrast, AM is applicable for managing the whole spectrum of hard to weak creativities (Madden and Bloom, 2001) and is therefore useful during any startup phase, as well as post such a phase, in addition to facilitating innovation in businesses that are not entirely new or that are not dealing with original and inventive content.[1]

AM is increasingly useful for sustaining artistic and managerial careers in the creative and cultural industries. Since the global financial crisis (GFC) of 2008, career trajectories within the creative and cultural industries have become even more uncertain, in both positive and negative ways, than they were prior to the crash. The positives, some authors argued, are that the creative and cultural industries have a role to play in regenerating post-crash prosperity in the West, and by extension they could potentially receive more funding and support from both public and private sources for this instrumentalist purpose (see Florida, 2014; Mellander, Florida and Rentfrow, 2012; Gabe, Florida and Mellander, 2013). Furthermore, there are important shifts occurring in Asia. Chinese cities such as Beijing, Shanghai, Macao and Hong Kong are currently investing heavily in arts and cultural infrastructure, as are cities such as Singapore (Ooi, 2010; Singh, 2013; Kong, 2005; Azevedo and Barbosa, 2014). According to Keane (2013), one of the most important purposes of this investment in China, and the development of China's creative industries overall, is to improve China's 'cultural soft power'. However, rather than studying such investments through the lens of gentrification or the commercialisation of art clusters for the purposes of state-to-society cultural soft power, Wang and Li (2017) argued, regarding the situation in Chinese cities such as Shenzhen and specifically in Dafen village, that

> At issue ... is the production of state space through multiple rounds of de-territorialization and re-territorialization to remake subjects, landscape, and their relations. Nevertheless, the process is not a one-directional state-to-society penetration of power, but involves contingent ally seeking, as well as resistances and struggles that constitute the counter-territorialization activities.
>
> *(709)*

Nevertheless, such investments in China contrast with the austerity environments that exist in some other countries, and indeed quite a spectrum has emerged in this regard between Asia, the US and Europe. At the US and European end of this spectrum lie the negatives; some have argued that since the GFC a number of challenges for the arts and cultural sectors have emerged. These challenges include reductions/changes in the funding of the arts (Gilfillan and Morrow, 2016); the threat to public arts funding of inclusion in austerity measures (Daniel, 2017; Fanthome, 2013; James, 2015); and the extent to which crowdfunding discourse threatens public arts funding (Brabham, 2017). The question of where countries such as Australia sit on this spectrum is interesting as the arts and cultural sector in this country has, since 2015, been through its most turbulent phase since the establishment of the Australia Council for the Arts (see Daniel, 2017; Gilfillan and Morrow, 2016). This has included the re-emergence of the debate about 'access' versus 'excellence' and how these relate to concepts of 'nation', as well as the decline of the category of 'multicultural arts' which accompanies the decline that currently shadows the discourse of multiculturalism generally (Khan, Wyatt and Yue, 2015). However, the arts in Australia have also come to function as a form of cultural diplomacy and are increasingly being used as a vehicle for Australia's pivot to Asia in the 'Asian Century' (Rösler, 2015). The cyclical effect of changing governments in liberal democracies means that the arts and cultural sectors are in almost perpetual flux within the cities upon which this book focuses (New York, London, Toronto, Sydney and Melbourne) (see Caust, 2015). At the same time as the arts and cultural sectors are subject to the pendulum swings caused by post-GFC tremors, digital technologies and democratising crowdfunding platforms are facilitating rapid innovation in the creative and cultural industries.

The fact that AM originated in the software industries is relevant here due to the influence that digital technologies have on the arts and cultural sectors. As discussed in the introduction to this book, AM originated for the purposes of developing software that better meets users' needs. It contrasts with traditional waterfall-style[2] project management, which often involves rigidly sticking to a plan, in the way that it involves a zigzagging pattern of adaptations in response to inevitable changes. These adaptations are informed by insights gleaned from frequent experiments and 'sprints'.[3]

The key to understanding the applicability of AM to artist management practices is the disruptive effect digital technologies have on artist-to-consumer (or fan) relationships. These relationships can be more direct in the digital age. The scope for experimentation relating to the production and consumption of cultural

artefacts has dramatically increased because artists, and their managers if they are not self-managed, can release content directly to consumers at any stage during the artistically creative process. This phenomenon of rapid and continuous innovation is a major influence on the sector currently (see Hughes et al., 2016; Rowe et al., 2016; Guerra and Kagan, 2016).

AM is characterised by the close monitoring of customer feedback, and each iteration of the developing product is designed to obtain and test such feedback. Thus, product development is not informed by assumptions about what customers want, but by what they *actually* want, need and/or will buy. This approach therefore reduces the risk involved in product development, and through the use of crowdfunding platforms, for example, consumers can buy into, and even partake in, the early stages of an artistically creative process in ways they could not in the past. In this way consumers are theoretically more likely to support the end product, and if they are not going to support it, then, again theoretically, risk is reduced because the product might not be made.

By enabling participants to respond to change, rather than follow a rigid plan, AM often involves small teams that work autonomously, with managers managing for goals rather than micromanaging processes. One of the key principles of AM is self-organisation. Discussing this principle, Medinilla (2012), an agile and lean expert and coach, noted:

> In their search for hyper-productivity, Agile pioneers from Nonaka-Takeuchi to Poppendieck, Sutherland, or Beck found that teams reaching this kind of state were absolutely not micromanaged or told what to do and how to do it. Instead, these teams had a goal and a purpose, and they collaborated to find the best ways to reach that goal.
>
> *(53)*

In this way agile management reinforces one of the best practice insights from the fields of group creativity research and OBM generally; namely, that managers should find good, smart people and then get out of their way. For example, Catmull (2008, 2014), an author and co-founder of Pixar, argued that power should be given to creatives and that managers should not micromanage on any level; and Amabile (1998), who is a leading scholar/researcher within the field of business administration and specialises in entrepreneurship and the management of creativity, put it this way: 'People will be more creative ... if you give them freedom to decide how to climb a particular mountain' (81). In the group creativity literature, Sawyer's (2007) theory of group flow features a similar insight.

This chapter examines agility within the creative and cultural industries on two levels. First, the individual level: divergent thinking and motivation is examined in relation to AM and self-management. Second, group creativity: the notion that diversity in a group's constitution increases the probability of the lateral associations (Kurtzberg and Amabile, 2001; Kurtzberg, 2005; Sawyer, 2007) required for hyper-productivity is examined with particular attention given to the negotiations

that occur within such self-organising groups, and between such groups and the other stakeholders and partners that are required for the co-creation of artistic ventures. Attention is also paid to the topic of freelancing and agility and the question of whether freelance careers are by their very nature more agile. This chapter features sections that concern agility in the dance and film sectors of the creative and cultural industries.

4.2 Agility on individual and group levels

As discussed in the introduction to this book, artist management can be defined as a form of group creativity that involves the interaction between artistic creativities and managerial creativities. Defining artist management in this way enables us to pluralise this form of creativity and to conceptualise it as a dialectic between these two clusters of creativities − creativities that are at times in conflict and at other times in harmony. The creative processes informing AM strategies in arts and cultural sectors such as dance and film are at times generated by an individual, while at other times they are generated in a distributed way amongst a group, or by a combination of both. It is therefore useful here to consider the concept of 'agility' on both an individual level and a group one.

The concept of a pivot is fundamental to the individual and group creativity involved in AM. AM is characterised by the close monitoring of customer feedback, and each iteration of a developing product is designed to obtain and test feedback. If the feedback is negative, then the agile team will 'pivot' in a new direction for the next iteration of the product. There are a number of agile management methods. For example, the scrum methodology features a backlog of product features that need to be developed. This list, or backlog, is organised in

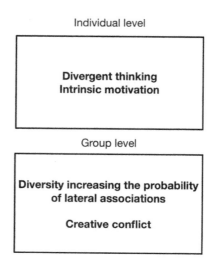

FIGURE 4.1 Agility on two levels

order of priority (see Philbin, 2017; Rubin, 2012). Project work is conducted via time-boxed iterations that are developed and tested during a set time frame (for example, a week or a month). A self-organising project team works on each iteration through a cycle of exploration, development, and then deployment. In this scheme, the self-organising project teams can react to (and pivot in response to) feedback they receive through the build-measure-learn feedback loop that each iteration features. Therefore over the lifespan of an agile project and its many iterations, a zigzagging pattern of (non-linear) development will emerge if there is more than one pivot. For Sawyer (2013), therefore, the term 'zigzag' is a more useful descriptor of this process than 'pivot' because it suggests multiple changes in direction or pivots rather than just one. In this way, in the context of this book's focus on the management of artistic creativity within the creative and cultural industries, AM simply becomes a means for understanding that some types of business creativity are similar to any other type of creativity. As Sawyer (2013), a psychologist, noted:

> No matter what kind of creativity I studied, the process was the same. Creativity did *not* descend like a bolt of lightning that lit up the world in a single, brilliant flash. It came in tiny steps, bits of insight, and incremental changes. Zigs and zags.
>
> *(2)*

When examining an artist's creative process, a zigzagging pattern of pivots will often emerge. However, the same is true for many other types of creativity, as Robinson (2015), an author and international advisor on education, the arts and creativity, posited:

> There are various myths about creativity. One is that only special people are creative, another is that creativity is only about the arts, a third is that creativity cannot be taught, and a fourth is that it's all to do with uninhibited 'self-expression.' None of these is true. Creativity draws on many powers that we all have by virtue of being human. Creativity is possible in all areas of human life, in science, the arts, mathematics, technology, cuisine, teaching, politics, business, you name it. And like many human capacities, our creative powers can be cultivated and refined. Doing that involves an increasing mastery of skills, knowledge and ideas.
>
> *(119)*

Bilton and Leary (2002) made a similar point specifically about managers, or to borrow their term, 'creativity brokers', within the creative and cultural industries. For them, the actual creative processes across artistic creativities and managerial ones are the same:

> Both are manipulating and exploiting ideas ... by creating a space within which individual talents, experiences and perceptions can collide in interesting

ways. If there is a distinction to be made between managers and artists, it is primarily one of scale.

(61)

These authors argued that for artists, this process primarily concerns their own thought process, while for managers, their creativities primarily concern the external relationships within the creative and cultural industries.

It is therefore useful here to consider artistic creativities, managerial creativities, innovation and agility on both an individual level and a group level because the internal and external brokering of ideas and exchanges between different talents, experiences and perceptions are interrelated and are both key to AM. For Bilton and Leary (2002), this occurs to the extent that 'the functions of management and cultural production blur together' (61). This conflation, or blurring together, differs from the argument put forward in this book however; namely, that pluralising creativity enables us to understand that artistic creativity and managerial creativity are different types of creativity that interact with one another in sometimes combustible and conflicting ways and at other times in generative ones. Nevertheless, like in Bilton and Leary's article, the similarities between individual creative processes and the group ones that AM helps to facilitate are the focus of this chapter.

4.3 Case study: Agility in the dance sector

Within the field of dance, the cult of celebrity clouds understandings of the relationship between individual and group creativities. Discussing this phenomenon, Card (2006) noted that in addition to the cult of celebrity, the marketing culture of the arts also complicates the management of dance-making processes. Both of these have an impact on the social psychology involved in these processes. Discussing democratic dance-making processes, as opposed to autocratic, choreographer-led ones, Card (2006), a dancer and dance researcher, observed:

> Even open claims to a democratic practice are difficult to defend in a society that has never really come to terms with the 'death of the author'. And this despite a more-than-passing acquaintance with the tenets and application of deconstruction, cultural specificity, and a post-structuralist, post-modern sensibility.

(6)

This tension between perceptions of individual creativity versus group creativity, or autocratic, command-driven process versus democratic process, has also been addressed by Gilfillan (2016). When considering Barthes' (1967) notion of the death of the author along with arguments against the cult of the choreographer, it is easy to understand why a binary between individual creativity and group creativity has emerged in this field. Gilfillan's (2016) work is useful here because it does not claim to find the middle ground between these two forms of creativity, but

rather locates them on a time scale (a micro one). As such, it enables analysis of the moments when the different parties take the lead with regard to the task at hand, and it allows one to understand the 'shifts in power between a dance-maker and dancers during a process' (7). Following Gilfillan, a theory of moment-to-moment agility can be proposed here in order to generate an understanding of the moment-to-moment fluctuations in active and passive power exchanges between dancers, dance-makers, producers, and managers as they partake in artistically creative and managerially creative processes. Discussing moment-to-moment agility and group creativity, Emma (Nashville-based Australian dancer and dance researcher) noted that:

> The testing of ideas often happens within the process, to develop further what's happening. Rather than being autocratic, the floor gets opened up for anybody's opinion on what's happening or ideas, whether that be through movement or discussion … So in that sense there is that ability to give and take and to find a solution in the immediate process.
>
> *(Interview 22)*

As outlined above, such a process of testing ideas in the immediate dance-making group is mirrored by agility that is built into the Australian funding system for dance.

4.3.1 Defining dancer/dance-maker management

To further understand agility, artist management and artist self-management within the dance sector, it is important to examine the different management approaches that exist within the many subgenres of dance, as well as the fact that dancers and dance-makers do not refer to artist management as 'artist management'. Any attempt to understand how artist management operates within the different subgenres of dance requires a taxonomy of the specific terms used to describe the various roles within dance subgenres.[4] To this end, Emma stated:

> In the field of contemporary dance there's often artists who are self-managed to a certain degree, and particularly well-known choreographers might have a manager/producer to help them organise their shows to public performance. Within commercial dance the majority of dancers will have an agent who in some respects acts as a manager because that's the only way they can get to auditions. The large majority of auditions are closed and very few are open call auditions, so that's how they get into the sector. There's a bit of a split between how the two genres, commercial versus independent dance, work.
>
> *(Interview 22)*

Therefore within these two subgenres, contemporary and commercial dance, the terms 'self-management', 'producer' and 'agent' are used as opposed to the terms 'artist management' or 'manager'. Sydney-based and self-managed contemporary dancer Anne discussed this further:

> As a dancer, and probably I would say for most dance artists, that word 'manager' isn't part of our vocab, other than if you break down the amount of time spent on making the work, then promoting and producing the work, and then administration and a lot of that being connected to management, the percentage of management is huge, as opposed to the little kernel of the actual thing that you should be doing. I don't know if many people attach it to that idea. It is a little bit more integrated – for me, it's integrated into my thinking that this is what I have to do and this is just a slightly different role to serve the number one purpose of making the work.
>
> *(Interview 21)*

As a self-managed artist within the field of contemporary dance, Anne conceptualises 'management' as simply part of the overall process of producing her work. The dialectic between the artistic creativities and the managerial creativities involved in producing her work is managed by her individually.

On an individual level such as this, divergent thinking,[5] openness to ideas and intrinsic motivation are key to the managerial creativities of a freelance contemporary dancer. These relate to planning (or a purposeful lack thereof), and therefore in some ways they correlate with agile management methods. Divergent thinking is relevant here because it is a thought process that involves identifying multiple solutions to a problem, or simply multiple and diverging ideas and possible directions for artistically creative work as well as for managerially creative ideas (see Scratchley and Hakstian, 2001; Runco and Acar, 2012). In their work concerning the measurement and prediction of managerial creativity, Scratchley and Hakstian (2001: 380) found that divergent thinking was a necessary key cognitive ability and that 'openness' was a corresponding personality trait that is useful for predicting managerial creativity. And in the context of the creative and cultural industries, managerial creativity is a type of creativity that a self-managed dancer such as Anne needs to progress her career. On the corresponding personality trait of 'openness', Scratchley and Hakstian (2001) said:

> We can discern a picture of the creative manager as a person who likes to experiment and who is not afraid of ambiguity or failure. These attributes appear similar to aspects of the Big Five personality dimension, openness to experience (hereafter openness).
>
> *(369)*

For a dance-maker such as Anne, divergent thinking and openness are relevant for both the artistic creativity and the managerial creativity involved in her work, as is intrinsic motivation. In her seminal work concerning the link between creativity and intrinsic motivation, Amabile (1985; Amabile and Pillemer, 2012: 10) originally tested her intrinsic motivation hypothesis of creativity by analysing the motivational orientation of creative writers. Amabile (1985) noted that:

> An intrinsically motivated state is conducive to creativity, whereas an extrinsically motivated state is detrimental. ... People are said to be intrinsically motivated to engage in a particular task if they view their task engagement as motivated primarily by their own interest and involvement in the task.
>
> *(393)*

Discussing her motivational orientation when dance-making, Anne (self-managed contemporary dance-maker) observed:

> For me, it was – as I get older, I don't want to work with difficult people. I want to work with people where it's just fun. I don't mean fun as in 'oh, we're having a great time' but that, you know, everyone's on the job and they want to be there. We all have something shared in terms of why we're doing it. For me that's the most important thing. I don't even care in the end what the piece is; it's about that process and that experience.
>
> *(Interview 21)*

Therefore Anne is primarily intrinsically motivated to be involved in the processes of dance-making. A freelance artist such as Anne requires divergent thinking, openness and intrinsic motivation in order to keep progressing her self-managed career.

When planning is considered, AM correlates with these factors. Discussing the way in which she eschews traditional waterfall-style career planning by not conceptualising her trajectory by way of, for example, a three-year plan, Anne continued:

> A three-year plan? Wow! How do you even think about that? Because I could never even have a plan 'till the end of the year because you would have things scheduled in that were survival. I know I've got that grant and someone's asked me to do that job, and you just make the trajectory and the through line and … aim to get to the end somehow. Maybe some people are very much more aims and goal-driven and have a plan, but I never did. I remember going to things where they would say, 'as artists you must have a three-year plan'. But it's going to change in the next month! And it's got to go on some other course! That's the reality.
>
> *(Interview 21)*

Therefore, in this case, Anne has managed her career in an agile way by default by simply pursuing the goal of creating contemporary dance works. While she has not herself conceptualised it in this way, an AM approach is evident here.

AM is also arguably evident in the dance subgenre of ballet. On an individual level, ballet dancers have to organise their own training so that they can compete through open auditions for a ballet company. When compared with commercial dance, the role of an agent is less relevant, and it involves self-management to the

extent that dancers attempt to piece together a series of, for the most part, yearly contracts with companies. Discussing this subgenre of dance, Emma (Nashville-based Australian dancer and dance researcher), who studied with a Chicago-based ballet studio company early in her career, noted that:

> Ballet companies are a bit different because everything is open audition ... it's the same for a contemporary dancer who wants to work in a company structure rather than an independent structure; the dancer then has to manage their own training while auditioning to get a job. Jobs are on a yearly contract basis in most cases, unless they're a principal dancer with a company, the highest rank in the company ... Some might get a secondment of eight weeks for the purpose that they need more people for a particular production and hope that gets them an entryway in, but mostly it's open auditions. You have to manage your own training while trying to audition [and] find your own funding to manage your own training because you have to pay for your training.
>
> *(Interview 22)*

An issue that complicates attempts to fund their own training is the fact that ballet dancers have to embrace agility in a geographical sense. This is because they have to go where the work is, and this can make it difficult for them to hold down a part-time job as part of a portfolio career (see Throsby and Zednik, 2010; Bridgstock, 2011). This in turn can make it difficult for them to pay for someone to train them and/or a space in which to train themselves between contracts with ballet companies. Emma went on:

> You either have to have a space that you can train in to train yourself, or ... most major cities worldwide will have a company that then has classes open to the public or a studio that has classes open to the public, so in Sydney it's Sydney Dance Company. They have their public program, so you pay them to go to class. There's difficulties in managing that and then, of course, because generally dancers of any type have to move for work. You go where the work is; you don't wait for it to come to you wherever you are.
>
> *(Interview 22)*

In a similar way to touring musicians, ballet dancers find it difficult to maintain some of the income-generating activities that constitute their portfolio career, because they constantly have to move to a new geographical location for dance work:

> It's harder for them to hold down other jobs – they need to support themselves doing dance teaching or something unrelated, working as a barista. It becomes difficult because all of a sudden, oh, there's an audition, I need to go to that audition. I have to travel to New York to go, so that takes up two days to get there and do the audition.
>
> *(Interview 22)*

To a certain extent, ballet dancers therefore have to be agile in relation to all of the activities that constitute their portfolio career; they often need a part-time job that will be flexible enough to enable them to travel for dance work.

On the level of group creativity, moment-to-moment agility is evident in how the dance-maker and dancer collaborate to create work during the lifespan of a contract. The notion that diversity in a group's constitution increases the probability of the lateral associations (Kurtzberg and Amabile, 2001; Kurtzberg, 2005; Sawyer, 2007) required for hyper-productivity is relevant here. Such diversity of membership helps a group move in more novel directions during moment-to-moment collaborative processes. Discussing moment-to-moment collaboration and agility as it relates to group-level agile management strategies, Emma continued:

> I wouldn't frame it in terms of management, but definitely for the life of that contract the dancer is involved with that dance-maker – you'd call it a contract, whether they've got a signed agreement or not. They're definitely a manager as well as a creative in the process. When it comes to perhaps things like schedule conflicts, the management side of that dance-maker might come out. And the moment when collaboration would happen in that sense, or anything relating to managing other creatives, lighting crews, staging crews, everything like that, you definitely could call it moment-to-moment collaboration. They have to bring it together as a group to get to public performance, so it could be separated from the creative process when the moment-to-moment collaboration comes in; but at the same time, they have a crossover because the dance work develops in a way that responds to contextual things that are happening.
>
> *(Interview 22)*

Therefore the interrelationship between the artistic creativities and the managerial creativities in this example occurs on a moment-to-moment basis, with the artistic creativities taking the lead in one moment and the managerial ones during the next as the group responds to contextual elements and factors that affect their practice.

4.4 Case study: Agility in the film sector

This section provides a descriptive and prescriptive analysis of artist self-management practices within the film sector through a case study of the career of Sydney-based screenwriter, director and producer Peter Maple. This section is descriptive to the extent that it describes how artist self-management within film and its associated industries naturally fits the agile paradigm, even though for the most part this is not how participants in this sector such as Peter conceptualise how they manage their own career. This section is prescriptive to the extent that I argue that the agile lens is useful for progressing this form of management within the creative and cultural industries.

One of the key elements that has facilitated agile management practices across many sectors is the decreasing cost of experimentation. Discussing the decreasing

cost of experimentation in film in the digital age and the extent to which this has enabled him to pivot in his career from being an actor to also becoming a screenwriter, director and producer, Peter noted:

> First of all, camcorders came in, video recorders, which made it easier for people to record their own stuff; audiences got used to things not being so polished over time filmically; they understood that you could still watch and tell a screen story with shaky camera work, with low-grade camera work. So you can kind of create your own work now and get it out there and you can even film on phones now, as we know. Then the internet, you've got more of an outlet for people to see it now as well. That's led to me trying to create my own content, and in recent years I've started producing, and writing even, features. We've got a feature film out there at the moment that got made on just people's 'in kind'. It's here. It's been connecting. We picked up a distributor for that, but initially we just made that and we were just putting it out there ourselves. We put a screening up at the cinemas that we paid for ourselves but that got word of mouth going, and you hope enough people in the industry see it and hear about it. We're currently living in that process of it getting recognised.
>
> *(Interview 19)*

In this example, the feature film-making process correlates with agile management processes due to the fact that Peter is able to efficiently experiment with the technologies necessary to pivot in his career over time to become a film-maker. However, clearly this process was a long and grinding one as, for Peter, this 'pivot' has taken three years: 'I'm yet to see the full fruits of that labour, and that was about a three-year journey from starting to writing, to shoot, to edit, to now it being screened and going around the festivals'. Peter attributed the creative self-efficacy (creative confidence) he has to pivot in his career to become a film-maker, and, in his words, to 'legitimise' himself as an artistic 'creative', to his holistic actor training:

> Again, in generating my own content and work to 'legitimise myself' I took on doing a Masters of Writing at NIDA[6] in recent years. I'd always been writing for myself throughout the years, and my Bachelor of Performance as well was very encouraging of devising as well; it wasn't one of those acting schools where you go and you just learn to be an actor. You're not just a prop or a tool for a director where you are given a text and you analyse that text and your sole role is just to play that character. We were also encouraged to look at what's going on in the world and hopefully comment on it and develop our own projects through nontraditional theatre storytelling, non-traditional spaces as well, using homes, using warehouses, using outdoors, whatever, trying to connect with people that way.
>
> *(Interview 19)*

When asked about the notion of a minimum viable product (MVP) and its applicability to the management of his career in theatre and film, Peter noted that he has the equivalent of 20 MVPs going all at once:

> To self-manage … you've kind of got to have 20 projects that you're juggling at once. If you invest all your time into this one particular project, it'll be a stronger project; but if it doesn't come to fruition, that's the issue. So even though it's harder to juggle 20 at once and they may all end up being slightly less developed or in depth, or a bit of a shadow of what they would be if they were the central project, the possibilities of one of those 20 hitting is obviously higher.
>
> <div align="right">(Interview 19)</div>

In terms of AM, in a relatively loose way, these 20 projects are equivalent to MVPs; a self-managed film-maker such as Peter uses this many projects to experiment with ideas and then reacts to feedback on these ideas. He is also reactive to potential collaborators' expressed desires to work with him to further realise one or two of these ideas.

4.4.1 Collaboration has a lifespan

Artist self-management in film is a form of group creativity; the nuances of group creativity are therefore relevant to the groups that film-makers such as Peter form and then manage. As discussed in the introduction to this book, one particular nuance is that the psychology of creativity can lead to disloyalty because, as Sawyer (2007, 2012) found, while familiarity with each other is a requirement for a team to achieve group flow,[7] members may over time become too familiar with each other, bored and less effective, and therefore they will often move on in their attempts to chase the 'high' associated with being a state of group flow. The film industries primarily operate on a project-by-project basis, and therefore groups within these sectors naturally form and dissolve relatively rapidly. Peter's experiences reflected this:

> With theatre or film projects, the team comes together for that project and then dissolves. It's very much the case. There's a positive and negative to it. The positive is that it makes any new project different because it's different people, and they may be people who are specifically appropriate to the different personality of that project so it benefits it. The negatives are that you're always having to, once that dissolves and if you go on to a new project with different people, first of all find those new people; are they appropriate for that project?; you've got to learn a new working language with one another; there's no guarantee that you're going to align with those other artists, not only creatively but personally as well. I've come across lots of struggles, either artistically or even just personal clashes. It's just a fact of life that you can't get

on with everyone. In particular in regards to the arts as well, if people are serious, they're quite passionate; so they can be quite determined about what they believe.

(Interview 19)

Therefore while the high of group flow is potentially attainable for film-makers such as Peter due to the rapid forming and dissolving of groups in this sector, the nature of project-based work such as this means that conflict is rife within many of the groups that practitioners form. These groups then naturally just dissolve or are purposefully dissolved because of such conflict. However, not all forms of conflict dissolve groups in such a way, as some types of conflict are creative. In order to hold such groups together, for the artist manager or self-managed artist, knowledge of both the role of conflict and the different types of conflict is often required.

4.4.2 Creative conflict

Discussing the management of collaborative decision-making processes at Google, Google Executive Chairman and ex-Chief Executive Officer (CEO) Eric Schmidt and former Senior Vice President (SVP) of Products Jonathan Rosenberg (Schmidt and Rosenberg, 2014) argued that

> Reaching the best idea requires conflict. People need to disagree and debate their points in an open environment, because you won't get buy-in until *all* the choices are debated openly. They'll bobblehead nod, then leave the room and do what they want to do. So to achieve true consensus, you need dissent. If you are in charge, do not state your position at the outset of the process. … As General Patton famously said: 'If everyone is thinking alike, then somebody isn't thinking.'

(154)

Discussing conflict as it relates to team-level creativity, like Schmidt and Rosenberg, Kurtzberg and Amabile (2001) argued that conflict has a role to play in group creative processes. These authors built on the body of individual creativity research to examine the ways in which groups generate insights and a collective ability to 'think outside the box'. While lateral thinking (de Bono, 1991), associative thinking and divergent thinking (Guilford, 1950, 1967) are key to this process for individuals, Kurtzberg and Amabile (2001) noted that for groups or teams of people, 'the input of other people's ideas, knowledge structures, and perspectives at particular stages of the thought process might have important effects on how creative ideas are formed, perhaps by increasing the probability of lateral associations' (286). In film-making groups, such as those with which Peter is involved, diversity of group membership enables the collaboratively generated thoughts to leap from category to category, rather than these processes simply following pre-existing paths of

cognition. For Kurtzberg and Amabile, 'noticing similar features in seemingly unrelated elements appears to be a crucial skill in associative thinking' (286), and this is something that Peter factors into his film-making processes:

> The biggest thing, I think, is meeting other people, but not just people within your own circles. That's something I'm slowly learning, and it becomes more and more obvious. If you can cast a wider net, and it's not this kind of really consciously advantage-taking situation, but if you can find as many different people in different fields, then again it's like having 20 projects; if you have numerous amounts of collaborators in different fields, then it's going to create more opportunities as well as possibilities.
>
> *(Interview 19)*

However, whilst for Peter, this attempt to facilitate associative/lateral/divergent thinking through engaging collaborators in different fields creates more opportunities/possibilities for his work, this can simultaneously cause conflicts relating to communication and coordination difficulties as well as in relation to the direction of the artistically creative work. Such tension and conflict can also be exacerbated by the fact participants often feel very passionate about artistically creative work. This can be a problem because, as Kurtzberg and Amabile (2001) said, 'Conflict can affect a person's mood, rapport with others, and even patterns of thinking' (290). Thought processes can become rigid and narrow (Carnevale and Probst, 1998). On the other hand, when divergent thinking and openness are correlated with high levels of creativity, it is surprising to note that in this context, some types of conflict – specifically task-based conflict that is manifest by way of disagreements of opinion regarding specific work issues and goals – can aid the creative process (see James, 1995). Discussing both conflict that is detrimental to the group creative processes with which he is involved and conflict that is beneficial to these processes, Peter noted:

> It can be both. It tends to be more in hindsight that you realise that it was beneficial. It's hard to deal with in the moment. When I say hindsight, much later, once the project's over and you look back at it. It's not like a day after the conflict or a week after, because you're still active with that person or those people and on that project, so what you're generating within your own mind is still running around. But once you get that time away from it, you can look back and go, oh, it has benefited the project. Probably you learn to grow from it as well, and your art grows from it too.
>
> *(Interview 19)*

Discussing this very phenomenon, Kurtzberg (2005) found through her research that heterogeneous teams are often more creative, though they perceive themselves and their teams to be less creative. She also found the inverse to be true; homogenous teams perceive their output to be creative even though often it is not. This

is because there is a difference between 'feeling creative' and 'being creative' when it comes to groups: 'Homogenous teams seem to excel at more emotional outcomes such as trust, liking, and positive attitudes, and heterogeneous teams seem to excel at more performance-based outcomes such as originality, complexity, and decision performance' (55). Because positive emotions can lead to assumptions of positive outcomes, self-managed artists such as Peter need to be aware of the moments when the creative groups with which they are involved *feel* creative as opposed to *being* creative. They also have to factor in the cost of heterogeneity; while it can enhance creativity by increasing the probability of lateral associations, there can be a cost in terms of team cohesiveness and affect, emotional conflict and membership turnover (Kurtzberg, 2005).

This is where broader understanding of this issue of perceptions of conflict, along with an understanding of the different types of conflict, would aid the members of groups that self-managed artists such as Peter form. On the tendency for task-based conflict during a collaborative process to be interpreted as personal or relationship-based conflict that leads to a breakdown of the relationship, Peter said:

> I can get quite close to other artists if we are of a similar ilk, and I struggle normally if we're not. Only recently I had to work with another artist on a project and we just weren't gelling. Weren't gelling artistically. We kind of got on fine personally, but then the artistic clashes just got bigger and stronger and everyone – the two of us dug our heels in and it got quite ugly to the point where I was like, I just need to survive this project and get through it and do the bare minimum. Then the result that came of it, looking back on it with hindsight, was quite strong, and I've since worked with that artist again and we now have one of the strongest relationships. So it's built from fire, that one. That's really rare for me. Normally that would be done and dusted, I'll never see that person or work with them again. There was something in that [experience] that created a positivity in the end.
>
> *(Interview 19)*

This is an example of task-based conflict during a collaborative process and of an artist being able to get through this process with their relationship with the other participant still intact. This is partly because Peter was able to recognise that not all conflicts are the same. Discussing the different types of conflict that are relevant here, Kurtzberg and Amabile (2001) pointed out that

> Previous research has identified three main categories of conflicts: task-based conflict, which pertains to discussions and debates about the work being done; relationship-based conflict, which pertains to the interpersonal interaction among group members; and process-based conflict, which pertains to the strategies, plans, and division of roles and responsibilities.
>
> *(290)*

While some task-based conflict can be beneficial to the output of the group, too much of it can become counterproductive (Jehn, 1995), and relationship-based conflict and process-based conflict are both damaging to groups. Kurtzberg and Amabile (2001) posited that it is important to categorise the type of conflict involved as different types of conflict have different effects (291). This is indeed something that Peter noted he has (sometimes) been able to do:

> You can be aware of it in the moment as well at times, that it's benefiting the project, the conflict. It kind of takes two states of mind or two states of thinking to do that. You need to dissociate from the emotion to be able to recognise that.
> *(Interview 19)*

This topic of creative conflict is an important one for the arts and for artist management because it enables managers and self-managed artists to identify the different types of conflict, to analyse what is actually happening in a group, and to assess whether it is actually contributing to the creative process or whether it is detrimental.

4.5 Conclusion

The question of the applicability of agile methods needs to be considered in terms of the artistic creativities and the managerial creativities that are the focus of this book. This chapter concerned agile management, and it has focused more on self-managed artists than on artist managers. This is because self-managed artists are good examples of agile management; as artists, they possess artistic/aesthetic autonomy, and because they are their own manager, they can pivot more easily. When an artist has a separate manager, pivoting involves a negotiation between more than one person. The ease of enacting agile methods also relates to the hard and soft architecture of the creative and cultural industries and which element of these industries is being considered. In relation to the 'paradox' of the creative and cultural industries, DeFillippi, Grabher and Jones (2007) stated that the

> 'hard architecture' of projects and organizations ... is inseparably entwined with the 'soft architecture' of communities and networks. ... [S]oft architecture ... generates new ideas ... hard architecture is more geared towards making money out of these ideas.
> [...] The open source-movement has shifted the locus of creativity and innovation ... from the hard to the soft architecture.
> *(514)*

Due to the prevalence of such 'soft architecture' in this field, agile project management necessitates a close working relationship between the artist and the artist manager. This is because strategies and solutions evolve over time and they

can change quickly. Understanding that artist management is a form of group creativity is fundamental here because, from the manager's perspective, their client needs to be part of the team rather than outside of it. This is also true in reverse, particularly with regard to hard artistic creativity. The artwork itself may determine what happens next, rather than the audience for it, and therefore managers and artists need to work together to navigate the nuanced interrelationship between innovation in terms of the actual artistic product and building an audience for it. As Stitz (2017) noted, 'a creative arts organisation needs to be prepared to innovate in administration and structure as well as in creative product'. Agile development is therefore useful in terms of both artistic creativity and managerial creativity. Furthermore, the creative and cultural industries sector 'provides more flexible working environments within generally less hierarchal structures. Perhaps this is because collaboration is to an extent embedded within the DNA of performance making' (ibid.). Some sectors of the arts are therefore well suited to agile approaches because small autonomous working groups are commonplace.

This chapter has provided both a descriptive and a prescriptive analysis of artist management practices within two sectors of the creative and cultural industries: dance and film. It has described what it is like to manage artists in the creative and cultural industries and, through the case study of Peter Maple's self-management within the film sector, what it is like to manage your own career. This chapter has argued that the use of agile methods within the creative and cultural industries for the management and self-management of artists could be expanded through raising awareness of the differences between agile, waterfall and integrated project management within this context. Although the participants in this research did not describe their management processes using the vernacular of the agile movement, working in an agile way fits the mindset that was dominant within the (albeit small number of) cases examined in this chapter. Indeed, the nature of artistic creativity is such that artists and artist managers have often worked in these ways in the past; it is just that through the use of agile management processes, other sectors of the economy are beginning to operate like artists do.

Areas for further research include the possibility of experimenting with the various agile management methods, possibly through the use of creative practice (nontraditional) research. In this chapter, it has only been possible to discuss agile management practices in the creative and cultural industries in a relatively loose way; this is simply because the chapter was descriptive and prescriptive and because the artists featured for the most part (particularly in dance) do not use the word 'management' to describe the management of their work and careers, let alone the term 'agile project management'. Therefore each iteration of work they described simply correlates with agile management practices.

Much could be gleaned from research experiments in the creative and cultural industries that involve applying specific agile methods. For example, specific application of a method such as the scrum methodology for the management of artists within the creative and cultural industries, touched on briefly in this chapter, is an area for further research. This method features a backlog of product features

that need to be developed. This list, or backlog, is organised in order of priority (see Philbin, 2017; Rubin, 2012). As previously discussed, project work is conducted via time-boxed iterations that are developed and tested during a set time frame with self-organising project teams working on each iteration. Further research might examine the relevance of agile methods terms such as 'batch size' and the extent to which the role of a scrum master correlates with that of an artist manager.

Notes

1 The latter organisations may be dealing with traditional content; for example, content that may well be more effective at triggering an audience's moods and feelings than inventive content.
2 For a detailed outline of the differences between waterfall, agile and integrated project management in creative firms, see Burgoyne (2015).
3 Each iteration, also sometimes considered to be an experiment, is completed in a brief cycle that is sometimes called a sprint.
4 This chapter focuses on contemporary dance, commercial dance and ballet while acknowledging that there are many other subgenres of dance.
5 The concept of divergent thinking was originally developed by Guilford (1950, 1967; Guilford & Hoepfner, 1971).
6 NIDA stands for National Institute of Dramatic Art. NIDA is Australia's leading institute for education and training in the dramatic arts.
7 As discussed in the introduction to this book, for positive psychologist Csikszentmihalyi (1996, 1997), 'flow' is a particular heightened state of consciousness. Sawyer (2007), who is also a psychologist, found that improvising groups attain a similar, but collective, state of mind which is also a peak experience. 'Group flow' is therefore derivative of 'flow'.

References

Amabile, T. (1985) 'Motivation and Creativity: Effects of Motivational Orientation on Creative Writers', *Journal of Personality and Social Psychology*, 48, 2: 393–399.
Amabile, T. (1998) 'How to Kill Creativity', *Harvard Business Review*, Sept–Oct. Online: <https://hbr.org/1998/09/how-to-kill-creativity> Accessed 30 August 2017.
Amabile, T. and Pillemer, J. (2012) 'Perspectives on the Social Psychology of Creativity', *Journal of Creative Behaviour*, 46, 1: 3–15.
Azevedo, M. and Barbosa, Á. (2014) 'The Creative Industries as an Integrated Factor in a Sustainable Model for Macao's Economic Development', *Creative Industries Journal*, 7, 2: 121–133.
Barthes, R. (1967) 'Death of the Author', *Aspen*, 5–6.
Bilton, C. and Leary, R. (2002) 'What can Managers do for Creativity? Brokering Creativity in the Creative Industries', *International Journal of Cultural Policy*, 8, 1: 49–64.
Brabham, D. C. (2017) 'How Crowdfunding Discourse Threatens Public Arts', *New Media & Society*, 19, 7: 983–999.
Bridgstock, R. (2011) 'Making it Creatively: Building Sustainable Careers in the Arts and Creative Industries', *Australian Career Practitioner Magazine*, 22, 2: 11–13.
Burgoyne, E. (2015) 'The Difference Between Waterfall, Agile & Integrated Project Management in Creative Firms', *Adsubculture*, 21 January. Online: <http://adsubculture.com/traffic-project-management/2015/1/21/the-difference-between> Accessed 4 September 2017.

Card, A. (2006) 'Body for Hire? The State of Dance in Australia', *Platform Papers*, 8: i–iv, 1–63.
Carnevale, P. and Probst, T. (1998) 'Social Values and Social Conflict in Creative Problem Solving and Categorization', *Journal of Personality & Social Psychology*, 74, 5: 1300–1309.
Catmull, E. (2008) 'How Pixar Fosters Collective Creativity', *Harvard Business Review*, Sept. Online: <https://hbr.org/2008/09/how-pixar-fosters-collective-creativity> Accessed 30 August 2017.
Catmull, E. (2014) *Creativity, Inc.: Overcoming the Unseen Forces that Stand in the Way of True Inspiration*, New York: Random House.
Caust, J. (2015) 'Cultural Wars in an Australian Context: Challenges in Developing a National Cultural Policy', *International Journal of Cultural Policy*, 21, 2: 168–182.
Csikszentmihalyi, M. (1996) *Creativity: Flow and the Psychology of Discovery and Invention*, New York: HarperCollins.
Csikszentmihalyi, M. (1997) *Finding Flow: The Psychology of Engagement with Everyday Life*, New York: Basic Books (MasterMinds).
Daniel, R. (2017) 'Arts and Culture in an Era of Austerity: Key Stakeholder Views on the Current and Future Australian Context', *International Journal of Cultural Policy*, online before print: 1–12.
de Bono, E. (1991) 'Lateral and Vertical Thinking', in J. Henry (ed.), *Creative Management*, London: Sage, pp. 16–23.
DeFillippi, R., Grabher, G. and Jones, C. (2007) 'Introduction to paradoxes of creativity: Managerial and organizational challenges in the cultural economy', *Journal of Organizational Behavior*, 28, 5: 511–521.
Fanthome, L. (2013) '"Am I Still an Artist?" Sustaining Arts Practice in an Age of Austerity', *Visual Culture in Britain*, 14, 3: 281–300.
Florida, R. (2014) *Rise of the Creative Class – Revisited: Revised and Expanded*, New York: Basic Books.
Gabe, T., Florida, R. and Mellander, C. (2013) 'The Creative Class and the Crisis', *Cambridge Journal of Regions, Economy and Society*, 6, 1: 37–53.
Gilfillan, E. (2016) *Dance-Making: Moment-to-Moment Collaboration in Contemporary Dance Practices*, PhD thesis, Macquarie University, Sydney.
Gilfillan, E. and Morrow, G. (2016) 'Sustaining Artistic Practices Post George Brandis's Controversial Australia Council Arts Funding Changes: Cultural Policy and Visual Artists' Careers in Australia', *International Journal of Cultural Policy*, online before print: 1–19.
Guerra, P. and Kagan, S. (eds) (2016) Arts and Creativity: Working on Identity and Difference. 9th Midterm Conference of the ESA RN – Sociology of the Arts, University of Porto, Portugal.
Guilford, J. P. (1950) 'Creativity', *American Psychologist*, 5, 9: 444–454.
Guilford, J. (1967) *The Nature of Human Intelligence*, New York: McGraw-Hill.
Guilford, J. and Hoepfner, R. (1971) *The Analysis of Intelligence*, New York: McGraw-Hill.
Hughes, D., Evans, M., Morrow, G. and Keith, S. (2016) *The New Music Industries: Disruption and Discovery*, Cham, Switzerland: Palgrave Macmillan.
James, C. (2015) 'Aesthetics in the Age of Austerity: Building the Creative Class', in P. Hanna (ed.), *Anthology of Philosophy Studies*, Athens: Athens Institute for Education and Research, pp. 37–48.
James, K. (1995) 'Goal Conflict and Originality of Thinking', *Creativity Research Journal*, 8, 3: 285–290.
Jehn, K. (1995) 'A Multimethod Examination of the Benefits and Detriments of Intragroup Conflict', *Administrative Science Quarterly*, 40, 2: 256–282.
Keane, M. (2013) *Creative Industries in China: Art, Design and Media*, Cambridge, UK; Malden, MA: Polity Press.

Khan, R., Wyatt, D. and Yue, A. (2015) 'Making and Remaking Multicultural Arts: Policy, Cultural Difference and the Discourse of Decline', *International Journal of Cultural Policy*, 21, 2: 219–234.

Kong, L. (2005) 'The Sociality of Cultural Industries', *International Journal of Cultural Policy*, 11, 1: 61–76.

Kurtzberg, T. (2005) 'Feeling Creative, Being Creative: An Empirical Study of Diversity and Creativity in Teams', *Creativity Research Journal*, 17, 1: 51–65.

Kurtzberg, T. and Amabile, T. (2001) 'From Guilford to Creative Synergy: Opening the Black Box of Team-Level Creativity', *Creativity Research Journal*, 13, 3–4: 285–294.

Madden, C. and Bloom, T. (2001) 'Advocating Creativity', *International Journal of Cultural Policy*, 7, 3: 409–436.

Medinilla, Á. (2012) *Agile Management: Leadership in an Agile Environment*, Heidelberg: Springer.

Mellander, C., Florida, R. and Rentfrow, J. (2012) 'The Creative Class, Post-industrialism and the Happiness of Nations', *Cambridge Journal of Regions, Economy and Society*, 5, 1: 31–43.

Ooi, C.-S. (2010) 'Political Pragmatism and the Creative Economy: Singapore as a City for the Arts', *International Journal of Cultural Policy*, 16, 4: 403–417.

Philbin, S. (2017) 'Investigating the Scope for Agile Project Management to be Adopted by Higher Education Institutions', in Z. Mahmood (ed.), *Software Project Management for Distributed Computing: Life-Cycle Methods for Developing Scalable and Reliable Tools*, Cham: Springer, pp. 345–366.

Robinson, K. (2015) *Creative Schools: Revolutionizing Education from the Ground Up*, London: Allen Lane.

Rösler, B. (2015) 'The Case of Asialink's Arts Residency Program: Towards a Critical Cosmopolitan Approach to Cultural Diplomacy', *International Journal of Cultural Policy*, 21, 4: 463–477.

Rowe, D., Noble, G., Bennett, T. and Kelly, M. (2016) 'Transforming Cultures? From Creative Nation to Creative Australia', *Media International Australia*, 158, 1: 6–16.

Rubin, K. S. (2012) *Essential Scrum: A Practical Guide to the Most Popular Agile Process*, Upper Saddle River, NJ: Addison-Wesley Professional.

Runco, M. and Acar, S. (2012) 'Divergent Thinking as an Indicator of Creative Potential', *Creativity Research Journal*, 24, 1: 66–75.

Sawyer, K. (2007) *Group Genius: The Creative Power of Collaboration*, New York: Basic Books.

Sawyer, K. (2012) *Explaining Creativity: The Science of Human Innovation*, 2nd ed., New York: Oxford University Press.

Sawyer, K. (2013) *Zig Zag: The Surprising Path to Greater Creativity*, San Francisco: Jossey-Bass.

Schmidt, E. and Rosenberg, J. (2014) *How Google Works*, London: John Murray.

Scratchley, L. S. and Hakstian, A. R. (2001) 'The Measurement and Prediction of Managerial Creativity', *Creativity Research Journal*, 13, 3–4: 367–384.

Singh, K. (2013) 'Many Asias But One Singapore: The Problematics of Creative Industry', *Creative Industries Journal*, 6, 1: 71–77.

Stitz, T. (2017) 'Why Leadership Models in the Arts Need to Evolve', *ArtsHub*, 18 February. Online: <www.artshub.com.au/education/news-article/opinions-and-analysis/professional-development/tim-stitz/why-leadership-models-in-the-arts-need-to-evolve-253185?utm_source=ArtsHub+Australia&utm_campaign=271cc54b05-UA-828966-1&utm_medium=email&utm_term=0_2a8ea75e81-271cc54b05-302204490> Accessed 31 August 2017.

Throsby, D. and Zednik, A. (2010) *Do You Really Expect to Get Paid? An Economic Study of Professional Artists in Australia*, Surry Hills, NSW: Australia Council for the Arts.

Wang, J. and Li, S. M. (2017) 'State Territorialization, Neoliberal Governmentality: The Remaking of Dafen Oil Painting Village, Shenzhen, China', *Urban Geography*, 38, 5: 708–728.

5

STORYTELLING IN THE CREATIVE AND CULTURAL INDUSTRIES

Where is creativity? Creative cities and artist management

5.1 Storytelling in the creative and cultural industries

In this chapter, I broaden the context for the examination of artist management processes through a consideration of the role of geographic location(s) in these processes and therefore in career development in the creative and cultural industries. The work of Csikszentmihalyi (1996, 2014) is relevant here. Csikszentmihalyi, who is a positive psychologist, shifted the base questions concerning creativity from 'what is creativity?' and 'who is creative?' to 'where is creativity?' (Garder, 1993, cited in McIntyre, 2003: 1). Through doing so, he came to envisage that creativity operates within a system that involves the interrelationship of three component parts: the person, the domain, and the field. He believes that these elements 'jointly determine the occurrence of a creative idea, object or action' (Csikszentmihalyi, 2014: 52). Geographic location is fundamental for accessing the domain and the field for both artistic and managerial creativities in this model, and because of this, storytelling creativities relating to geographic locations are used by artists and artist managers.[1]

For artist managers, accessing the field and domain in one geographic location is often key to accessing the field and domain in another. This is because the more international territories that are involved, the greater the potential exchange value of their client's copyright (see Morrow, 2008) and the bigger the market is for touring. This is why interest in one territory may be reciprocated in another. The process of achieving interest from potential investors involves much domestic and international travel because of the interest of different territories. The process through which this interest is generated involves (truthful) storytelling about the other territory and the passion people in this particular place have for the project.[2] Associations such as the International Music Managers Forum (IMMF) are often used by members to build international relationships for this purpose. Regarding

the IMMF, which is also known in each member country simply as the Music Managers Forum (MMF), one interviewee, Toronto-based artist manager in popular music Ben, noted:

> The MMF has made me a better manager because it opened up the world marketplace to me; it has educated me in different ways. And that may not be anything that the MMF did specifically, but if you create an opportunity for people to get together and talk and network, then that creates the opportunity for education. The fact that we do get together a lot both domestically and internationally and we talk.
>
> *(Interview 5)*

For artists themselves, building and sustaining a career often involves accessing the field and domain in multiple geographic locations and, therefore, a lot of domestic and international travel, often through the process of touring (Morrow, 2008).[3] Therefore while an artist and/or artist manager may have a base in a particular 'creative city' (Florida, 2002, 2014), artist management is often transnational as it involves the interrelationships between multiple 'creative cities' and the process of articulating these connections through the creation of a story that can be told to potential audiences through the traditional media and via social media – often with the help of a publicist and/or a social media strategist – or on stage while touring, and also to potential business partners and investors, often through trade fairs and festivals and via organisations such as the IMMF. In this way art is a story between places rather than being centralised in one place, and this is what artist managers are managing.

5.2 Sporting analogies

The word 'story' is used here because it forms part of the vernacular of artist managers in sectors of the creative and cultural industries such as music, as well as of fundraisers in other sectors of these industries (see Radbourne and Watkins, 2015). Many of the managers interviewed for this project envisaged their role as helping to build a story about their artist which is then used to coordinate, persuade and motivate the various entities and people who work for the artist. One interviewee, New York-based label owner and distributor Mike, used US sporting analogies to describe this function, comparing the role of the artist manager to that of quarterback or point guard: 'the quarterback, or the point guard is becoming the centralised source for anything that the artist wants to do' (Interview 10).

Such analogies support Watson's (2002) argument that the unique relationship between artist and manager is the nucleus around which a successful musical career revolves. In order to develop this argument further, Watson used the analogy of a bicycle wheel to describe the structure that evolves due to the fact that (if successful) eventually the manager and the artist will assemble a network of other relationships to try to further the artist's career. Watson (2002) claimed that the

artist and manager might build a team that includes record company staff, booking agents, live crew, publicists, accountants, music publishers, record producers, merchandisers, and many other specialists. In his analogy, the unique combination of the artist and manager constitute the hub in the middle of a wheel. The artist and manager together work out where they want to go and how they want to get there. They then start assembling the additional members of the team around the hub like the spokes of a wheel. While the individual spokes themselves are important, the artist/manager hub remains pivotal in every situation. Even after the artist and manager have assembled all the right 'spokes', the career 'wheel' still needs to be persuaded to roll in the right direction (Watson, 2002: 2), and storytelling is key to this process.

Watson stated that most of the responsibility for this persuasion usually falls on the shoulders of the manager as their main job is to coordinate and persuade. This is why if an artist is to become creatively and/or commercially successful, their career demands at least as much management as talent and ambition (Frascogna and Hetherington, 1997: 7). Watson's analogy is useful as it suggests that artist managers and self-managed artists each face the same basic set of challenges when attempting to establish, develop and sustain artist careers. In addition to featuring discussion about access to various geographic locations, the use of storytelling to coordinate and persuade the career wheel to roll in the right direction often involves describing attributes that the artist already has.

5.3 An artist manager's checklist

This storytelling function forms part of the branding process for artists, and it often relates to the 'checklist' that some artist managers have for the artists they sign. These checklists are in place because artist managers know that if an artist meets the criteria on their list, then others in the industries will become more interested in working with, and investing in, the artist. I have previously cited (Morrow, 2008)[4] New York-based artist manager George Stein's[5] seven-point list of criteria for the popular music artists he signs:

1) The songs – the music is key ... that alone will knock millions of people off the starting blocks because they can't write.
2) They have to be able to sing, which is another separate talent.
3) They have to be able to perform, which is different to singing.
4) A singer/songwriter needs to be able to play an instrument and be a good musician, which is another separate talent.
5) They have to be focused, smart and ambitious. ... They really need to prime themselves and be smart, not just focused. I mean there are people who are focused who are just real dumb. They have to 'get it' to actually devote themselves to 'it'.
6) They have to be good-looking ... maybe not beautiful, because when I say good-looking I mean interesting looking. They have to have a 'look'.

7) They have to be young. With other professions the clock is not clicking to the same extent, though unfortunately it does not work like that for the artist.

(Adapted from Morrow, 2008: pp. 6–7)

This list is specifically designed for signing artists to major recording labels in the US. Of course, many other factors can be involved in building careers in the creative and cultural industries. However, in response to claims that there are exceptions to his list, Stein noted:

Everyone is going to think of exceptions to this, but they are exceptions. What I tell my class, and what I practise myself, is that if you are missing any one of these things you are really swimming against the current. And your time and your investment is too valuable, you have to think about this.

(Cited in Morrow, 2008: 6)

The storytelling process within the creative and cultural industries – with which artist managers engage – therefore often involves a story of youth. This is because, initially at least, most of the attributes in checklists such as Stein's have to be in place before the manager will sign the artist; they know that the people with whom they will seek to partner will have a similar mindset. Within the context of the creative and cultural industries, the focus on youth of sectors such as popular music is similar to that of other performing arts such as (some genres of) dance, and it is perhaps the saddest point on Stein's checklist. The need to possess these attributes at a very young age raises issues for artist development. For some artist managers, artists – rather than having time to develop these abilities and attributes – simply need to meet these criteria already.

In addition to artist managers facilitating and perpetuating such a youth orientation within the creative and cultural industries, this focus on young artists is often also enshrined within cultural policies, the criteria for some arts funding initiatives, and also within the statutes of some taxpayer-funded broadcasters (Harris, 2016; Lee and Lee, 2016; O'Brien and Donelan, 2008; Røyseng, Mangset and Borgen, 2007; Wilson, 2014). Within the Australian popular music industries, for example, this youth orientation revolves around the youth broadcasting (and taxpayer-funded) media outlet triple j.[6] Being added to the radio playlist of youth-related taste-making outlets such as triple j[7] will often also feature on the checklists of Australian artist managers in popular music. This requirement of youth (for previously unknown artists at least) often sits alongside another common point on artist manager's checklists within the field of popular music: the political orientation of the artist. Some artist managers feel that they need to agree with the artist's politics before they will sign them because they know that, if successful, they will help the artist to build a platform from which they can express their political views. As one interviewee, highly successful Toronto-based veteran artist manager Bob, observed, 'So I think what's really happening now is that artists are seeing the

power they can have' (Interview 8). This is particularly the case when the artist's work is also designed to facilitate the instrumental purpose of instigating social or political change in some way. As Hesmondhalgh and Baker (2011) noted, artists, or in their words, 'cultural producers' (165), are very powerful because they constitute a small number of people who, through their work, communicate with many other people. And when this reach is combined with the prestige attached 'to artistry and knowledge, this gives creative workers influence' (165).

5.4 Moving people to action

In their work concerning the role of storytelling in fundraising efforts for not-for-profit organisations and social and political causes generally, McCrea, Walker and Weber (2013) discussed the process of 'connecting through narrative' (n.p). Their work is useful here to shed light on the storytelling processes that are required throughout all stages of an artist's career trajectory. Perhaps because the creative and cultural industries are so youth oriented, the process of storytelling gains in relevance as artist managers attempt to help artists sustain careers post their youth. McCrea et al. (2013) said that 'learning how to make deep connections with the emotional needs of potential partners is the key to growing the resources available to your favorite cause' (n.p). For them, leadership is about moving people to action, and they noted that storytelling is an ancient way of doing this, because:

1) Stories deal with the universal currency of experience.
2) Stories touch our senses. A well-designed story appeals to each of the physical portals through which we perceive the world – the senses of sight, sound, touch, smell and taste.
3) Stories involve challenge, choice, and resolution. Every good story depicts one or more humans caught up in challenge, forced to make a choice, and experiencing an ultimate resolution – good, bad, joyful or tragic.
4) Stories teach us about ourselves and about the world.

(n.p.)

Radbourne and Watkins (2015) used the work of McCrea et al. (2013) in their monograph concerning philanthropy and the arts in a way that resonates with this book. Both of these texts engage with Ganz's (2010) notion of a 'public narrative', which is a story that motivates potential partners in a project to act. Radbourne and Watkins (2015) noted that according to Ganz, 'the public narrative has three crucial elements: the story of self, the story of us, and the story of now' (n.p). These three elements are relevant to artist management processes.

First, 'the story of self' relates to the identity of the artist, why they are motivated to do what they do and what their unique talents are. Second, 'the story of us' relates to the shared values and passions of potential partners, including fans, who will help to build the artist's career. Third, 'the story of now' brings the public narrative up to date and speaks to immediate needs. It is relevant to the process of

obtaining funding through crowdfunding campaigns and also through more traditional means, such as advances from record labels and song publishers. It also invites the listener to become 'an active part of the living "we" embodied in the story' (McCrea et al., 2013: n.p.).

5.5 B2C and B2B storytelling

Within the creative and cultural industries, artist management involves the creation and facilitation of stories concerning artists in two primary ways. First, artist management involves the process of story building through the traditional media as well as via social media (with the help of a publicist and/or a social media strategist) in order to help articulate and shape how the artist's brand is understood directly by the audience/fans (business-to-consumer/B2C). This relates to the process of 'fascinating' an audience and may simply involve helping potential audiences to understand the artist's ability to fascinate. As Watson (2013), a highly successful Australian artist manager, noted: 'At the end of the day, successful artists are the ones who can fascinate a crowd. Successful careers will be made by artists who continue to have the ability to fascinate.'

Second, artist management also involves the narrative-building process within the business as it relates to deal structures that maximise the value of the copyright involved. This second level relates to how the artist's brand is understood amongst the business people and funding agency decision makers (and other intermediaries) who constitute a particular sector of the creative and cultural industries (business-to-business/B2B).

With regard to the first level – B2C – narrative building may relate to an artist's association with other, often more famous, artists, to 'international success' stories – particularly for artists from smaller territories such as Australia and New Zealand who are attempting to access larger territories such as the US – or to 'coolness' narratives that perpetuate and add to an artist's subcultural capital (Thornton, 2006). On the second level – B2B – storytelling typically relates to who an artist manager or artist knows, or has access to, who can help to do a deal(s) that will potentially increase the exchange value of the artist's copyright and income streams associated with these rights as well as other revenue streams such as live performance. B2C and B2B narratives are interrelated, and in the digital age, for the B2B narrative to be meaningful, there needs to be a B2C story to tell first (see Chapter 3 of this book).

An example of a typical B2B narrative structure in the music business was featured in my analysis of artist management practices in the music industries (Morrow, 2008). I discussed three methods that artists and artist managers from smaller territories such as Australia use to release recordings in the US or the UK:

(1) Signing directly to an American or British independent or major label,
(2) Sourcing a deal with a multinational out of a smaller market and having it released in the United States or United Kingdom through an intercompany

license agreement, or (3) Licensing or assigning the right to exploit the copyright in a pre-existing record to a label in the United States or United Kingdom.

(5)

Albeit in 2008, I concluded that obtaining resources and backing were the central concerns in relation to these three methods of releasing recordings (Morrow, 2008). The B2B storytelling processes and associated discourse, particularly amongst artist managers,[8] typically prioritised the principle that signing directly to an American or British independent or major label was the most viable option in such cases. This was because, first, they own the record and their A&R[9] staff have their egos and reputations attached to it, and second, there is a longer-term relationship and commitment to the project. These two points meant that this option would lead to the strongest backing in the larger territory and thus maximise the career-building potential of the deal being done. Again quoting New York-based artist manager George Stein, I noted (Morrow, 2008) that in relation to the latter two options, 'they'll only do it if there is already a buzz, but not if they have to create it' (9). However, this point, that there already needs to be a 'buzz' around a particular artist for dealmaking processes to be triggered, has become even more important in the digital age, with 'buzz' being defined in this context as many people talking about and telling the story of a particular artist. Furthermore, in the age of social media, statistical data and other evidence can be provided to substantiate claims that there is a buzz around a particular artist. This fact has had an impact on the aforementioned dealmaking options.

For example, in my previous co-written work concerning career building in the music industries (Hughes et al., 2016), we stated that there has been a shift from a linear process (artist-industry-fan) to a circular one (artist-fan-industry-artist-fan-industry). During the time of linear dealmaking and career-building processes, B2B storytelling for the most part needed to take place before B2C storytelling could occur on a sufficient scale to create a sustainable career. This is because artists and their management, as a first step, needed to access the gatekeepers who controlled the distribution and broadcast channels required to access consumers' attention. Due to the impact the internet has had on artist management processes, this is now the other way around. The B2C storytelling process needs to take place first, or at least start to a certain extent, before the B2B storytelling process will be triggered. This latter storytelling process is then needed to further build the (already building) audience for the artist's work. Discussing this shift, Watson (2016) said:

> The first steps are usually directly from artist-to-fan; most gatekeepers now typically *follow the fans* when it used to be the other way around. We thus live in a world of 'build it and they will come', with the still-coveted high rotation radio spins and magazine covers increasingly going to artists who have already proved online that their creations are made of the right stuff. This is bad news for anyone sitting around hoping some Svengali will swoop out of the clouds

and make them a star, but it is fantastic news for hard-working artists who are keen to engage directly with their audience. It's also good news for music consumers who have more access to more music, more affordably than ever, but it's mixed news for the people who used to be gatekeepers.

(ix)

Some may argue that this has taken some of the romance, power and ego out of being an artist manager, or an A&R staff member at a record label. This is because it is less about gambling on one's instincts in an attempt to 'pick a winner' and more to do with reacting to hard evidence that an artist is building connections with an audience. Watson (2016) continued:

> This iterative discovery process obviously means that industry intermediaries no longer have to just back their instincts – instead they can support whatever is already generating an exponential adoption curve within their audience. As a result, garnering the support of such powerful people now typically depends on pointing to proof of early reactivity rather than on appeals to gut feel or longstanding relationships.
>
> (ix)

While the egos of artist managers and other gatekeepers used to benefit (or not, if unsuccessful) from their seemingly omniscient role of picking and gambling on 'winners', such gatekeeping roles have morphed into simply enabling and amplifying the audience 'likes' that have initially been generated by artists themselves (ibid.). In this way, artist managers and other intermediaries have begun to operate even more like venture capitalists in other fields in that they are looking for a startup to demonstrate exponential growth before they will invest (see Chapter 3).[10] In any case, although the timing of the B2C and B2B storytelling and story building processes have been inverted in the digital age, impacting on the well-being, and egos, of gatekeepers such as artist managers, these storytelling and building processes themselves are still extant and required.

5.6 Storytelling etiquette

It is therefore useful here to examine the etiquette relating to storytelling and relationship-building processes in the creative and cultural industries within the various channels for direct communication. One way to conceptualise artist management is that it involves building a social sculpture that is constituted by the network of partners around the world who are contributing to the artist's career, and a story associated with this social sculpture, that connects cities. In order to understand how this is done, it is important to understand the etiquette of who can talk to whom in a particular industry sector. As a general rule, and depending on confidentiality clauses within the various agreements between the parties, this etiquette is such that: artists are allowed to talk about their work and business to other

artists; agents are allowed to talk to other agents; managers are allowed to talk to other managers; and entities such as record labels often only talk to each other through their lawyers because the agreements they have with artists involve copyright and therefore copyright law. In other words, etiquette prevents a manager talking directly to another manager's artist client or an agent talking directly to another agent's client. This is why there are attempts to include clauses like the following in codes of conduct in creative and cultural industries sectors such as music:

14) Music Managers shall respect the integrity of other managers in their relationships with their artists and not actively interfere with same.
15) If approached by an artist who was previously the client of another manager, a manager shall confirm that the artist has fulfilled his, her, or their legal obligations to the previous manager before entering into a management relationship with the artist.

(Music Managers Forum, Australia; see Appendix C)

Thus all communication should be channelled through the appropriate representative. While this etiquette may be a loose one – because an artist may simply bump into a manager or agent who is not their own at a conference, a festival or a show – it exists in the music industries due to the issue of poaching, or at least because of 'perceptions' of poaching from an agent's or an artist manager's perspective.

When an artist is able to walk away from a deal, there is potential for poaching to take place. For instance, live performance booking agents typically only do 'handshake' deals with their clients because in most jurisdictions they are not required to have a written agreement if they are commissioning 10 per cent or less of their client's live performance income.[11] Likewise, a typical artist management agreement is in the form of a service provision agreement.[12] It is easier for an artist to walk away from either a handshake agreement or a written service provision agreement with a manager than it is for them to get out of a commercial agreement with a record label or a song publishing company relating to copyright. Thus, etiquette exists to protect the interests of these service providers.

However, discussing the validity of the concept of 'poaching', highly successful New York-based artist manager in popular music Daniel noted:

> Poaching, you know it's an interesting word. Because if you look at it from an artist's point of view, it's really their choice. They get to choose who their manager is or to whom they are bound. It depends on what their agreement is with their manager. If they promise somebody years of income in return for an investment of time and energy at the beginning, then you know they have that obligation … I mean successful artists have to pay people in real-time cash based on touring or touring income or other things. So to me, in those situations, if an artist is paying me and I'm getting paid for my time and then they want to leave, I mean, emotionally I'm gonna be very hurt and I may try

[to] talk them out of it, I may get depressed. But I don't think it should be illegal. I just think that ultimately it's their choice. I hope they make the right choice.

(Interview 14)

Therefore while an artist manager may argue that the issue of poaching exists, an artist may simply state that it is their choice who their service provider is. Nevertheless, this etiquette between artists, managers and agents exists for the purposes of respectfully managing the relationships involved in career building.

This etiquette also means that in building a 'buzz' by facilitating story-building processes on both B2C and B2B levels, artist-to-artist communication is a trump card. This is because the etiquette is such that artists are allowed to talk to other artists. And if an artist wants another artist to tour with them or to co-write a song with them, or if they want to generally champion another artist, the artist's representatives, such as their agent and their manager, will simply react to this for the obvious reason that they represent the artist. Within the creative and cultural industries, this communication channel is also known by way of the truism that 'talent finds talent'. A classic example of this involves New York-based artist manager Danny Goldberg's signing (along with his co-manager John Silva) of the band Nirvana simply because another client of his – the band Sonic Youth, led by singer Kim Gordon and her husband and lead guitarist Thurston Moore – showed enthusiasm about the band. As Goldberg (2008) stated:

> Sonic Youth was continuing to discover and showcase new bands, which is how John and I met Nirvana. It has become clear to me that Kim and Thurston had their finger on the pulse of postmodern rock and roll, and when I heard their enthusiasm for Nirvana I knew we should try to sign them.
>
> *(177)*

Goldberg was so trusting of Thurston Moore's storytelling about Nirvana that he signed them to management well before he saw them perform live.

> I finally saw Nirvana in concert when they were booked as the opening act for Dinosaur Jr. at the Palace. Standing in the back by myself on the periphery of the audience I was completely overwhelmed. … I shivered at the thought of how casually I had taken the signing of them. What a lucky break!
>
> *(182)*[13]

There is therefore an uneven power relationship in the storytelling processes that form part of an artist's management. An artist championing the story of another artist is more powerful than a representative championing the story of an artist. At showcase events, music trade fairs and conferences such as South by Southwest (SXSW) in Austin, US, BIGSOUND in Brisbane, Australia, Canadian Music

Week (CMW) in Toronto, Canada and The Great Escape in Brighton in the UK, 'building a buzz'[14] around a particular artist can be defined as many people telling the story of a particular artist, people who are not simply just the artist or their representatives. And amongst this immense amount of discourse, the opinions of artists about other artists often carry more weight. This is particularly the case in the digital age, as some have argued that there has been a shift in the power balance within the industries in favour of artist managers and artists and away from major record labels (see Hughes et al., 2016).

An example of this is the British band Mumford & Sons curating their own festival under the brand name Gentlemen of the Road and setting up their own record label under the same name. Discussing this shift in power, and the question of whether a code of conduct should be established for artist managers through the IMMF because of the shift, Bob (successful Toronto-based veteran artist manager) noted:

> It's obviously true that there is a bigger focus going to be placed on managers. But on the other hand, it's very difficult for me to say that there could have been any bigger focus than the one that you know, Colonel Tom Parker[15] had, or Albert Grossman[16] had, or Peter Grant[17] had, or any of the famous managers in the past had on them. So I guess in general it's true that managers may well be picking up some of the slack that was left with the major record company. But then nobody ever really ended up working with a major record company who didn't have a manager anyway; there's very few examples. So there's always managers there anyway. So I think the real shift of power is to the artists. There should be an artist code of conduct I think. I think managers are minor players in the scenario you're unfolding, to be truthful. I mean the real fact is it's going to be artists that are going to be the power. So they should have a code of conduct. Good luck.
>
> *(Interview 8)*

This shift in power to artists can be understood partly as a result of the different equity position artists can, and necessarily have to, achieve in the digital age through the circular career development model (discussed in Chapter 3). Considering their project to be a startup and having a direct relationship to their audience that they and their management control puts them in this position.

5.7 Case study: SXSW favours the storytellers

Within the broader context of the creative and cultural industries, this shift in power to artists is not unique to musicians. The process of storytelling at, and then subsequently about, events such as SXSW is something that film-makers engage with as well. An example of storytelling about such an event was provided by Catherine Fargher,[18] a Sydney-based film-maker, scriptwriter and transmedia game developer and a participant in this study:

In America I saw quite a lot of the inventor-entrepreneurs and I got a real sense at South by Southwest that it was almost like if you'd been in America at the turn of the nineteenth century. There would have been Ford inventing his motor car assembly lines and Edison with his light bulb. It felt like going to South by Southwest at the turn of this century, 2010s, that you were seeing the same entrepreneurial spirit around the information revolution. We've got the industrial revolution, the information revolution. But there were a whole lot of people coming up with new ideas and there was a whole lot of money floating around those ideas – there were people in top hats spruiking their wares about Bitcoin;[19] there were people showing their wares. It was quite a kooky performative space and much more of a creative space than, say, an academic conference ... It sort of favours the brave and the bold and storytellers and the sellers and the more performative-type people.

(Interview 20)

The insights Fargher gleaned by attending SXSW resonate with the core argument in this chapter: that storytelling is a key process for the management of artists within the creative and cultural industries. Earlier in this chapter I discussed this issue of storytelling in relation to the 'stories of youth' that inform the startup phase of some artists' careers, in ways that are in line with the youth orientation of some sectors of the creative and cultural industries. However storytelling is relevant throughout a career. This is because a specific factor relating to the nature of creative labour, identified by Hesmondhalgh and Baker (2011), is the creative labourer's 'willingness to take the periodic risk of being out of work along with the continual risk of investing in their careers' (Neff, 2005, cited in Hesmondhalgh and Baker, 2011: 122). In this sense, for artists such as Fargher, the startup phase does not exist once in an artistically creative career; this is something that self-managed artists and artist managers have to engage in throughout a career – constantly reinventing themselves and thinking about what else they can do in their attempts to continue to fascinate an audience. This process of continually reigniting an artistically creative career sometimes relates to the discourses of 'creative cities' and to city branding initiatives, creative precincts and arts funding initiatives. Fargher continued:

We've been able to access a lot of R&D[20] money from the Australia Council.[21] They've been great. Altogether we've had $85,000 from them. Three lots. I had a $40,000 new work grant in 2015 ... and I went to South by Southwest as well with that money, so I really had a look at entrepreneurial models over there as well. In terms of agile management and seeing how people were getting things up, that was really influential in my thinking ... At South by Southwest there was a real maker culture and there was a real entrepreneurial culture ... We've slowly been developing all that work to get it up at a really professional level, but at the same time we've been using that maker culture idea. And so I collaborated with a group of game developers that I met at City

of Sydney[22] ... We were really lucky to get a City of Sydney creative precinct office for a really cheap rent – I think it was $400 a month, but between three of us. Dr Egg[23] had a whole space like this, and we were able to run meetings, we were able to bring people in, we were able to start all that consult, but also next door to us we had game developers, new media producers, people who'd been at QUT[24] creative industries, all of these people setting up enterprises. I was probably the oldest person there.

(Interview 20)

In her attempts to sustain her artistically creative career, Fargher has been lucky to benefit from numerous funding initiatives that distribute taxpayer money from various levels of government. At each step she has been able to use these opportunities to create a public narrative (Ganz, 2010) that has then enabled her to obtain further funding.

So far in this chapter, I have discussed the process of 'connecting through narrative' (McCrea et al., 2013) in a positive way. However, in the creative and cultural industries there is also a dark side to storytelling and story building through artist management discourse. This involves a process of 'destroying through narrative'.

5.8 Destroying through narrative

I have argued in this book that artist management is a creative industry function. Underlying this argument is the basic premise – identified by behavioural economists Gino and Ariely (2012) as being shared by much creativity research – that creativity should be stimulated because it generates new solutions, opportunities and ideas and, therefore, should be facilitated. However, these authors ask the question: 'Is creativity always beneficial?' (445). In the context of a discussion of storytelling in the creative and cultural industries, the answer to this question is 'no'; creative ability can also be used to engage in, and justify, unethical behaviour. This is because, as Gino and Ariely noted, there is a dark side to creativity in that original thinkers can be more dishonest.

In Chapter 4, I argued that divergent thinking, openness to ideas and intrinsic motivation are key to the managerial creativities of a freelance contemporary dancer. These relate to planning (or a purposeful lack thereof), and they correlate with the agile management methods that were discussed in Chapter 4. Divergent thinking was relevant to the analysis of artist management and artist self-management in that chapter because it is a thought process that involves identifying multiple solutions to a problem, or simply multiple and diverging ideas and possible directions for artistically creative work as well as for managerially creative ideas (see Scratchley and Hakstian, 2001; Runco and Acar, 2012). Furthermore, as was discussed in Chapter 4, in their work concerning managerial creativity, Scratchley and Hakstian (2001: 380) advocated for divergent thinking and 'openness'. While this cognitive ability is fundamental to managerial creativity, when faced with ethical

dilemmas, divergent thinking can also be used to justify unethical behaviour. As Gino and Ariely (2012) noted: 'Typically operating together, divergent thinking and cognitive flexibility help people find creative solutions to difficult problems. ... One such context is provided by ethical dilemmas' (446).

Through their research into behavioural economics, these researchers found that their subjects typically behaved dishonestly enough to benefit from their unethical behaviour, 'but honestly enough to maintain a positive self-concept' (ibid.); in other words, most people cheat (but only a little bit). They found a positive correlation between creativity, including short-term creative mindsets as well as creative personalities, and dishonest behaviour when people are faced with ethical dilemmas. This is because divergent thinking and openness positively correlate with moral flexibility, and therefore creativity promotes dishonesty by increasing one's ability to self-justify bad deeds. The fact that these authors found that most people cheat, if only a little, suggests that when telling stories for the purposes of making headway in the creative and cultural industries, many artist managers and self-managed artists 'fudge' the stories they tell – but not as much as they possibly could have.

In fact the artist managers interviewed for this project consistently characterised artist managers as being mavericks. These characterisations are in line with the 'heroic' model of creativity, rather than the 'structural' model outlined at the start of this chapter, and while the mythology of individual genius has continued to dominate business thinking generally (see Bilton, 2010), the fact that artist managers deal with artistic creativity directly seems to exacerbate the generation of heroic, maverick – slightly on the wrong side of the law – self-images by artist managers. For example, Bob (successful Toronto-based veteran artist manager) noted in response to a question regarding whether a code of conduct should be established for artist managers:

> I don't see how the application of a code of conduct would be applied to the group of people that I have met in my last 50 years in the music business to be frank, if you want to know the truth. I mean I just – it's a pretty unruly bunch. The best of them I think sort of lived outside the law. But as Bob Dylan would say, to live outside the law you must be honest. So I don't equate codes of conduct with honesty. I tend to think that they have great codes of conduct in politics, and there isn't a greater dishonest bunch than politicians.
>
> *(Interview 8)*

Gino and Ariely (2012) pointed out that artist managers are not the only ones to behave unethically, and their work concerning the link between dishonesty and creativity/innovation has important implications for fields as diverse as education, business and policy: 'We are often surprised to learn that successful and ingenious decision makers in these [other] contexts have crossed ethical boundaries' (455). The difference with regard to the music business, as a specific sector of the arts and

cultural industries, is that such a crossing of ethical boundaries is romanticised. This is reflected in Toronto artist manager Bob's comments regarding efforts to curb such behaviour:

> I think to some degree, what's happening is we're beating the colour out of the whole thing. So to some degree everything's getting less interesting. So to some degree I like those old characters from the '50s and '60s who probably did everything wrong but ended up creating a world where some of the best music ever done was done, and people still love that music.
>
> *(Interview 8)*

Such a tendency to romanticise the 'colourful' characters of the past serves to reinforce problematic stereotypes of artist managers (see Morrow, 2013). This discourse arguably stems from the legacy of the record business' origins in the US, which, at its most extreme, literally involved connections between pioneering entrepreneurs in this sector and the Mafia (see Dannen, 1991). This connection partly existed because such entrepreneurs were 'making it up as they went along' and partly because the business was simpler then. In the broadcast era, there was a scarcity of distribution outlets for music and, as a result, an abundance of audience attention directed towards these scarce outlets (Anderson, 2006). Therefore if you could force, bribe, threaten and manipulate the decision makers who controlled these outlets, you could have one of your artist's recordings broadcast to a large audience, thus maximising the potential for the song to become a 'hit'. Thankfully, such behaviour is not effective in the digital age because there is now an abundance of distribution outlets for music and, therefore, a scarcity of audience attention for any one outlet. And yet the tendency to justify unethical behaviour as a means to an end still pervades discourse concerning the artist manager's role and any potential regulation of this role. Bob continued:

> You know after a while I get tired about hearing about, you know, how shitty the major labels are and how perfect the artist label is. I want to hear the music. Show me the new Bob Dylan; show me the new Beatles. Show me the results and then we'll take a look at the blood count. Let's not count the blood first.
>
> *(Interview 8)*

This tendency to reinforce the idea that successful and ingenious decision makers in the music industries have crossed ethical boundaries in the past, through the telling of colourful 'war stories' about them, unfortunately makes it easier for those who engage in the process of creating false stories and slanderous rumours about their competitors to gain an advantage. For example, the process of 'destroying through narrative' may involve a booking agent spreading a rumour that a competing agent's tour is not selling well, so that venue bookers will favour their clients in the future. The agent who is the victim of such a negative story/rumour may then

encourage the manager or promoter of the tour to take out a full-page advertisement in the music-related print media in order to counteract the effect the story is having.

The effects of such a process of destroying through narrative are compounded by the claim made by one interviewee that it is difficult to take legal action in this sector of the creative and cultural industries. Discussing the role a potential code of conduct for members of the IMMF could play in facilitating ethical behaviour, and whether such a code could be enforceable, Ben (Toronto-based artist manager in popular music) noted:

> I think that it is socially enforceable for sure. And to be honest in some respects that has more of a bite to it than a legal one. You know I mean even though there are laws that need to be followed and laws of business, and while there's less now, over the years there have been all kinds of shady managers out there. These managers just continue to move from band to band and do the same shady practices they've always done. And yes maybe a band sues them or maybe they get a black mark or whatever, but there is always one more band that is going to fall into that trap. A band that didn't hear about it or didn't know about the legal case … In most situations legal cases are very hard to pursue, and even after you've pursued them and you win, generally there's not enough money left to cover the damages anyway. So the lawyers are the ones who win.
>
> *(Interview 5)*

Despite Bob's perspective (quoted above) and his tendency to look favourably on the 'colourful' artist management practices of the past, Ben argued that he has witnessed a change in the way in which stories are shared amongst artist managers and other participants in this sector of the creative and cultural industries:

> I've seen management change a lot in the time that I've been doing it. When I first got into it, it was very much the 'old days', and I've seen it change a lot in the last seven years. I think the fact that everyone is more open and communicative in general has dissipated some of the more shady characters because if you're more open and share stories about your experiences as a manager with other managers or as a manager with other bands, or whatever the case may be, then people advise each other that 'you may want to avoid that person' or 'don't sign an agreement that looks like that' or 'don't fall into this trap'. I think what that really does is that it empowers the artist and it empowers the good managers, as opposed to power and balance, which is historically how our business has operated, you know. Ten plus years ago there was a lot more shady business going on.
>
> *(Interview 5)*

In this sense, so-called shady business practices can also be destroyed through narrative – and this represents a positive change. The stereotype of the artist

manager is a problematic one (Morrow, 2013), and like any stereotype, it is unfair when negative characterisations are used to make generalisations concerning the work of artist managers within the creative and cultural industries. As Bob noted: 'What percentage of people are bad managers? A small percentage, probably less than there is in politics, used car salesmen, grocery store owners and almost everything. Certainly less than, say, police' (Interview 8).

5.9 Conclusion

In this chapter I have argued that storytelling is a key process for the management of artists within the creative and cultural industries. I discussed this practice of storytelling in relation to the 'stories of youth' that inform the startup phase of some artists' careers, in ways that are in line with the youth orientation of some sectors of the creative and cultural industries, as well as in terms of this being a process that self-managed artists and artist managers have to engage in throughout a career – constantly reinventing themselves and thinking about what else they can do in their attempts to continue to fascinate an audience. This process of continually reigniting an artistically creative career sometimes relates to the discourses of 'creative cities' and to city branding initiatives, creative precincts and arts funding initiatives. And while an artist and/or artist manager may have a base in a particular 'creative city' (Florida, 2002, 2014), artist management is often transnational as it involves the interrelationships between multiple 'creative cities' and the process of articulating these connections through the creation of a story that can be told to potential audiences through the various means that have been outlined in this chapter. In this way art is a story between places, rather than being centralised in one place, and this is what artist managers are managing.

Notes

1. Storytelling creativities relating to geographic locations can be added to the broader list of 'human capital career creativities' identified by Bennett and Burnard (2016). These authors used the theoretical lenses provided by the work of Bourdieu (1986) to examine the multiple human capital career creativities that graduates of higher education institutions need to be able to create, and then sustain, careers in the creative and cultural industries. The notion of storytelling creativity posited here most closely correlates with Bennett and Burnard's (2016) community-building creativity and career-positioning creativity.
2. Some international territories carry more weight in this regard, reflecting their size and influence. For example, interest in the US and the UK will spark interest in Australia due to the size and influence of these territories. However, interest in Australia may not generate interest abroad due to the size of this territory.
3. Artist management and artist self-management therefore involve a lot of very carbon-intensive activities such as flying between cities and countries. For more information regarding the environmental impact of such roles within the creative and cultural industries, as well as the level of awareness of this impact and opportunities for improvement in terms of sustainability and climate action, see Berry, Wynne and Riedy (2014).

4 Portions of this chapter were previously published as: Morrow, G. (2008) 'Creative Process as Strategic Alliance', *International Journal of Arts Management*, 11, 1: 4–15. They have been reused here with kind permission from the *International Journal of Arts Management*.
5 George Stein is best known for his management of the late Jeff Buckley. He is an artist manager and attorney based in New York City.
6 triple j forms part of the Australian Broadcasting Corporation (ABC) and is primarily a youth-oriented radio station on the FM band. It also has a strong web presence with competitions such as 'triple j unearthed' and the annual 'triple j Hottest 100' listener poll. It therefore also promotes and distributes music online by way of a meritocracy. It has an interesting relationship to the creative and cultural industries in Australia because it is funded by the taxpayer and, therefore, independent of these industries. At the same time, however, it is one of the most important taste-making outlets for popular music in the country. triple j broadcasts nationally, and therefore in the context of this chapter, it plays a key role in facilitating the inter-city, inter-state and transnational 'stories' concerning artists' careers.
7 triple j's branding policy requires lowercase lettering to be used.
8 It is important to note here that this type of discourse is specifically associated with artist managers in music and not with people working at major recording labels. This is for obvious reasons: major labels from smaller territories such as Australia want to sign the artist's copyright for the world to maximise its value to them. They would then release through option 2; that is, by way of an intercompany licence agreement with their affiliate in the larger territory.
9 A&R stands for Artists and Repertoire. A&R staff are responsible for talent scouting as well as the overall artistic development of recording artists and songwriters at a record label or music/song publishing company.
10 While this is being couched here as somewhat of a dramatic change in the process of investing in artists, Watson (2013) noted that this is similar to the way in which some entrepreneurs in the past used live performance to gauge audience interest; they would 'walk into a venue and look left, then look right, and if they couldn't see the walls of the venue past the crowd they would sign the band'.
11 This is the case in the Australian state of New South Wales, for example.
12 Because artist managers are typically service providers, in practice, artists can walk away from artist management agreements with no long-term consequences relating to the ownership and control of their copyright. They just need to compensate the manager as per the 'sunset' (post-termination) clause in their management agreement.
13 The story of Nirvana is an immensely tragic one as it concerns lead singer Kurt Cobain's heroin addiction and suicide at the age of 27. He thus joined the '27 club' of popular music artists who have died at age 27, such as Jimi Hendrix, Janis Joplin, Brian Jones, Jim Morrison and Amy Winehouse (amongst many others).
14 This is the vernacular of this type of event. Note that there are many other events of this type other than those listed here.
15 Colonel Tom Parker is famous for having managed Elvis Presley.
16 Albert Grossman is famous for having managed Bob Dylan, Janis Joplin and The Band.
17 Peter Grant is famous for having managed Led Zeppelin.
18 Unlike the other participants in this chapter who were interviewed on conditions of anonymity, Fargher gave consent for her identity to be disclosed.
19 Bitcoin is a digital payment system that is known as a 'cryptocurrency'. It was designed so that 'anyone can send or receive any amount of money with anyone else, anywhere on the planet, conveniently and without restriction' (Bitcoin, 2017).
20 R&D stands for Research and Development.
21 The Australia Council for the Arts is the Australian government's arts advisory and funding body. It distributes a pool of taxpayer money to various initiatives, organisations and projects that have a role in facilitating artistic creativity in society in some way. This is done via peer review so that the distribution of funding is at 'arm's length' from the Australian government.

22 In this context, Fargher is using the term 'City of Sydney' to refer to the local level of government and to the City of Sydney Council's initiatives to facilitate artistic creativity within the city through the establishment of various creative precincts.
23 Dr Egg is the name of Fargher's production company.
24 QUT stands for Queensland University of Technology.

References

Anderson, C. (2006) *The Long Tail*, New York: Hyperion.
Bennett, D. and Burnard, P. (2016) 'Human Capital Career Creativities for Creative Industries Work: Lessons Underpinned by Bourdieu's Tools for Thinking', in R. Comunian and A. Gilmore (eds), *Higher Education and the Creative Economy Beyond the Campus*, Abingdon; New York: Routledge, pp. 123–142.
Berry, F., Wynne, L. and Riedy, C. (2014) *Changing Tune: Scoping the Potential of the Australian Music Industry to Address Climate Change*, Sydney, Australia: Institute for Sustainable Futures, UTS.
Bilton, C. (2010) 'Manageable Creativity', *International Journal of Cultural Policy*, 16, 3: 255–269.
Bitcoin (2017) 'Getting Started with Bitcoin'. Online: <https://www.bitcoin.com> Accessed 4 September 2017.
Bourdieu, P. (1986) 'The Forms of Capital', in J. Richardson (ed.), *Handbook of Theory and Research for the Sociology of Education*, New York: Greenwood, pp. 241–258.
Csikszentmihalyi, M. (1996) *Creativity: Flow and The Psychology of Discovery and Invention*, New York: HarperCollins.
Csikszentmihalyi, M. (2014) *The Systems Model of Creativity: The Collected Works of Mihaly Csikszentmihalyi*, Dordrecht: Springer.
Dannen, F. (1991) *Hit Men: Power Brokers and Fast Money Inside the Music Business*, Reprint edition, New York: Vintage.
Florida, R. (2002) *The Rise of the Creative Class: And How It's Transforming Work, Leisure, Community and Everyday Life*, New York: Basic Books.
Florida, R. (2014) *Rise of the Creative Class – Revisited: Revised and Expanded*, New York: Basic Books.
Frascogna, X. and Hetherington, L. (1997) *This Business of Artist Management: A Practical Guide to Successful Strategies for Career Development in the Music Business for Musicians, Managers, Music Publishers and Record Companies*, New York: Billboard Books.
Ganz, M. (2010) *Why David Sometimes Wins: Leadership, Organization, and Strategy in the California Farm Worker Movement*, New York: Oxford University Press.
Gino, F. and Ariely, D. (2012) 'The Dark Side of Creativity: Original Thinkers Can Be More Dishonest', *Journal of Personality and Social Psychology*, 102, 3: 445–459.
Goldberg, D. (2008) *Bumping Into Geniuses: My Life Inside the Rock and Roll Business*, New York: Gotham.
Harris, A. M. (2016) *Creativity, Religion and Youth Cultures*, London: Routledge.
Hesmondhalgh, D. and Baker, S. (2011) *Creative Labour: Media Work in Three Cultural Industries*, Abingdon; New York: Routledge.
Hughes, D., Evans, M., Morrow, G. and Keith, S. (2016) *The New Music Industries: Disruption and Discovery*, Cham, Switzerland: Palgrave Macmillan.
Lee, S. H. and Lee, J. W. (2016) 'Art Fairs as a Medium for Branding Young and Emerging Artists: The Case of Frieze London', *Journal of Arts Management, Law, and Society*, 46, 3: 95–106.
McCrea, J., Walker, J. and Weber, K. (2013) *The Generosity Network: New Transformational Tools for Successful Fund-Raising*, New York: Deepak Chopra.

McIntyre, P. (2003) *Creativity and Cultural Production: A Study of Contemporary Western Popular Music Songwriting*, PhD thesis, Macquarie University, Sydney.

Morrow, G. (2008) 'Creative Process as Strategic Alliance', *International Journal of Arts Management*, 11, 1: 4–15.

Morrow, G. (2013) 'Regulating Artist Managers: An Insider's Perspective', *International Journal of Music Business Research*, 1, 4: 9–35.

O'Brien, A. and Donelan, K. (2008) *The Arts and Youth at Risk: Global and Local Challenges*, Newcastle upon Tyne, UK: Cambridge Scholars Publishing.

Radbourne, J. and Watkins, K. (2015) *Philanthropy and the Arts*, Carlton, Vic.: Melbourne University Publishing.

Røyseng, S., Mangset, P. and Borgen, J. S. (2007) 'Young Artists and the Charismatic Myth', *International Journal of Cultural Policy*, 13, 1: 1–16.

Runco, M. and Acar, S. (2012) 'Divergent Thinking as an Indicator of Creative Potential', *Creativity Research Journal*, 24, 1: 66–75.

Scratchley, L. S. and Hakstian, A. R. (2001) 'The Measurement and Prediction of Managerial Creativity', *Creativity Research Journal*, 13, 3–4: 367–384.

Thornton, S. (2006) 'Understanding Hipness: "Subcultural Capital" as Feminist Tool', in A. Bennett, B. Shank and J. Toynbee (eds), *The Popular Music Studies Reader*, Abingdon; New York: Routledge, pp. 99–105.

Watson, J. (2002) 'What is a Manager?' in M. McMartin, S. Eliezer and S. Quintrell (eds), *The Music Manager's Manual*, Sydney: The Music Managers Forum (Australia), pp. 1–11.

Watson, J. (2013) Keynote presentation, BIGSOUND Conference, Brisbane, 12 September.

Watson, J. (2016) 'Foreword', in D. Hughes, M. Evans, G. Morrow and S. Keith, *The New Music Industries: Disruption and Discovery*, Cham, Switzerland: Palgrave Macmillan, pp. v–xi.

Wilson, C. (2014) 'Youth, Radio and Australian Popular Music Policy', *Perfect Beat*, 14, 2: 100–119.

6

THE ARTIST–ARTIST MANAGER RELATIONSHIP

Agile by default

6.1 The specificity of artist management labour

As I discussed in the introduction to this book, within the context of organisational, business and management studies (OBM), artist management within the creative and cultural industries is unique because quite often managers work *for* their artists. Whilst artist management can be defined as a form of group creativity, the managerial creativities within this 'group' are for the most part subordinate to the artistic creativities, and to the artist. The uniqueness of artist management stems from this subordination to artistic creativities and the fact that such symbolic creativities 'cannot be reduced to set rules or procedures' (Hesmondhalgh and Baker, 2011: 84). This is why 'creative management is unlike the top-down inflexible supervision found in many other industries' (84), and as I have argued throughout this book, agile management methods are a good fit for artist management because this form of management is less directive and 'has a muted and accommodating style' (Ryan, 1992, cited in Hesmondhalgh and Baker, 2011: 84).

This chapter therefore outlines how the principle of artistic/aesthetic autonomy structures the artist–artist manager relationship. It also questions the professional autonomy of the artist manager from an ethical perspective. As discussed previously, artist management can be defined as being a form of group creativity that involves the interaction between artistic creativities and managerial creativities. While the uniqueness of artist management stems from its subordination to artistic creativities and the fact that such symbolic creativities are not bound to set rules, managerial creativity and the 'professional autonomy' stemming from this type of creativity *should* perhaps be *more* bound to set rules and procedures.

The fact that, historically, artist managers such as those interviewed for this book (see Chapter 5) have prided themselves on 'making up the rules' as this profession has evolved has important ramifications for the artist–artist manager relationship,

particularly with regard to the issue of trust in this relationship. This chapter therefore explores the relationship between agile management methods, creativity, the law and codes of conduct. As there are often no regulatory frameworks for artist managers[1] and the artist manager's work involves responding to the artistic/ aesthetic autonomy of the artist, agile management processes may lead to some artist managers crossing ethical boundaries. This chapter thus also explores the topic of self-regulation within the music sector of the creative and cultural industries in addition to providing a discussion of top-down, governmental initiatives to regulate artist managers.

6.2 An informal approach to management

Discussing the agile method and, more specifically, the psychology of agile team leadership, Crowder and Friess (2015) noted that this method is

> Geared around more of an informal approach to management, while putting more time, effort, and emphasis on flexibility, communication, and transparency between team members and between the team and management. It promotes an environment of less control by managers and more facilitation by managers. The role of the manager takes on a new psychological role, one of removing roadblocks, encouraging openness and communication, and keeping track of the change-driven environment to ensure that the overall product meets … goals and requirements, while not putting too much control on the ebb and flow of the agile development process. Change is no longer wrong; the lack of ability to change is now wrong.
>
> *(9)*

While I argue in this book that the agile method is an appropriate one for artist managers within the creative and cultural industries to use, there is a balance to be struck between the divergent thinking, openness and flexibility required for managerial creativity and an adherence to some rules and procedures. The question of removing roadblocks is an interesting one in this context, particularly when the roadblock is an ethical boundary. So, what are the rules and procedures for artist managers?

Interestingly, from the perspective of interviewee Mike, a New York-based record label owner, distributor and former Chief Financial Officer (CFO) for a major record label, there basically are none, apart from the requirement to adhere to the common law and to relevant legislation.[2] He therefore prefers to deal with professionals who work in the creative and cultural industries other than artist managers because they lack the extreme professional autonomy of artist managers and are bound to regulatory regimes:

> One of the reasons we liked to do business with the business manager or the attorney, from a business ethics point of view, was that if an attorney does

something that's wrong then he [sic] can lose his attorney's licence. Same thing with a CPA³ – if he does anything wrong then he can lose his CPA licence, and so they don't want to do that because they would lose their livelihood. So you have a situation where a code of conduct already exists and we can depend on that in the way that they are going to do business. Whereas for an artist manager there really is no equivalent code of conduct; some are good, some are bad, some you want to work with and others you don't.

(Interview 10)

While there have been various attempts to regulate artist managers (see Gilenson, 1990; Hertz, 1988; Morrow, 2013) and there are professional organisations for artist managers in music – like the International Music Managers Forum (IMMF) and associated sub-branches in member countries, such as the Music Managers Forum Australia (MMF) and the Association of Artist Managers Australia (AAM) – the issue with any attempt to regulate artist managers in a similar way to lawyers or accountants is that no formal qualification is required for artist managers. This means that artists are often managed by a friend or relative, especially during the startup phase of their career (see Chapter 3); and in some genres of popular music, this has meant that some artist managers have behaved in problematic ways.

6.3 They found me with a gun in my hand

The most colourful example of this issue provided during the course of this research concerned the hip-hop subgenre of gangsta rap during the 1990s. During this time, according to interviewee Mike, who was a CFO at a major record label at the time and based in New York, it was not uncommon for an artist manager to open their jacket to display a gun, and his employer therefore had to employ armed guards:

> It was a difficult business at the time … Hopefully it's a little bit better now because we're not as deeply into it now, but when I ran the offices there, I had to have two guards at the office whenever the office was open. And those guards had weapons. They were armed guards because it was a problem. I used to get calls in the middle of the night: 'I got arrested. They found me with a gun in my hand, in my possession.' And I'd think, 'What do you want me to do? It's 4 a.m. in the morning.' It's a different kind of business. It has cleaned up a little bit, though not much maybe … But it is the nature of the business. Gangsta rap in those days was more gangster than rap. Because that was how they got their credibility, and it's still how they get their credibility. You know the famous story of 50 Cent and his nine bullets or whatever he had in his gut. But that was his claim to fame.

(Interview 10)

Because there are no formal qualifications required for artist managers and artists are often, initially at least, managed by a friend or relative, artist management does often feature a more informal approach to management; and when this is coupled with the fact that artist managers are responding to the artistic/aesthetic autonomy of the artist, artist management is agile by default. While in other fields the agile method is used to shift managers' mindsets away from 'controlling' towards 'facilitating', the specificity of artist management is such that there is arguably already an emphasis on 'flexibility, communication, and transparency between team members and between the team and management' (Crowder and Friess, 2015: 9). This was evidenced by a high-profile, London-based artist manager, Tom, who noted that 'there is always transparency in a relationship between any manager and his client because there has to be' (Interview 2).

Whilst threatening staff at a major record label with a gun is most definitely inappropriate behaviour, the fact that the artist manager is managing the '*concrete and named* labour of the artist' (Ryan, 1992: 41) – a type of creative labour that 'resists the abstractness and alienation that Marx attributes to pretty much all other work under capitalism' (Hesmondhalgh and Baker, 2011: 84) and that therefore 'causes a constant problem for capitalist businesses' (ibid.) – means that the artist–artist manager relationship is a 'special' and unique one. Discussing the contradiction of the artist-capitalist relationship, Ryan (1992) noted:

> Unlike many other types of workers, capital is unable to make the artist completely subservient to its drive for accumulation. The reason is simple. Since art is centered on the expressive, individual artist, artistic objects must appear as the product of recognisable persons; the *concrete and named* labour of the artist is always paramount and must be preserved. As socially constituted, artists appear to capital as the antithesis of labour-power, antagonistic to incorporation in the capitalist labour-process as *abstract* labour.
>
> *(41)*

This partly explains the aforementioned antagonism between artists and enterprises such as record labels and why, at the time of writing, there were concerns that music streaming services could potentially produce 'fake artists'; fake simply because the music on some of their generic playlists could be produced by music producers who are paid a flat fee by the streaming service (rather than a fee and a percentage of the ensuing royalties) (Deahl and Singleton, 2017). The streaming service could then own the copyright of the recordings and possibly also become the publisher of the songs released under a pseudonym, thus saving a large amount in royalty payments to artists, labels and song publishers. In doing so, the streaming service would be violating the rule that 'artistic objects must appear as the product of recognisable persons' (Deahl and Singleton, 2017).[4] At the time of writing there is no evidence that such services are operating in this way, with market leader Spotify noting: 'We do not own any song rights, we're not a label. All our music is licensed from rights holders and we pay royalties for all tracks on Spotify' (ibid.).

Even so, the controversy surrounding the *idea* that this *may* be possible reinforces the point that artist managers are managing a type of creative labour that resists abstractness and alienation.

Artist management is agile by default as the artist manager is professionally autonomous and because they are managing the concrete and named creative labour of the artist, a 'named' status that remains intact due to the widespread belief that the artistic/aesthetic autonomy of the artist can, and should, resist the abstractness and alienation to which other forms of labour are subject under capitalism. In addition to the 'specialness' of artistic labour, the idea that there are no set rules for artist managers, apart from the common law and relevant legislation, means that each artist–artist manager relationship is unique or, as one interviewee, Toronto-based veteran artist manager Bob, noted, 'special':

> Managers have special relationships with the artists that they work with. Some of these special relationships work one way; some work in other ways. Some are probably fabulous and some are probably horrifying. I don't see how one kind of boxes that up and decides how to define it one way or the other. So if you can't even define that, then I don't know how you can define how people are supposed to act, exactly.
>
> *(Interview 8)*

This point, that it is difficult to regulate something that you cannot define with a licensing requirement, was reinforced by another Toronto-based interviewee, Lawrence, who stated:

> As soon as I hear licence it's kind of a weird situation because this business was not set up by a bunch of established rules and regulations, and the closer you get to that kind of world, the further away you get from an artistic pursuit, because this is about free thinking, free-willed pursuit of an artistic vision. You don't do that with a licence. No the manager may not be the artist, but at the same time there's a certain amount of common vision that stands in what we do, which is why we do this in the first place. It's because there is a lot of individual freedom in it, there's a lot of different ways you can approach things, you can try things different ways, you can do this, you can do that.
>
> *(Interview 9)*

Interestingly though, Lawrence's argument for the frontier mentality stemming from artist management practices in the music sector of the creative and cultural industries was a qualified one: he still believes that copyright laws should not be breached.

> This is an occupation … that isn't necessarily based on licensing. Now as soon as those words come out of my mouth, obviously, I have to be careful for that comment not to be taken out of context, because the protection of copyright

is all about licensing and the fact of how an artist makes money and how a manager commissions is all about licensing and protecting copyright. But that's not the kind of licence I'm talking about.

(Interview 9)

So what kind of licence is he talking about? There are two ways in which the artist manager's role has, and could be, regulated within the music sector of the creative and cultural industries. One involves top-down governmental regulation by way of legislation, such as the licensing requirement that used to form part of the New South Wales (NSW) Entertainment Act 1989 in Australia; and the other involves self-regulation through associations such as the IMMF and its affiliates (Morrow, 2013). For the most part, the artist managers interviewed for this book tended to argue for the need to establish a code of conduct that would constitute a self-regulating mechanism for the profession and could be managed through membership of the IMMF. There was also a sense that this could be a way to avoid top-down governmental regulatory efforts: if managers could band together to prove that they can effectively self-regulate, then they could ward off any top-down governmental attempt to regulate them. Tom (high-profile, London-based artist manager) noted:

I think that there should be a code of conduct … there definitely needs to be a level of professionalism and a level of accountability and responsibility … We have so many different channels that as managers we have to be aware of and work with on behalf of our clients that there is more and more fiscal responsibility in being a manager than there has ever been before … You may very soon yourself be putting your own records out and managing a business, possibly even as a partner with your clients. So all the rules of engagement have changed and continue to change very dramatically and very quickly. So the need for a code I think is central to a community of people who are fast becoming the gatekeepers of the relationship that I would [say] a creator, or a creative client, will have.

(Interview 2)

This point, that there is more fiscal responsibility residing with the artist manager nowadays, was accompanied by the argument that artist managers have more professional autonomy than they previously had. Tom continued:

It was always frowned on when a manager took a position with a client that was deeper than a straight management-commission-type relationship. So, for example, if a manager, who will have invested heavily as well as his [sic] time with cash, put a proposal together to put to his client to become his publisher or his record label, there was a lot of mistrust. Frankly I think it was stirred up inappropriately by professional advisors – meaning lawyers … I have a client and the company that I operate through owns his sound recordings, and that

was set up very specifically at that client's request. Because it was what he wanted to do, it was how he wanted it to be structured ... It was pointed out to that client, who is actually incredibly well known and very famous, that this may not be to his best advantage commercially and potentially may be flawed. Everything was explained to him and at the end of the day he said, 'No, what I want is this structure'.

(Interview 2)

Therefore if the artist agrees to a particular business structure, then the artist manager is free to structure agreements in new ways. The artist managers interviewed for this book tended to argue for the establishment of a code of conduct that could become a self-regulating mechanism through organisations such as the IMMF and its affiliates, instead of governmental regulation that would operate in a similar way to the regulatory frames to which accountants and lawyers are subject. Their arguments revolved around two factors: (1) for artist managers to be regulated in a similar way to accountants and lawyers, a formal qualification would need to be established; and (2) if artist managers were paid an hourly rate as lawyers and accountants most often are, then artists would not be able to afford the service of artist management. As highly successful London-based artist manager Harry said:

Well this is another area where a slightly false equation is often presented, because if artist managers charged by the hour, like lawyers and accountants do, I'm sure they wouldn't mind being regulated. Because let me tell you something, if an artist manager charged the hourly rate that a lawyer charges and then they put in the hours that they put in, I don't think that they would mind the regulation at all because they would all be able to retire after two years. So it is not really equating like with like. The lawyer and the accountants are regulated, but they charge by the hour. It's like the difference between an art and a science. With lawyers and accountants, it is very linear and everybody knows what they are getting; it is all very comfortable and solid and the manager thing is all very speculative. So it's a completely different thing. You can't regulate one in the same way that you regulate the other.

(Interview 12)

However, while Harry noted that any effort to regulate artist managers in a similar way to accountants and lawyers would be inappropriate, he also argued that establishing a code of conduct as a self-regulating mechanism would not work either: 'In the coming marketplace it is very difficult to develop a mandatory code of conduct because all managers are looking at different business models' (Interview 12). While the interviewees tended to agree that increased fiscal responsibility resides with the artist manager in the digital age, this participant identified the increased professional autonomy of the artist manager as the main reason why the establishment of a mandatory code of conduct would not work. This is despite the previous comments that this is why a code of conduct is needed. While the

topic of regulation/self-regulation was, in general, discussed in this ambivalent way, the participants still made common points relating to the practice of 'double dipping' and regarding the artist manager's relationship to their client's bank account.

6.4 Double dipping

The professional autonomy of artist managers enables them an extreme form of agility in the dealmaking process when compared with professional advisors such as lawyers and accountants. This freedom, or 'agility', is a key facet of managerial creativity within the creative and cultural industries. However, one limit to this freedom that frequently arose during the research interviews for this project concerned the issue of double dipping and the need to develop a code of conduct that states that this is something artist managers should not do. Double dipping in this context can be defined as an artist manager receiving two income streams from two interests that are in conflict. For example, as was made evident earlier in this chapter, the music industries have become more complicated in the digital age, and this has meant that some artist managers are forming agreements with artists that are more involved than a straightforward service provision agreement whereby the manager commissions 15 to 20 per cent of the artist's 'adjusted gross' or net income across all five key income stream groups; namely, record sales, live performance income, song publishing royalties, merchandise and sponsorship. In a 'traditional' management agreement, the artist manager receives a percentage of the artist's income for providing the 'service' of artist management, and through these agreements, they typically do not licence or own the artist's copyright/intellectual property (this is why these agreements are called 'service agreements').

When the artist manager also becomes the record label, for example, there is potential for the artist manager to receive revenue as the record label from the sale of the artist's recordings *and* commission the artist's royalties from these sales because they are also the artist's manager. This is double dipping. Such double dipping also often involves a conflict of interest. In this case, the manager experiences a conflict between a desire to act in the best interests of the artist as their manager and a desire to work in the best interests of the label – because they also own the label.

As Bob (Toronto-based veteran artist manager) noted, for an artist manager to also be the artist's record label and song publisher is not a new phenomenon: 'It's always hard for me to get too excited by the new ideas of 360 deals[5] when I just spent 40 years doing it'. On the other hand, Tom (London-based artist manager) stated that artist managers constitute:

> a community of people who are fast becoming the gatekeepers of the relationship that ... a creative client will have. Whether they are dealing directly with their audience on a so-called fan-to-band relationship, whether they are dealing directly or indirectly through an ISP,[6] one way or another there is a contractual revenue-generating relationship. And in the live arena it is

becoming even more complex ... there is back to front bundling where you will be going in and doing a deal and the promoter may also be a record label now, or acting to facilitate as a label. So your responsibility as a manager is definitely now sitting on a different platform of responsibility.

(Interview 2)

In response to a question regarding how widespread the issue of double dipping is in the music industries, Mike (New York-based record label owner, distributor and former major record label CFO) noted:

Most of the [managers] that I deal with at the top end do not double dip; they take their 20% of whatever the artist earns. So they don't take 20% of the tour and then 20% again when the money goes into the artist's account. This is because they can afford to do this, they have major artists, they make a lot of money ... At the other end there is a lot of double dipping. Everybody does it. Some of it is above board and some of it is below board ... a lot of independent distributors like ourselves pay us through from the distributor, whether it be an EMI distributor or Universal or Fontana, they pass through the costs to the label for returns for scrapping, for refurbishing, and things like that. But they'll add on 7% or 10%. So they get 7% or 10% for all of the pass through costs plus 25% for the distribution fee. One of the things we tell people is that we don't do that. We take our distribution fee and everything else that we do is a pass through. But there is a lot of double dipping.

(Interview 10)

While such a practice is common in the record distribution business, Mike also stated 'I don't know how illegal the practice of double dipping is' and then provided the following example relating to the artist–artist manager relationship:

A situation where an artist manager brings someone to a PR person and then the PR person says to the artist manager, 'thanks for bringing me the business, we'll give you a 5% commission for bringing us the business' even though the artist manager gets a 20% commission on the income that paid for that PR work. So for example, if $10,000 of income comes in, then he gets his [sic] 20%. So then there's $8000 and he takes the $8000 and gives it to the PR guy, and then the PR guy gives him 10% of the $8000 as a commission for bringing the business ... They probably don't look at it as being double dipping or as being illegal or unethical, but I'm sure it happens a lot. Because whenever you bring business to somebody, they're prepared to give you a commission.

(Interview 10)

It is therefore clear that double dipping takes many forms in the music industries, and according to Mike, it is widespread within this sub-sector of the creative and cultural industries. This is concerning when considered in the light of findings by

behavioural economists Gino and Ariely (2012) (discussed in Chapter 5 of this book) that, 'When facing the opportunity to behave dishonestly, in fact, most people cheat, if only by a little bit, but not as much as they possibly could' (446). As discussed previously, these authors found a positive correlation between creativity, including short-term creative mindsets as well as creative personalities, and dishonest behaviour when people are faced with ethical dilemmas. This is because divergent thinking and openness positively correlate with moral flexibility, and therefore creativity promotes dishonesty by increasing one's ability to self-justify bad deeds. Gino and Ariely (2012) defined moral flexibility as 'individuals' ability to justify their immoral actions by generating multiple and diverse reasons that these actions can be judged as ethically appropriate' (447). While not technically illegal, the issue of whether double dipping is ethical is open to debate, and one can arguably make the case that the many novel ways in which double dipping can take place are the result of the dark side of managerial creativity within these industries. Mike continued on the subject of double dipping and commissions:

> So you're getting [a commission] when it comes in, and then when you're giving it out, you're getting another percentage. Which is not kosher but people do it all the time. And whether it's illegal? Probably not. It's really a question of disclosure ... Does the artist know that the artist manager is getting a commission for placing the business with a certain person? Probably not ... probably not. But the concept of the commission is in every business. Whenever you bring business to somebody, you'll get a commission.
>
> *(Interview 10)*

This form of double dipping, outlined by Mike, is also known as a 'kickback' and is used to extrinsically motivate one party to form an agreement with another over their competitors.

In the case where an artist manager also becomes the artist's record label, there is a neat solution to the issue of double dipping. As mentioned at the outset of this section, when setting up as a label, an artist manager is faced with a potential conflict of interest: a manager who also becomes the owner of the record label to which their artists are signed has the potential to receive a label share of the artist's royalties (and other income) as well as a manager's share. Rather than paying themselves twice, artist managers can structure their deals in the way that Mike outlined:

> What we do basically is a 'pot' business, because at times the artist wants to be his [sic] own label. Sometimes it is because he can't find a label to partner with, and at other times he doesn't want to sign with anybody else. But all of that goes into the pot. Whether it be the T-shirt sales or the record sales, or whatever sales it is, game sales, soundtracks – it all goes into the pot and then the manager takes out of that pot. So the manager may own part of the label with the artist, though all of the profits from that joint venture, so to speak, go

into the pot from which he takes his 20%. So he doesn't get 50% of the label profits and then 20% of the artist's 50%. He doesn't do that, at least not out of any of the deals that I structure … It is 20% of 100% rather than 50% of 100% and then 20% of the other 50% as well. It gets a little complicated because of all of the pieces. It's the same thing with the co-publishing.[7] Is the artist manager the co-publisher as well? … Does he get his 25% as co-publisher plus his 20% of the writer's share? It all depends on the deal that you make; and with the deals I make, where they want to do everything, I put it all in the one pot.

(Interview 10)

This solution arguably constitutes best practice relating to this issue. However, there is another facet to double dipping when an artist manager also becomes their client's record label. This concerns the question of whether such a structure gets in the way of the artist's career progression; by also being the record label, the artist manager may be getting in the way of another, more capable, label coming on board. In order to address this potential conflict of interest, Toronto-based artist manager Ben put forth his solution of being the 'manager first' as a possible best practice solution:

I think that it is only a conflict if you are not acting as the manager first. So as long as you are manager first and everything else second. [Otherwise] it definitely is a conflict because how can it not be? For example, all my deals are operated as manager first, so I go to a band and I say that if we can actually get a record deal then I don't really want to be the label because being the label is a pain in the butt. I would rather someone else be the label or we be the label together or whatever the case may be. So I'm always the manager first. In my record deals, I will let a band out of my record deals if a better opportunity comes along. So from that perspective I see that there is no conflict if they're able to get out of the deal. And of course it's clearly written into the agreement that they can get out of the deal if a better offer comes along, with a very small override.[8] The reason that you need the override is that if I put out a record and spend whatever on it, and six months from now a better offer comes along, then I need to know that I'm getting some type of recoupment back from what I put in, beyond that just as a manager.

(Interview 5)

Interestingly, Ben also started to operate as a song publisher because the songwriters with whom he worked were not paying him what he was owed for his work:

I started doing publishing deals a few years ago, or co-publishing deals, because what I found was that very few of the artists I dealt with were honest enough to give me commissions on publishing. Let me rephrase that – maybe it wasn't that they were dishonest; it was just that they were either not organised enough or not forthcoming enough to actually pay me my publishing

commissions ... So what I decided to do was do co-publishing deals with the bands that I did record deals with. So essentially I would be getting 5% more than I would be getting as a manager, under my co-publishing arrangement, but I would also give them an advance for that extra 5%. And again, same thing with the publishing deals – if a better deal were to come along, then I would let them out of the publishing deal. You know, if Universal came along and said that I want to give them a half million dollars for their publishing, then I would do that ... And of course as a manager I don't commission record sales or publishing sales, so I feel that with the way my deals work the band actually are better off because as a manager, if we signed a record deal, I would commission any sales or any advances, whereas being the record label, or the publisher, I don't ... They're not paying commissions on record sales, they're not paying commissions on publishing, but they have a record deal and a publishing deal.

(Interview 5)

Such a dealmaking process provides Ben and the bands he manages the agility needed to be able to make headway in the music industries – industries in which conditions of extreme uncertainty are the norm.

6.5 The bank account

Another topic upon which the comments of numerous interviewees converged regarding best practice and conduct concerned the artist manager's relationship to their client's business-related bank account. It became evident through the course of conducting the interviews for this book that during the startup phase of an artist's career development, an artist manager will often be a signatory to their client's business-related bank account so that they can do their client's bookkeeping. This is because often the artist cannot afford to pay a bookkeeper. As soon as the artist can afford it, the artist manager will often insist that they pay a bookkeeper/business manager to fulfil this role. Regarding this progression, Lawrence (Toronto-based artist manager) noted:

> I keep the artist's money as far away from me as possible. The artist's money does not come into my bank account. I never see it. So if it's performance income, the agent would probably accept a deposit cheque, and that goes into the agent's account in trust. The balance gets paid to the artist. Depending on the nature of the artist, how successful they are, how long they've been around, how much money their company is generating, there will be a time when we would advise them to create their own company as opposed to putting it in their personal bank account ... So there's different ways of approaching all of that stuff, but as it relates to handling the artists money, I personally don't go near it.
>
> *(Interview 9)*

However, Lawrence did contextualise this by saying that his artists are commercially successful enough to have the cash flow needed to pay a bookkeeper, and that before this stage, some artist managers will often manage their client's money in trust. He continued by noting that if

> they're successful enough that their career is generating income, there's cash flow, then they should be keeping their own books. You can counsel them on how to do it, you can introduce them to people who can do it at a fair price, you can negotiate on their behalf with somebody who can do it for a small retainer on a monthly basis versus, or plus, a percentage.
>
> (Interview 9)

However, if the artist is not generating sufficient revenue to be able to afford a bookkeeper, then the artist and the artist manager find themselves in a situation whereby the artist manager may fulfil this role. Regarding this particular nuance, Lawrence went on:

> You might believe in an artist and sign an artist to a deal where they're not making money ... it's been extremely rare when I have signed a client and right from day one they were profitable. That probably would happen in a case where a manager is taking over a client that's changing management. They've already got a fan base, they've already been selling records, they've had air play, they've toured, they're making money, but they want to make a change ... From the first gate you're in a positive cash flow. But more often than not from my experience ... and it varies with different managers, but I'm usually in a situation where I'm taking on new talent and developing them to the point where they are profitable. In that scenario you start with somebody today and they haven't even done a gig yet; you might even be putting them on retainer to pay their rent and buy the groceries for a few months. So in that case the money might go through your company, but as quickly as possible I try to get it away from me.
>
> (Interview 9)

Therefore best practice as articulated by this interviewee is that while the artist is in the startup phase and cannot afford to pay a bookkeeper, the manager may keep the books through being a signatory to the artist's business-related account.[9] Then as soon as the artist can afford a bookkeeper, this bookkeeper or business manager should be the one who pays the artist manager's invoices, rather than the artist manager paying their own invoices. Lawrence further reiterated this point by noting that he

> would rather defer management commissions on this new artist so they can afford to have a bookkeeper, or so they can afford to have a road manager whose job it is to keep track of the books on the road and when they come

off the road. There's so many different ways you can structure it, but for my purposes, I don't want to be a partner with the band as far as their company is concerned. Even in a 360, that doesn't mean I take their money; they still have their own company. They write me a cheque; if they're making money, I send them an invoice for my commissions.

(Interview 9)

However, while this interviewee proposed this way of operating as best practice, he also noted that it is sometimes difficult to chase artists to pay the commissions that they owe him:

I've got a handful of artists that owe me all kinds of money. I knew going into this game that when you work with an artist, it's on spec.[10] You know there's a speculative nature to the business we work in. You hope not to lose a lot of money, and if you do lose money, hopefully the worst-case scenario is you lose commissions that you should have made that they never paid you.

(Interview 9)

Lawrence also discussed the common point, made by multiple interviewees, that while the professional autonomy of artist managers is such that they are now more commonly in a position whereby they may themselves invest capital into their client's career by also becoming, for example, a record label or song publisher (thus crossing the line from being service providers working for commission to potentially having equity in the project), the obvious downside is that artist managers can lose a lot of money doing this:

Where it gets scary is when you start dumping in your own money, and then how deep do you go? Especially when you start talking about the 360 arrangement. Somebody's got to put up the money. So quite frankly I think I've maybe in 30 years, if I've had maybe 12 clients, I'd say probably 9 of them I've invested in, and maybe 2 or 3 came at a time in their career when I wasn't their first manager, where they had a positive cash flow but they wanted to improve something about their business, something about their representation.

(Interview 9)

Regarding this issue of artist managers investing their own money in their client's career, another interviewee, London-based artist manager Jim, stated:

You get people all the time going, 'I managed an act for three years and I spent all this money on photos and all this and now they've dumped me and his dad's managing him' … They go, 'What are my rights?' and I say, 'You can sue them but do you really want the stress and have they got any money and is he having any success? Because if he's not, really what's the point? What

are you going to get out of this at the end of the day?' They're going to duck and dive for years and what, you're going to get five grand in three years' time and you're going to have mega amounts – just don't do it next time. Well that's the first rule. Don't put your own money in. But people do. People still do it.

(Interview 4)

When managers invest their own money into their client's career, this may increase their desire to directly manage the artist's money; and while being a signatory to the artist's business-related bank account may not be best practice, the professional autonomy of artist managers is such that they *can* operate this way. This may happen because they desire to do so (particularly if they have invested their own money) and because the best practice way of operating (having a separate business manager/bookkeeper) necessitates the artist being able to afford, and be willing to pay, a business manager/bookkeeper to work for them. This is one of the reasons why another Toronto-based artist manager, Ben, noted that the issue of resourcing bookkeeping remains one of the biggest problems within the Canadian music industries and that practices vary wildly depending on the level of the artist:

Well it differs here because unless you are of a certain level, managing a mid- to above level artist, most people can't afford to even have an accountant. Obviously they have someone at the end of the year do their taxes, but that involves them walking in with a box of crumpled up receipts, you know? In my case, even managing mid-level acts, some of them simply didn't have anybody to do their books and accounting for them. In many cases in the early stages of my management career, I ended up being the fall guy for much of this.

(Interview 5)

The loose way in which an artist's money is managed in the music industries can be problematic for all parties involved. Ben continued:

As much as it can also be a negative for a band because someone is ripping them off, it's also quite frankly a really bad situation for a manager to get into because … for example, I've had situations where I had an artist do a tour of Canada and I did all the accounting for it because they had no one to do it and the road manager did a terrible job – again, crumpled up receipts and money in bags from merch sales and door sales. At the end of the day I think the tour grossed $120,000 [CAD], and I think we lost money simply because it was so poorly handled by the road manager. On the road, money was just being spent on things and disappearing … there was a tour bus that cost way too much and all kinds of stuff, and you look at that and think that we should have made $50,000 [CAD]. Instead we lost $4000 [CAD] … Somehow you have to find someone to take care of it, whether that is your uncle or your brother. But that's our biggest problem in this country, and I'm sure it's the

same anywhere else. It's extremely expensive to have someone do your books for you and therefore most artists can't afford to do it.

(Interview 5)

Therefore, while there are clearly established best practices relating to the artist manager's relationship to the artist's bank account, these remain cost prohibitive for the majority of artists.

6.6 Conclusion

As was discussed in the introduction to this book, the balance of power in the relationship between artist and artist manager is unique as the artist manager works for the artist while, at the same time, the artist is often following the artist manager's lead. The balance of power also shifts between the two parties. This shift in power relations is the result of the supply of and demand for artist management labour at the different stages of an artist's career trajectory. There are many more artists who are in the startup phase of career development (and who may not break out of this phase) at any one time than there are artist managers who are willing to speculatively invest time and, as we have seen in this chapter, sometimes money into their career development. However, this dynamic is inverted if an artist becomes commercially successful. At this point there are many more managers who are interested in managing an artist who will generate profits for them from the outset of their relationship than there are artists who are generating sufficient revenue to generate such attractive commissions.

This is why any attempt to regulate artist managers should go both ways; the issue of artist manager advocacy is important here in addition to artist advocacy. This is because, ironically, the better a manager is at helping an artist break out of the startup phase of career development, the more vulnerable is the position they themselves end up being in (see Chapter 3) as the artist might seek new management that is commensurate with their new standing in the industries. However, this dynamic is also related to an artist manager's knowledge base, as Bob (Toronto-based artist manager) articulated:

> I used to think when I was first starting that if I did my job right, the first thing I should do is teach an act to be able to fire me. In other words, I should put myself in a position of redundancy. If somebody should work with me, at the end of a year or two, they would know everything there was to know about the music business, and then they could get rid of me.

(Interview 8)

To a certain extent, managers are builders; and by analogy, once a builder has built your house, you do not need the builder anymore.

Interestingly, this shifting power balance between artist and artist manager fits with issues discussed in this chapter such as double dipping and the artist manager's

relationship to their client's bank account. Former New York-based label executive Mike stated that double dipping is common at the entry, or 'lower', levels, but that it is not common at the top levels of the business. Similarly, Toronto-based artist manager Lawrence noted that at the entry level, artist managers will often manage their client's bank account through having a trust account or by being a signatory to the artist's business-related bank account, but then as soon as the artist can afford to pay a business manager/bookkeeper, the artist manager will no longer pay their own invoices to their client – instead, the business manager will. These practices are reflective of the shifting power balance in the artist–artist manager relationship; once the artist achieves commercial success and the power balance shifts in their favour, the artist manager has to engage in best practices otherwise their client may move on to be managed by one of their competitors. This effectively constitutes a self-regulating mechanism within this marketplace.

In addition to this shifting power balance in the artist–artist manager relationship, there are also more nuanced and day-to-day power shifts between the two parties that stem from the flexibility of this type of management – flexibility that is generated by the artistic/aesthetic autonomy of the artist and the professional autonomy of the artist manager. In order to further conceptualise this shifting power dynamic within the artist and manager group, Gilfillan's (2016) theory of moment-to-moment collaboration (introduced in Chapter 1) is useful. The theory of moment-to-moment collaboration involves understanding that there are moment-to-moment fluctuations in active and passive power exchanges between dancers and dance-makers, or in this case, between artists and artist managers. Both the artist and the artist manager, on a moment-to-moment basis, contribute to each other's creativities, and in this way artists' careers collaboratively emerge over time in ways that respond to both the artistic/aesthetic autonomy of the artist and the professional autonomy of the artist manager.

Notes

1 There are exceptions to this, some of which are outlined in Gilenson (1990), Hertz (1988) and Morrow (2013).
2 Even though there is no legislation specifically regulating artist managers, they are subject to rules/laws set by legislation in areas such as tax, planning, occupational health safety and welfare, drug control, road rules and gun control.
3 In the US, CPA stands for Certified Public Accountant, whereas in Australia, it stands for Certified Practising Accountants.
4 Gensler and Christman (2017) contextualised this controversy within the creative and cultural industries by noting that, 'in the video-streaming business, companies such as Netflix, Amazon, Hulu and others have in recent years begun producing and relying increasingly on self-produced programming which often gets more promotion than the more expensive, outsider-produced fare and returns a higher margin. But generally these businesses clearly demarcate their own homegrown brands from others.' The difference relating to the allegations made against music streaming services is that they do not make it clear which music is produced in-house.
5 The 360-degree (or '360') deal involves a record label participating in all five revenue stream groups stemming from an artist's career: record sales, live performance income,

song publishing revenue, merchandise sales and sponsorship. For a more detailed outline of the history and purpose of 360 deals, see Hughes et al. (2016: 21) and Goodman (2010: 257).
6 ISP stands for Internet Service Provider.
7 Mike was referring to song publishing here.
8 An override is a royalty that one label (usually a larger label) pays to the label that first signed the artist (usually a smaller label) for the right to do a new deal with the artist.
9 In Australia, for example, such accounts are usually established using a sole trader 'Australian Business Number' (ABN), a partnership ABN, or a company number or ABN, as opposed to the artist using their own personal bank account.
10 The word 'spec' in this context is shorthand for 'speculative'.

References

Crowder, J. A. and Friess, S. (2015) *Agile Project Management: Managing for Success*, Cham: Springer.

Deahl, D. and Singleton, M. (2017) 'What's Really Going on With Spotify's Fake Artist Controversy', *The Verge*, 12 July. Online: <https://www.theverge.com/2017/7/12/15961416/spotify-fake-artist-controversy-mystery-tracks> Accessed 4 September 2017.

Gensler, A. and Christman, E. (2017) 'How Spotify's "Fake Artist" Controversy Has Increased Tensions With Label Partners, Could Hurt Bottom Line', *Billboard*, 19 July. Online: <www.billboard.com/articles/business/7872889/spotify-fake-artist-playlist-controversy-record-label-tensions-ipo> Accessed 4 September 2017.

Gilenson, H. (1990) 'Badlands: Artist-Personal Manager Conflicts of Interest in the Music Industry', *Cardozo Arts & Entertainment Law Journal*, 9: 501–544.

Gilfillan, E. (2016) *Dance-Making: Moment-to-Moment Collaboration in Contemporary Dance Practices*, PhD thesis, Macquarie University, Sydney.

Gino, F. and Ariely, D. (2012) 'The Dark Side of Creativity: Original Thinkers Can Be More Dishonest', *Journal of Personality and Social Psychology*, 102, 3: 445–459.

Goodman, F. (2010) *Fortune's Fool: Edgar Bronfman Jr., Warner Music, and an Industry in Crisis*, New York: Simon and Schuster.

Hertz, B. (1988) 'The Regulation of Artist Representation in the Entertainment Industry', *Loyola Entertainment Law Journal*, 8, 1: 55–73.

Hesmondhalgh, D. and Baker, S. (2011) *Creative Labour: Media Work in Three Cultural Industries*, Abingdon; New York: Routledge.

Hughes, D., Evans, M., Morrow, G. and Keith, S. (2016) *The New Music Industries: Disruption and Discovery*, Cham, Switzerland: Palgrave Macmillan.

Morrow, G. (2013) 'Regulating Artist Managers: An Insider's Perspective', *International Journal of Music Business Research*, 1, 4: 9–35.

Ryan, B. (1992) *Making Capital from Culture: The Corporate Form of Capitalist Cultural Production*, Berlin; New York: Walter de Gruyter.

7

CONCLUSIONS: THE FUTURE OF ARTIST MANAGEMENT

Artist's voice, manager's voice

7.1 The rapid escalation of complexity

The aim of this book has been to contribute to our understanding of the work of artist managers and self-managed artists within the creative and cultural industries. This has been achieved by addressing the questions: What is it like to manage an artist? Or if you are a self-managed artist, what is it like to manage your own career? Is artist management more 'creative' than management jobs in other sectors? As I argued in Chapter 6, due to the professional autonomy that artist managers have, artist management is more creative, in both positive and negative ways, than management jobs in other sectors. Furthermore, in the early career stage, artist management has more in common with startup management than other forms of management.

We saw in Chapter 3 that the lean startup (Ries, 2011) and effectuation (Sarasvathy, 2008) methods for startups are useful for addressing the complexity and uncertainty that stems from attempts to answer the following questions relating to career development and arts investment: What is art? What is art for? What good are the arts? How can we sell art? Both methods eschew more traditional business planning and provide a way to control a future that is inherently unpredictable and extremely uncertain – especially during the startup phase of an artist's career development. In Chapter 4, I turned my attention to the management of artistic careers post the startup phase and argued that agile methods are useful for managing the whole spectrum of hard to weak creativities (Madden and Bloom, 2001) in addition to facilitating innovation in arts-related businesses that are not entirely new or that are not dealing with original and inventive content.

I have argued throughout this book that artist management contrasts with other forms of management that emphasise linearity, conformity and standardisation, because artist management is organic, adaptable and diverse. As we saw in Chapter 6,

the uniqueness of artist management stems from its subordination to artistic creativities and the fact that such symbolic creativities are artistically/aesthetically autonomous and, therefore, open-ended and not bound to set rules. We also came to understand that partly due to the autonomy of what they are managing, artist management features an extreme form of professional autonomy, a form of professional autonomy that is exacerbated by the lack of a formal qualification requirement for artist managers. And the freedom, flexibility and creativity of artist managers is arguably only going to increase due to the rapid escalation of complexity within the creative and cultural industries brought about by the digitisation of aspects of these industries and the way in which they will increasingly interface with the data economy.

Furthermore, the creative and cultural industries are located in a world in which there is an unprecedented level of interdependency, interconnection and complexity. This final chapter therefore focuses on the future of artist management; I argue that this rapid escalation of complexity is the biggest challenge facing artists and artist managers. Through the presentation of case studies from two of the sectors of the creative and cultural industries featured in this book, music and dance, this chapter addresses the questions: How can artists' best interests be served in this context? How can artist managers' best interests be served in this context?

7.2 Creativity: The key leadership competency for the future

Discussing the broader context of the global economy, Robinson (2011), who is an author and international advisor on creativity and education, noted:

> At the top of the agendas of global business and public sector leaders, there are three widely shared perspectives. First, they believe that a rapid escalation of complexity is the biggest challenge confronting them. They expect it to continue – indeed to accelerate – in the coming years. Second, they are equally clear that their enterprises today are not equipped to cope effectively with this complexity in the global environment. Third, they agree overwhelmingly that the single most important leadership competency for organizations to deal with this growing complexity is creativity.
>
> *(12)*

To zoom back into the context of the creative and cultural industries, both artists and artist managers need to be creative if they are to successfully meet this future. This is why in the introduction to this book, I defined artist management as a form of group creativity that involves the interaction between artistic creativities and managerial creativities. While this interaction is at times harmonious and at other times combustive, a one-dimensional understanding of the commerce versus creativity dichotomy will not serve artists or artist managers in the future. Artists and artist managers have a duty of care to one another, and there is a need to respect each other's creativities and to not simply believe in a 'creatives' versus 'non-creatives'

divide.[1] While the default position of a number of regulatory attempts to rein in the professional autonomy of artist managers has been to focus on advocacy for artists, there is also a need to advocate for artist managers. The issues stemming from exploitation and self-exploitation within the creative and cultural industries go both ways: while artists are sometimes exploited, so too are artist managers – *by artists*. This final chapter therefore examines some of the data collected for this book concerning best practices and codes of conduct for artist managers, as well as initiatives and ideas gleaned from this research that are designed to benefit artists.

The interests of the artist and the artist manager for the most part align. However, there are some key ways in which they do not, and therefore there is a need to address these here. Discussing this issue within the music industries, one interviewee, London-based artist manager Harry, said that interests do not align 10 per cent of the time (Interview 12). Harry noted that the Featured Artists Coalition (FAC) has a key role to play in the music sub-sector of the creative and cultural industries with regard to this 10 per cent of the time when artists' and artist managers' interests conflict.

7.3 Music case study 1: The Featured Artists' Coalition

The FAC is a UK-based not-for-profit organisation that was founded in 2009 in order to 'Support, promote and protect the artist community in the music industry. … The FAC nurtures a community of artists and provides support, advice and education in order to empower artist entrepreneurs in the ever evolving music industry' (Featured Artists Coalition, n.d.).[2]

The FAC provides workshops, mentoring and networking opportunities for its members, and in doing so it aims to function as a 'collective voice, actively promoting transparency and fairness within the industry'. The FAC is not only a powerful organisation within the music sector of the creative and cultural industries, and also more broadly within these industries; it also wields a certain amount of broader political influence. As I mentioned in Chapter 5, Hesmondhalgh and Baker (2011) noted that some artists are very powerful because they can communicate with many people. The fact that some members of the FAC routinely communicate with millions of people through their work gives them political influence. As the FAC articulates: 'Artists possess a persuasive voice in influencing political debates, so the FAC ensures that voice is heard by government and policymakers in the UK, USA and EU' (Featured Artists Coalition, n.d.).

Within the music sector of the creative and cultural industries, the FAC also wields considerable influence with regard to the standards and business practices of record labels, music publishers and other business partners, such as artist managers and their firms. To this end, the FAC has a seat on the board of UK Music, which is an umbrella organisation for the music sector of the creative and cultural industries. According to the FAC:

> This ensures the artist voice is heard at the highest level and on an equal footing alongside labels and other stakeholders. The FAC is also at the heart of

umbrella artist organisation IAO (International Artist Organisation) in order to unite artists on an international level.

The FAC also aims to provide thought leadership relating to music and technology, specifically in relation to

> Emerging forms of creative expression and new and innovative ways for artists to earn a living from what they do. The FAC works positively with the technology sector to stand up for the artist's position while identifying solutions and opportunities to enhance the options available to artists.

Regarding the interrelationship between the FAC and the International Music Managers Forum (IMMF), London-based artist manager Harry argued that the following approach could be pursued to represent the best interests of artists and artist managers. Of the FAC, he said:

> It's basically a good idea, to actually have an artist's voice, because there was always a problem with the IMMF ... in so much as 90% of the time, artists' rights and managers' rights co-align, but then there is 10% of the time when they don't. And it's that 10% that does need to be addressed, and the Featured Artists Coalition can kind of address that.
>
> *(Interview 12)*

For Harry, the FAC and the IMMF have important roles to play in the education and training of future artists and artist managers:

> So basically, whereas we started off talking about the IMMF or some other similar body putting guidelines as to what the agreements mean up on a website, it actually might be more appropriate for the Featured Artists Coalition to be interpreting what it means to the artist, and the managers' organisation to be putting forward the various scenarios and how they will pan out for the manager, if you see what I mean. And then it is incumbent on the artists to go to the FAC to get the artists' point of view, and the managers to go to the IMMF to get the managers' viewpoint, and then their independent advisors can actually negotiate and pick a suitable model.
>
> *(Interview 12)*

The FAC has an important role to play in representing the best interests of artists in an increasingly complex industry and world. It is also a literal manifestation of a shift in mindsets relating to the artist's and the artist manager's roles; artist entrepreneurs necessarily have to become more cognisant of the business creativities that are required to build their careers:

> The good thing about the FAC is that it encourages artists to feel that they need to know, in the new environment, exactly what the business side means.

> There is no longer that attitude of 'OK, I'll leave that to my manager'. They now have an organisation that is actually about artists ... and the artists realise that it is a business ... and they are encouraging the artists to actually understand for themselves what the business side of it means.
>
> *(Interview 12)*

Therefore within the music sector of the creative and cultural industries, the FAC has a role to play in educating artists and in giving artist entrepreneurs a voice.

7.4 Music case study 2: The International Music Managers' Forum

The IMMF was first introduced in Chapter 5. It is worthwhile here spending some more time examining this organisation. Like the FAC, the IMMF's mission is to advocate for the business and legal interests of artists. However, the key difference between the IMMF and the FAC is that artist managers are not allowed to join the FAC – this organisation is only for 'featured' artists themselves. Because the role of the artist manager is primarily to advocate for the best interests of artists, the IMMF advocates for fairness and transparency in a similar way to the FAC. However, as mentioned earlier in this chapter, artists' and artist managers' interests do not always co-align. Therefore the FAC has a more specific and less conflicted role to play in advocating for fairness and transparency relating to artists than the IMMF does.

The IMMF is the international umbrella organisation of national associations of artists and their managers from 'Over 30 countries comprising of 1,200 individual entertainment manager members. The IMMF connects music managers around the world to share experiences, opportunities, information and resources' (IMMF, 2013).

According to their website, the IMMF maintains a presence at international music industry conferences, showcase events and trade fairs:

> In past years the IMMF has been involved in Conference programming, keynote events, breakout sessions specific to managers. IMMF has also 'Showcased' new artists at events at Midem (France), Popkomm (Germany), Reeperbahn Festival (Germany), c/o Pop (Germany), Musikmesse (Germany), In The City (UK), The Great Escape (UK), Go North (UK), Music and Media (Finland), Eurosonic (Netherlands), Festival In (Portugal), Monkey Week (Spain), BIME (Spain), Westway Festival (Portugal), Vienna Waves (Austria), Exit Festival (Serbia), Medimex (Italy), Tallinn Music Week (Latvia), Sonic Visions (Luxembourg), Big Sound (Australia), Musexpo (USA), SXSW (USA), Canadian Music Week (Canada), the World Creators Summit and WOMEX.
>
> *(IMMF, 2013)*

A number of national branches of the IMMF, such as the Association of Artist Managers (AAM) and the Music Managers Forum (MMF) in Australia, attempt to self-regulate their membership by way of a code of conduct (see Appendices B and

C for these organisations' complete codes of conduct). Examples of specific clauses that relate to the issues identified in Chapter 6, double dipping and the artist manager's relationship to their client's bank account, are as follows:

> Declare and fully disclose to an artist any conflict of interest whether it is actual, perceived or potential, including any income or other consideration earned by the manager directly or indirectly in conjunction with their artists' performance or services.
>
> *(AAM Australia Code of Conduct)*

> Where a manager acts in any other capacity as well as manager for his, her or their clients where such activity ordinarily involves the charging of fees or commissions, the manager shall not charge multiple fees or commissions, instead charging either the agreed management commission alone or the fee or commission usually charged for that other activity and forgoing their management commission. Where the manager elects to charge a fee or commission other than the management commission they shall first gain the consent of their artist in writing.
>
> *(MMF Australia Code of Conduct, para 17)*

It is interesting to note that even within this one country, self-regulatory attempts to rein in the professional autonomy of artist managers have varied. The MMF's clause relating to the issue of double dipping (above) is more detailed and specific than the AAM's clause. Likewise, the MMF's clause relating to the artist manager's relationship to the artist's bank account (below) is more specific than the AAM's equivalent clause:

> Operate and conduct their own management business and the artist's business in a professional, transparent, accountable & ethical manner.
>
> *(AAM Australia Code of Conduct)*

> The Manager must ensure that all monies (income and expenditure) due to the artist are managed completely separately to the private assets of the manager.
>
> *(MMF Australia Code of Conduct, para 10)*

The codes of conduct that have been established by the IMMF member organisations also vary in *how* these associations will actually self-regulate: the MMF cancels the membership of any member who breaches their code, while the AAM Code of Conduct is simply an aspirational one.

7.5 Judas Goat

While the FAC and the IMMF both have a mission to advocate for the business and legal interests of artists, there are some important nuances to the relationships

that artists and artist managers have to other entities in the creative and cultural industries that are important to consider here. These issues arguably affect the advocacy of the IMMF. As I discussed in Chapter 3, the notion of 'affordable loss' (Sarasvathy, 2008) is different for the artist manager than it is for the artist. Any one manager has many more attempts at establishing a career than any one artist does. This means that for some artist managers, their ongoing relationships with other entities such as record labels are more important to them than their relationship with any one particular artist. And according to one interviewee, Melbourne-based artist manager Sam, record labels use this fact, and their position as licensees or assignees of the artist's copyright, to their advantage:

> It is well known that if a manager is called a 'trouble manager', the record company will try and remove him [sic] from the artists. If an artist has a personal services contract with the manager, the artist can walk away, but when they have a commercial contract with the record company, they can't walk away. So in many ways they're vulnerable to losing or retaining a manager but not a record or publishing deal, because it's all about this product called copyright. So a manager can just walk away, but when a record company treats them just as badly, there's no ability to actually walk away that won't affect their career until the end of time, and record companies will use everything in their power to get what they want.
>
> *(Interview 17)*

Sam went on to discuss the situation whereby an artist manager is offered the opportunity to set up their own record label in a joint venture (JV) with a major record label. He also mentioned the scenario whereby a major record label employee leaves employment at a major to become an artist manager, often to set up a JV with the label for which they formerly worked. By analogy, he argued that such a manager then acts as a Judas goat. A Judas goat is a goat that is trained to assist in the herding of animals such as sheep or cattle. The Judas goat leads the other animals to a destination that the farmer dictates, including to a slaughterhouse. While the other animals such as sheep are slaughtered, the life of the Judas goat is spared. Sam continued by discussing the nuances of the relationship between artist managers and record companies and the characterisation of the artist manager as a Judas goat for a major record label:

> There are lot of things that we share with record companies, positive things about promoting of music and value of copyright, but a lot of things that as managers we don't share with record companies ... The idea that managers will be seduced or be brought in and be the Judas goat or be used, for instance in the context of the IMMF, behind the scenes. Suddenly there are people sitting at the table who might as well be the major record companies, or who will immediately run to the major record companies. To me [this] is almost sabotage. It's very dangerous.
>
> *(Interview 17)*

Therefore the claim by the IMMF that they advocate for the business and legal interests of artists needs to be critically considered. And clearly the FAC has an important role to play in this area.

7.6 Dance case study: GoSeeDo and Book a Flash Mob

This book has also addressed the questions: Are agile management strategies used within the creative and cultural industries? Can agile methods be used for managing artists within these industries? What is the difference between waterfall, agile and integrated project management within these industries? Does working in an agile way require a different mindset to that currently dominant within these industries? Have artists and artist managers within the creative and cultural industries always worked in an agile way due to the nature of artistic creativity?

I have argued that due to the flexible nature of artistic creativity, working in an agile way does not require a different mindset to that currently dominant within the creative and cultural industries. This flexibility is derivative of the artistic/aesthetic autonomy of the artist. Chapter 4 described the various correlations between artist management/self-management practices and the agile paradigm. The zigzagging, iterative nature of both artistic and managerial creativities in this sector means that waterfall management styles – styles that involve a linear trickle down from the different, and often isolated, project stages – are arguably not as useful. Neither are integrated ones that involve a mixture of waterfall and agile approaches. Furthermore, artistic contributions are often understood in various and often flexible ways depending on the audience, the arts funding body, the patron, and so on. In fact, one may argue (for example, while applying for funding) that artistic creativity is beneficial *in and of itself*, while also arguing that the artwork in question generates *instrumental* benefits. In the arts, articulating the rationale for what artist managers are helping to create can also involve agility.

As I argued in Chapter 4, the key to understanding the applicability of agile management (AM) to future artist management practices is the disruptive effect digital technologies have had in relation to artist-to-consumer (or fan) relationships. These effects will arguably increase in importance in terms of the future of artist management, particularly in the context of the rise of the data economy (as I discuss below). The philosophy informing AM also correlates with some of the 'best practice' insights from the fields of group creativity research and organisational and business management (OBM). One common and recurring insight within these bodies of literature is that managers should find good, smart people, and then get out of their way (Catmull, 2008, 2014; Amabile, 1998). Catmull's notion that power should be given to creatives and that managers should not micromanage on any level is a truism that resonates with AM. By enabling participants to respond to change, rather than follow a rigid plan, AM often involves small teams that work autonomously, with managers managing for goals rather than micromanaging processes. Furthermore, this key AM principle of 'self-organisation' reinforces Sawyer's (2007) findings that equal participation is a requirement for group flow.

This motif – that managers should find good, smart people and then get out of their way – is more of a natural fit for AM than it is for either waterfall or integrated management styles.

Interestingly, the data and case studies from the field of dance most clearly demonstrated AM processes within the context of the arts. For example, in Chapter 4, I explained that dance funding in Australia through bodies such as the Australia Council for the Arts is conducted in a series of stages that reflect the various iterations of a dance project or piece. Another example of such an iterative approach within the field of dance concerns New York City-based Misnomer Dance's GoSeeDo initiative and its associated service, Book a Flash Mob.[3] Regarding this initiative, and the dance theatre from which it sprung, Nashville-based Australian dancer and dance researcher Emma noted:

> Misnomer Dance Theater is a small to medium, not-for-profit contemporary dance company directed by Chris Elam. He also does research into finding ways for dancers and other creatives generally to make more money out of their entire process. He came up with a project called GoSeeDo.
> *(Interview 22)*

GoSeeDo is essentially a social media platform that is free to join. This platform then links to Book a Flash Mob, which functions as a booking agency for commercial dance events. Regarding the extent to which GoSeeDo facilitates direct dance-maker-to-consumer relations, thus facilitating iterative, agile development of dance works, Emma continued:

> It's a forum, a place that artists can go and advertise, for instance, a showing of something that's in progress, or a chat with the artist to learn about something more. So that way they're marketing and gaining funds from other stages of the career process, not just the final outcome.
> *(Interview 22)*

Thus GoSeeDo is a direct dance-maker-to-consumer social media platform through which artists and producers can secure a diverse range of bookings for their work and performances. The platform is free to use; GoSeeDo's business model simply involves them commissioning 10 per cent of the fee for any actual booking secured through the service. GoSeeDo's platform then enables the affiliated booking agency, Book a Flash Mob, to source dancers from all over the US for various commercial dance events. These can take place across multiple cities simultaneously, such as the NBA Playoffs Five City Flash Mob campaign that took place on 21 May 2014 (NBA, 2014). Book a Flash Mob is therefore a service of GoSeeDo and operates more like a traditional agency; potential users of the service can request a quote from Book a Flash Mob rather than communicating directly with the dance-makers. As highly commercial initiatives, both services tout their corporate affiliations on their websites. For example, GoSeeDo's landing page

features US-based brands such as Sears, NBA, Hyatt, United States Postal Service, Unilever, and Monster. Below this list of commercial entities is a list of mass media outlets, including: *Good Morning America*, *The New York Times*, *Fortune*, *The Huffington Post*, TEDx, Social Media Week, *Nightline* and *CBS News*. At the top of the landing page is a link labelled 'Flashmob my event!' that then links to the Book a Flash Mob agency service. Interestingly, one of the endorsements provided on the website speaks to the commerce versus creativity dichotomy and the surprise that one participant had regarding the extent to which their artistic/aesthetic autonomy remained intact during such a commercial application of their work:

> With some astonishment, an opportunity with GoSeeDo that seemed mostly about making a little side income has turned out to be an enriching artistic experience offering many areas for learning and artistic gain in ways I wouldn't have anticipated.
> *(Melissa Krodman, Director and Dance Artist, Philadelphia, quoted in GoSeeDo, n.d.)*

Another endorsement on the website spoke to the idea that organisations such as GoSeeDo are the future of arts management: 'GoSeeDo is helping artists create new performing opportunities. I believe their strategy is the future of arts marketing and audience participation' (Erica Essner, Artistic Director, Essner Performance Co-Op, New York, quoted in GoSeeDo, n.d.).

The GoSeeDo site itself states that it offers dancers and dance-makers an opportunity to generate more sustainable income:

> Build new, year-round income streams with the help of our innovative blueprints for extending your booking portfolio, our lead generation service, and GoSeeDo's best-practice marketing templates, supported by our Learning Center. We help you deepen your connection with existing fans, and attract bookings from new audiences.

Discussing the origins of the service, and the fact that it emerged in the US, a territory that does not publicly fund the arts in the way in which the other countries upon which this book has focused do, dancer and dance researcher Emma noted that Book a Flash Mob founder Chris Elam:

> had a Rockefeller grant to develop the research further and create this platform … it's very much like any social platform; it has to be taken on board by the people who want to gain benefit from it to succeed. I think given the nature of the arts as an independent sector in America, not having the public funding that we [in Australia] have, and every year you're going to have different amounts of funding from philanthropy, other sponsors, etc., he wanted to find a way to ensure that his company had enough to pay the dancers every year. So one way became doing something like this, and he turned it into that idea.

Here, [in Australia] it's very much dependent on public funding for the independent dance sector in particular. Getting sponsors on board is quite difficult because unless there's an interest in dance it's hard for people to know whether it's going to be successful or not … if they're going to sponsor it from a business point of view. And that's a problem because of funding decreasing. They have to be more creative in how they manage that funding base.

(Interview 22)

With regard to initiatives such as this and also the option of crowdfunding dance works, Emma spoke of an intergenerational divide regarding use of these sorts of dance-maker-to-fan initiatives: 'I think crowdfunding is being used a lot more by younger artists, just maybe because they're more familiar with it … I think the moment of change is now. We have to wait and see what happens' (Interview 22).

The process of connecting directly with fans, releasing the equivalent of minimal viable products (MVPs) and engaging in iterative sprints to develop dance works is increasingly involving the use of social media and especially online video platforms. Regarding the use of such platforms, Emma continued:

It's growing, particularly with the next wave of dancers and dance-makers coming in who are more technologically savvy. They're definitely using it more, creating their own Facebook pages, for instance, or YouTube pages for in-process as well as final works. There are other platforms like Form Dance Projects, who give studio space at Riverside[4] for dancers to practice and build in, and then they also use social media to promote whoever is using their space or whoever they've given the theatre to as a grant … It's becoming more connected and is linking through. 'They're performing here, we're supporting them, go visit their page.'

(Interview 22)

According to Emma, there are also a lot more blogs and vlogs featuring dance communities. A vlog is a video blog, and such outlets are increasingly present on social media platforms. However, there is a tendency for US-based vlogs in this sector to dominate:

I think some of the more popular vlogs are in America because they have the power to keep that growing, whereas I haven't really seen so many that are really popular in Australia. In ballet, there's a ballet education one which is an American one. There's a few magazines which have created vlogs; for instance, *Reel Time* gives out a few postings now and then on Facebook. They're getting more into that now they're all digital, no print copy any more. That could be a definition of one because you get a lot more commentaries coming through as things are happening, rather than afterwards. Magazines like *Dance Informer, Dance* magazine, etc., there's a whole bunch. Some of them have an Australian version as well as an American version. And having the ability to be in real

time and review, both advertise and perhaps review in real time, is getting a following. People are likely to go, 'ooh, that's on this weekend I'll go and see it'.
(Interview 22)

The digitisation of the dance work development process changes artist management practices in this sector because it makes artists, producers and managers more accountable for the impact of their work at the various stages of development. This is reflective of a broader trend that is affecting both public and private funding processes.

7.7 Creative and cultural industries case study: Culture Counts

Culture Counts is a 'digital evaluation platform for measuring cultural impact' (Culture Counts, n.d.). It enables users to monitor the impact of their project(s) in real time. By providing multiple methods of electronic data collection, Culture Counts can better facilitate use of the lean startup (Ries, 2011) and effectuation (Sarasvathy, 2008) methods for startups within the context of the arts. As I discussed in Chapter 3, the lean startup and effectuation methods are useful for addressing the complexity and uncertainty that stem from attempts to answer the arts investment-related questions: What is art? What is art for? What good are the arts? How can we sell art? As the attempt to answer these questions in Chapter 3 demonstrated, these are fiendishly difficult questions, and this is why, as Radbourne and colleagues found, arts managers often find it difficult to articulate exactly what audiences get out of the experiences that they help to create (Radbourne, Johanson and Glow, 2010). Both the lean startup and effectuation methods eschew more traditional business planning and provide a way to control a future that is inherently unpredictable and extremely uncertain. And while it may not be possible to put the experience of engaging with an artwork or performance into words, Culture Counts can provide some of the data required to inform decisions in this uncertain context.

As discussed in Chapter 3, the lean startup method and effectual logic are like first and second gear: they are useful for starting artistic enterprises and careers, though eventually managers and artists shift away from these logics. This is why I also introduced agile management (AM) strategies in Chapter 4 and argued that AM is applicable for managing the whole spectrum of hard to weak creativities (Madden and Bloom, 2001). It is useful during any startup phase, as well as post such a phase, in addition to facilitating innovation in businesses that are not entirely new or that are not dealing with original and inventive content. These methods and logics resonate with the mission of emergent services such as Culture Counts:

> Imagine a scenario where cultural organisations around the world are measuring the quality of their work using a standardised set of metrics that they themselves have shaped. Imagine they are using new mobile technologies and web-served databases to benefit from real-time data analytics; gaining

immediate insight into the cultural experiences of their audiences, participants and peers. Imagine they are using this data to make better cultural programming decisions, focus marketing efforts and grow audiences. Imagine too that they are connecting, benchmarking and sharing these insights, to attract greater support and resources for themselves and the sector. This is the scenario that Culture Counts has been striving to create, working in close partnership with the cultural sector in England and Australia.

(Culture Counts, n.d.)

As I outlined in Chapter 5, many of the managers interviewed for this project envisaged their role as helping to build a story about their artist which is then used to coordinate, persuade and motivate the various entities and people who work for the artist. Services such as Culture Counts arguably have a role to play in the future of artist management through the way in which the data collected using their tools can help artists and artist managers 'to produce richer stories about their unique impact and value, facilitate deeper engagement and interaction with audiences and communities, and build stronger cases for support and investment' (Culture Counts, n.d.). The future of artist management therefore will arguably involve using the qualitative and quantitative data that services such as Culture Counts can help collect to shape 'impact' and 'value' stories within this sector. One endorsement on the Culture Counts website, written by Pat Swell from Access Arts, noted:

We now have great data to mine and apply. I'm pleased Access Arts has been part of the Culture Counts pilot as it has given us hard evidence, rigorous results and impartial validation as we embark on this process of deciding our next directions.

The five key principles informing the operation of Culture Counts are as follows:

Standardise the definitions of indefinite terms like 'quality' so as to create a common descriptive language.

Give control of that language to the sector.

Modernise the means of data collection, analysis and reporting so that it operates in real time and very low cost.

Enable organisations across the world to compare their results and insights, thereby strengthening the combined voice of the sector.

Engage arts funders and investors to ensure that funding decisions are driven by data, thereby ensuring long term sustainable access to those resources.

(Culture Counts, n.d.)

Services such as Culture Counts can provide the data artists and artist managers need to substantiate arguments concerning the social and cultural value of what they do, in addition to the economic value. Because the economic value of the arts can be more easily measured and understood, it tends to dominate the discourse of

the 'creative industries'. A number of authors have discussed the way in which the 'symbolic goods' of the creative industries can generate profits, can grow both national and international economies, can attract people to 'creative cities', are a source of future employment growth in response to decreases in manufacturing sector work, and can help the global economy rebound from the 2008 global financial crisis (see Cunningham, 2006; Florida, 2002; Gabe, Florida and Mellander, 2013; Garnham, 2005; Hartley, 2005). Against this discursive frame of the creative industries, a number of authors have argued that the cultural or 'intrinsic' value of the arts becomes lost in this sea of instrumentalist arguments for supporting the 'creative industries' and that arts managers should primarily argue for the cultural value of the arts (Caust, 2010; Craik, 2007; Glow, 2010). Culture Counts potentially provides the data needed by arts managers to more effectively promote cultural value in this way.

Engaging with the work of Holden (2004), Glow (2010), who is a scholar in the field of arts management, argued that such forms of value are 'symbolic, aesthetic, spiritual and expressive', that they are key to audience experience and that they may not be able to be economically rationalised (588). Likewise, Radbourne, also a scholar in the field of arts management, noted that arts consumers are increasingly on a 'quest for self-actualisation where the creative or cultural experience is expected to fulfil a spiritual need that has very little to do with the traditional marketing plan of an arts company' (Radbourne, 2007, cited in Glow, 2010: 590). As I have argued throughout this book, the lean startup method, effectual logic and agile methods are useful for artists and artist managers to use at various career stages in order to co-create value with audiences by responding to feedback throughout the creative process. Services such as Culture Counts can potentially provide the data needed by artists and artist managers to use these methods in order to better understand how engaging with their work enables audiences to produce intrinsic benefits, to self-actualise and to contribute to the co-creation of cultural value.

7.8 Big data, automation and the future of work

Services such as Culture Counts and business management theories such as the lean startup method and the agile methods examined in this book can all be located in an historical context in which there is increasingly prevalent discourse concerning 'big data' and 'automation', and the impact these will have on the lives and work of future human beings. Artist management practices need to be located within this historical moment. As Glow (2010) noted:

> What we learn from the evolving theoretical discourses around management throughout the twentieth century is that its defining features are to some extent historically determined; there is no 'natural' or fixed defining characteristic of management ... how we define and understand 'management' is a function of discourse.
>
> *(586)*

This book has contextualised artist management practices within the creative and cultural industries within the period 2009 to 2017, and it is evident that the characteristics of artist management during this period are derivative of the context and practices of *this* particular period. This period has seen the rise of IBM's 'Watson' supercomputer, a machine that 'combines artificial intelligence (AI) and sophisticated analytical software for optimal performance as a "question answering" machine' (IBM Watson, 2017), which can be used by a vast range of organisations and businesses to aid decision-making and to assess risk. This includes financial institutions such as banks in their attempts to assess the level of risk they take on lending money to particular businesses and individuals. This particular period has also featured the use of 'policing software' in the US state of California whereby law enforcement agencies have seen robberies decline by a quarter following use of PredPol software. Meanwhile, according to Stiegler (2017), US economist and former Chairman of the Federal Reserve of the United States (1987 to 2006) Allan Greenspan argued that blame for the 2008 global financial crisis 'ought not to fall only upon the president of the US Federal Reserve: the whole apparatus of computerized formalization and automated decision-making undertaken by financial robots was involved' (13). Regarding big data, Davis, who is the Vice-Chancellor of the University of Melbourne, said:

> Today, the world's most valuable resource is no longer oil but data. Amazon, Apple, Facebook, Microsoft and Alphabet, Google's parent company, are the five most valuable listed firms in the world, collectively taking in over US$25 billion in the first quarter of 2017 alone. Whether you're going for a run, watching television, browsing online, or even just sitting in traffic, virtually every activity creates a digital trace, and you are being watched. Our connected, always-on world has generated huge volumes of data, but also heightened concerns. At the cost of our privacy, this data economy brings new opportunities, particularly in public policy. Big data is now being used to fight obesity, to predict crime hotspots, to help NASA map dark matter.
>
> *(In Goldbloom and Davis, 2017)*

In an analysis of Google's business model, Anderson (2008) went so far as to argue that data makes theory obsolete, authoring an article provocatively entitled: 'The end of theory: The data deluge makes the scientific method obsolete'. In the context of a discussion concerning changes to advertising and political campaigning, Cambridge Analytica CEO Alexander Nix noted that

> Communication is fundamentally changing. Back in the days of *Mad Men*,[5] communication was essentially top down; that is, it's creative-led. Brilliant minds get together and come up with slogans like Beanz Means Heinz and Coca Cola Is It. They push these messages onto the audience in the hope that they resonate. Today, we don't need to guess at what creative solution may or may not work. We can use hundreds or thousands of individual data points on

our targeted audiences to understand exactly which messages are going to appeal to which audiences way before the creative process starts.

(Nix, 2016, cited in Goldbloom and Davis, 2017)

This book has examined artist management practices in the creative and cultural industries within this historical context and in doing so has identified the following areas for further research: Are services such as Culture Counts automating artist management? What does big data mean for the field of arts management? Does the data deluge make aesthetic theory obsolete? Does the data deluge make artistic methods obsolete? How does the data deluge affect the artistic/aesthetic autonomy of the artist?

It is at this juncture that the future of artist management needs to be discussed in relation to the opportunities and threats relating to the 'automation' of the workforce, and indeed in relation to the very concept of 'work' itself. As philosopher Stiegler (2017) observed:

> The next ten years will, according to numerous studies, predictions and 'economic assessments', be dominated by automation. On 13 March 2014 Bill Gates declared in Washington that with the spread of software substitution, that is, as logical and algorithmic robots come increasingly to control physical robots – from 'smart cities' to Amazon, via Mercedes factories, the subway and trucks that deliver to supermarkets from which cashiers and freight handlers are disappearing, if not customers – employment will drastically diminish over the next twenty years, to the point of becoming the exception rather than the rule.
>
> (n.p.)

Within the time period this book was written, the aforementioned progress relating to big data and its associated 'data economy' has often been coupled with discussion of automation and resultant job losses. The case studies and arguments put forward in this book concerning agile management strategies within the context of the arts, and how these relate to the nature of creative labour within the creative and cultural industries, at best provide a preliminary sketch of the role of the artist, the artist manager, the arts and the creative and cultural industries in the future. As Kaggle[6] founder, Goldbloom, stated:

> We will start to see algorithms starting to help make business decisions more frequently and more precisely than we can do as humans, which does obviously open up a scary question. If algorithms are capable of doing things … there's a question around jobs and what would people do when a lot of the jobs that we currently do are taken over by algorithms.
>
> (In Goldbloom and Davis, 2017)

A common refrain within such discourse is the pace at which many human beings' time will be freed from work, and another is that governments move too slowly to address the issues stemming from automation. Goldbloom continued:

> Historically when we face big waves of innovation, humans have been able to retrain and we're very flexible and do things that technology can't do. The one potential difference here is that the change is coming so quickly, do we have enough time to retrain? This is not like the industrial revolution which took decades and decades and decades to unfold … the progress, you can measure in years, not in decades. There is certainly a scary dimension to the rise in machine learning and artificial intelligence … tech companies, Silicon Valley, iterates on a three-month cycle, traditional businesses iterate on a five-year cycle and government iterates on 100-year cycle … Government is trying to regulate in a world where they're not able to attract the best talent.
>
> *(In Goldbloom and Davis, 2017)*

The arts will arguably have a role to play in how various economies can function outside of the framework of wage labour. As Stiegler (2017) noted: 'The time liberated by the end of work must be put at the service of an automated culture, but one capable of producing new value and of reinventing work' (15–16). Therefore, another question for further research is: Will the arts become an increasingly important means through which people have something to do with their time post automation?[7] Will the arts become an (even more) important way in which people will maintain their self-efficacy and generate meaning, identity and value? Questions relating to the role of the arts post automation arguably shift the focus from economic value to the intrinsic or cultural value of art and to the social value of it. Therefore a further question is this: Do the instrumentalist arguments stemming from the creative industries literature become irrelevant if/when there is a universal basic wage?

In order to further historicise the discussion of artist management practices in this book, it is important to note here that we live in what is described as the Anthropocene. The term Anthropocene was originally coined by Paul Crutzen, an atmospheric chemist and Nobel laureate, in 2000 (Stromberg, 2013). According to Stromberg (2013),

> the word has picked up velocity in elite science circles: It appeared in nearly 200 peer-reviewed articles, the publisher Elsevier has launched a new academic journal titled *Anthropocene* and the IUGS convened a group of scholars to decide by 2016 whether to officially declare that the Holocene is over and the Anthropocene has begun.

Anthropocene is technically a geological term that articulates 'Earth's most recent geologic time period as being human-influenced, or anthropogenic, based on overwhelming global evidence that atmospheric, geologic, hydrologic, biospheric and other earth system processes are now altered by humans' (Anthropocene, n.d.). The challenges facing the human race in the Anthropocene, or the 'human age', are many, and artists, artist managers and arts managers do need to consider the impact of their activities on the environment.

It is in this context that author and social activist Klein (2017) has argued that a broader definition of 'green jobs' is needed:

> Looking after elderly and sick people doesn't burn a lot of carbon. Making art doesn't burn a lot of carbon. Teaching is low carbon. Day care is low-carbon. ... So we decided to deliberately extend the traditional definition of a green job to anything useful and enriching to our communities that doesn't burn a lot of fossil fuels.
>
> *(n.p.)*

While Klein's broader definition of 'green jobs' does include making art, a pressing question here is this: How can artists and artist managers contribute to a lower-carbon future when they are entirely dependent on high-carbon activities such as flying for international touring? As I discussed in Chapter 5, artist management is often transnational as it involves the interrelationships between multiple 'creative cities', and travel between such creative cities.

Following Carey (2005) and Dissanayake (1988), in most previous societies, artist management, arts management and the creative and cultural industries would not have existed conceptually, because art was not produced by a separate caste of people labelled 'artists' who needed 'managing', but was spread throughout any particular community as a universal human practice. For Dissanayake, the uniting principle of art practices amongst early humans was the behavioural tendency of 'making special' (74). In modern times, creative commons licensing liberates digitised artistic practices from the 'all rights reserved' default setting of copyright law in ways that enable more people to be engaged in the processes of 'making special' through participation in the arts, and this is assumedly the type of 'art making' to which Klein (2017) is referring. While artist management, arts management, and the creative and cultural industries, which form the focus of this book, are primarily involved in helping to 'make special' the works of a minority of people within a society who are known as artists, everyday creativities and creative commons licensing, and, in the context of a discussion of the data economy, 'automation' and the 'future of work', raise a final question for further research: Will the arts simply shift back to being a universally human practice that gives us humans 'selective value', and thus hope, as we attempt to survive the increasing impacts of climate change and associated mass displacement of human groups? Perhaps this will become the most instrumentalist application for the work of artists and artist managers to date. Or perhaps art has always had this function and does not simply exist for its own sake after all.

Notes

1 For Robinson (2011), this divide, or mindset, is derivative of systemic problems with education systems the world over. While a discussion of creativity and education is beyond the scope of this book, it is important to note here that a broader approach to creativity in education is needed to fundamentally shift this mindset.

2 The FAC board membership is as follows: Imogen Heap (CEO), Annie Lennox, Ed O'Brien (Radiohead), Fran Healy (Travis), Hal Ritson (The Young Punx), Howard Jones, Jeremy Pritchard (Everything Everything), Kate Nash, Katie Melua, Lemar, Lucy Pullin, Master Shortie, Nick Mason (Pink Floyd), Roxanne de Bastion, Rumer, Sam Lee, Sandie Shaw.
3 GoSeeDo.org is a non-profit resource for the arts conceived and created by Chris Elam and the team at Misnomer.org.
4 Riverside Theatres Parramatta is located in the geographical centre of Greater Sydney. It is a state-funded theatre complex.
5 *Mad Men* is an AMC television series featuring a lead character called Don Draper, an advertising executive and family man who works at a Madison Avenue firm.
6 Kaggle is a platform for predictive modelling and analytics competitions. Companies and researchers can post data to the site, and data scientists then compete to produce the best models for describing the data.
7 Interestingly, Kohn, Ryn, Nansen, Arnold and Gibbs (2017), in their research concerning 'death online', argued that social media platforms may be able to use algorithms to aggregate one's post across their lifetime in order to enable individuals to continue posting similar material and ideas after they are dead. By extending this idea to artists, a further question arises: Will artists be able to continue posting to social media and even 'creating' after death?

References

Amabile, T. (1998) 'How to Kill Creativity', *Harvard Business Review*, Sept–Oct. Online: <https://hbr.org/1998/09/how-to-kill-creativity> Accessed 30 August 2017.

Anderson, C. (2008) 'The End of Theory: The Data Deluge Makes the Scientific Method Obsolete', *WIRED*, 23 June. Online: <www.wired.com/2008/06/pb-theory/> Accessed 4 September 2017.

Anthropocene (n.d.) 'Welcome to the Anthropocene'. Online: <www.anthropocene.info/> Accessed 24 August 2017.

Carey, J. (2005) *What Good Are the Arts?* London: Faber.

Catmull, E. (2008) 'How Pixar Fosters Collective Creativity', *Harvard Business Review*, Sept. Online: <https://hbr.org/2008/09/how-pixar-fosters-collective-creativity> Accessed 30 August 2017.

Catmull, E. (2014) *Creativity, Inc.: Overcoming the Unseen Forces that Stand in the Way of True Inspiration*, New York: Random House.

Caust, J. (2010) 'Does the Art End When the Management Begins? The Challenges of Making "Art" For Both Artists and Arts Managers', *Asia Pacific Journal of Arts and Cultural Management*, 7, 2: 570–584.

Craik, J. (2007) *Re-visioning Arts and Cultural Policy*, Canberra: ANU Press.

Culture Counts (n.d.) 'Culture Counts: We Value Culture'. Online: <https://culturecounts.cc> Accessed 4 September 2017.

Cunningham, S. (2006) *What Price a Creative Economy?* Platform Papers No. 9, Sydney: Currency Press.

Dissanayake, E. (1988) *What is Art For?* Seattle, WA: University of Washington Press.

Featured Artists Coalition (n.d.) 'Featured Artists Coalition: About'. Online: <https://www.thefac.org/about> Accessed 4 September 2017.

Florida, R. (2002) *The Rise of the Creative Class: And How It's Transforming Work, Leisure, Community and Everyday Life*, New York: Basic Books.

Gabe, T., Florida, R. and Mellander, C. (2013) 'The Creative Class and the Crisis', *Cambridge Journal of Regions, Economy and Society*, 6: 37–53.

Garnham, N. (2005) 'From Cultural to Creative Industries', *International Journal of Cultural Policy*, 11, 1: 15–30.

Glow, H. (2010) 'Taking a Critical Approach to Arts Management', *Asia Pacific Journal of Arts and Cultural Management*, 7, 2: 585–594.

Goldbloom, A. and Davis, G. (2017) 'Kaggle Founder Talks Big Data', *Pursuit*, 15 June. Online: <https://pursuit.unimelb.edu.au/podcasts/kaggle-founder-talks-big-data> Accessed 4 September 2017.

GoSeeDo (n.d.) 'GoSeeDo: Where Creative Experiences are Made and Shared'. Online: <www.goseedo.org/> Accessed 4 September 2017.

Hartley, J. (2005) 'Creative Industries', in J. Hartley (ed.), *Creative Industries*, Malden, MA: Blackwell, pp. 1–40.

Hesmondhalgh, D. and Baker, S. (2011) *Creative Labour: Media Work in Three Cultural Industries*, Abingdon; New York: Routledge.

Holden, J. (2004) *Capturing Cultural Value*, London: Demos.

IBM Watson (2017) 'IBM Watson'. Online: <www.ibm.com/watson/> Accessed 30 August 2017.

IMMF (International Music Managers Forum) (2013) 'Networking'. Online: <http://immf.com/> Accessed 30 August 2017.

Klein, N. (2017) *No Is Not Enough: Resisting Trump's Shock Politics and Winning the World We Need*, Chicago, IL: Haymarket Books.

Kohn, T., Ryn, V., Nansen, B., Arnold, M. and Gibbs, M. (2017) 'Researching Death Online', in L. Hjorth, H. Horst, A. Galloway and G. Bell (eds), *The Routledge Companion to Digital Ethnography*, Abingdon; New York: Routledge, pp. 112–120.

Madden, C. and Bloom, T. (2001) 'Advocating Creativity', *International Journal of Cultural Policy*, 7, 3: 409–436.

NBA (2014) 'NBA Playoffs Five City Flashmob', *YouTube*, 27 May. Online: <www.youtube.com/watch?v=QVvL-_Khi1k> Accessed 29 August 2017.

Radbourne, J., Johanson, K. and Glow, H. (2010) 'Empowering Audiences to Measure Quality', *Participations: Journal of Audience & Reception Studies*, 7, 2: 360–379.

Ries, E. (2011) *The Lean Startup: How Today's Entrepreneurs Use Continuous Innovation to Create Radically Successful Businesses*, New York: Crown Business.

Robinson, K. (2011) *Out of Our Minds: Learning to Be Creative*, Chichester: Capstone Publishing.

Sarasvathy, S. (2008) *Effectuation: Elements of Entrepreneurial Expertise*, Cheltenham; Northampton, MA: Edward Elgar.

Sawyer, K. (2007) *Group Genius: The Creative Power of Collaboration*, New York: Basic Books.

Stiegler, B. (2017) *Automatic Society: The Future of Work*, Trans. D. Ross, Cambridge, UK; Malden, MA: Polity.

Stromberg, J. (2013) 'What Is the Anthropocene and Are We in It?', *Smithsonian Magazine*, January. Online: <www.smithsonianmag.com/science-nature/what-is-the-anthropocene-and-are-we-in-it-164801414/> Accessed 4 September 2017.

APPENDIX A
THE INTERVIEWS

TABLE A.1

Interview No.	Pseudonym	Job title	Industry	Location	Date
1	William	Artist manager	Music	Sydney	17/07/09
2	Tom	Artist manager	Music	London	15/12/09
3	Stuart	Artist manager	Music	London	16/12/09
4	Jim	Artist manager	Music	London	22/12/09
5	Ben	Artist manager	Music	Toronto	05/01/10
6	Seth	Artist manager	Music	New York	06/01/10
7	Leonard	Artist manager	Music	Toronto	11/01/10
8	Bob	Artist manager	Music	Toronto	12/01/10
9	Lawrence	Artist manager	Music	Toronto	13/01/10
10	Mike	Record label executive	Music	New York	03/03/10
11	Leon	Artist manager	Music	London	18/04/10
12	Harry	Artist manager	Music	London	20/04/10
13	Robert	Producer manager	Music	London	21/04/10
14	Daniel	Artist manager	Music	New York	20/05/10
15	Mark	Artist manager	Music	New York	01/06/10
16	Matthew	Business manager	Music	New Jersey	04/06/10
17	Sam	Artist manager	Music	Melbourne	10/07/10
18	Ellen	Artist manager	Music	Melbourne	10/07/10
19	Peter	Actor/film director	Film	Sydney	03/02/17
20	Catherine	Film-maker/Scriptwriter	Film	Sydney	09/02/17
21	Anne	Contemporary dancer	Dance	Sydney	29/03/17
22	Emma	Dancer/dance researcher	Dance	Sydney	19/04/17

APPENDIX B
ASSOCIATION OF ARTIST MANAGERS CODE OF CONDUCT

14 September 2014

Code of Conduct for Artist Managers

This Code of Conduct is a guide to current and future Association of Artist Managers (AAM) members through their management career, to promote and encourage the utmost ethical, professional and innovative artist management in Australia. Members of the Association of Artist Managers shall aspire at all times and use their best endeavours to achieve each point outlined in the code. As a condition of membership in the AAM you agree to adhere to and to promote the AAM Code of Conduct to others.

Code of Conduct:

The Members of the AAM will aspire, at all times and to the best of their ability to:

1. Devote sufficient time to fulfil the agreed responsibilities of management in the interests of the artists as both parties understand them;
2. Possess and obtain the knowledge and skills to carry out the required duties of management as agreed and understood with the artists they represent;
3. Communicate and negotiate with the artist their responsibilities, obligations, duties and remuneration as a manager of the artist and have those preferably notated in a written agreement;
4. Seek support where required and commit to expanding their knowledge base and skills to assist in representing the artist's career with diligence in all phases of the artist's career;

5. Operate and conduct their own management business and the artist's business in a professional, transparent, accountable & ethical manner;
6. Ensure relevant financial and legal matters are communicated to the artist and where relevant refer the artist to an independent, third party advisor specializing in such financial and legal matters;
7. Uphold client confidentiality, ensuring appropriate use of information whilst exercising diligence and duty of care;
8. Declare and fully disclose to an artist any conflict of interest whether it is actual, perceived or potential, including any income or other consideration earned by the manager directly or indirectly in conjunction with their artists' performance or services;
9. Ensure the commission rate agreed with the artist is in line with standard industry norms;
10. Be aware of and operate within the parameters of any relevant State and Federal legislative requirements;
11. Be culturally aware and act respectfully toward all the nationalities, religious, gender and ethnic groups.

© & ® *AAM (Aust) / L. de Souza – leanne@aam.org.au*

APPENDIX C
CODE OF CONDUCT OF MMF AUSTRALIA

Music Managers must at all times and to the best of their ability:

1. Devote sufficient time so as to properly fulfil the requirements of good management in the interest of the artists.
2. Not act in any fashion which is detrimental to their clients' interests.
3. Conduct themselves in a manner which is professional and ethical and which abides by best business practices and methods accepted in their country and comply with any Statutory Regime that is in place or is created.
4. Conduct all of their affairs with their clients in a transparent manner.
5. Protect and promote the interest of their clients to the highest possible standard.
6. Exercise the rights and powers implied or granted to them by their clients in the written or oral agreements for the client's best interest.
7. Ensure that no conflict of interest shall interfere with the discharge of their duties towards their clients.
8. All conflicts of interest must be disclosed immediately and noted in any artist agreement.
9. The Manager's share of the proceeds coming from the artist's professional (artistic) activity may not exceed 25% of the artist's income.
10. The Manager must ensure that all monies (income and expenditure) due to the artist are managed completely separately to the private assets of the manager.
11. The Manager makes a commitment (is duty bound) to absolute transparency in all contractual and financial business dealings that concern collaboration with the artist. This includes in particular giving access to all accounting, settlement of accounts with third parties, and contracts.
12. Should a member be proved to have breached the Code of Conduct, they may be debarred (expelled) from the Organisation. The expulsion process is

decided according to the Constitution. In the event of an expulsion from the organisation, the particular member is no longer entitled to use MMF membership credentials and the Organisation is entitled to advise the membership, the IMMF; its affiliates or associated entities, including Government and Industry bodies.

13. Should the individual seek or renew such membership of any other organisation affiliated with the IMMF, MMF will use its utmost powers to ensure such a member will not be granted membership or if membership granted it is conditional on that member's behaviour and adherence to the Code.
14. Music Managers shall respect the integrity of other managers in their relationships with their artists and not actively interfere with same.
15. If approached by an artist who was previously the client of another manager, a manager shall confirm that the artist has fulfilled his, her, or their legal obligations to the previous manager before entering into a management relationship with the artist.
16. Where a manager acts as publisher, agent, record producer or in any other capacity as well as a manager for his, her, or their clients, they shall declare such interests so that the artist has the ability to determine for themselves if they feel it constitutes a conflict of interest and therefore detrimental to the artist's career.
17. Where a manager acts in any other capacity as well as manager for his, her or their clients where such activity ordinarily involves the charging of fees or commissions, the manager shall not charge multiple fees or commissions, instead charging either the agreed management commission alone or the fee or commission usually charged for that other activity and forgoing their management commission. Where the manager elects to charge a fee or commission other than the management commission they shall first gain the consent of their artist in writing.
18. Managers must ensure that all monetary transactions made on behalf of or in the interest of the client and all books of account and records must always be reasonably open for the inspection of the artist or their appointed representative with reasonable notice, during business hours.
19. Where a manager engages an artist under a written agreement, the manager shall ensure that their client seeks and receives expert legal advice on the terms of such agreement before signing it.
20. Managers will endeavour to keep themselves well informed of current events and legislation, both national and international, as it pertains to the proper exploitation of their client's career and the proper administration of their clients' business/s. © & ® MMF (Aust) Ltd. / N. D. Brenner – nathan@immf.com

INDEX

Access Arts 116
agile management 2–4, 44–7, 53, 57, 61–63, 87, 89, 111–112; creative feedback 2, 44, 47–49; scrum methodology 48–49, 62–63
Amabile, Teresa 47, 52, 58–61
Amara, Nabil 20
Anderson, Chris 118
Anthropocene 120
Ariely, Dan 78–79, 95
art 6, 31; essentialism vs relativism 30, 38; history of the concept 29, 121; *see also* creativity; creative industries
artist management: adaptability 27, 52, 61–62, 87, 89; artist startups 33–37; artistic autonomy 89–90; balance of power 10, 34, 86, 101–102; bookkeeping 97–101; career development 33–34, 69; conflicts of interest 36–37; double dipping 37, 93–96, 109; group creativity 4–5, 9, 62; international markets 66–67, 71–72; lifespan 4–5, 33–34, 101; management as creativity 8–9, 11, 50, 52, 62; mavericks 79–80; not micromanagement 47, 111; motivation 1, 39–40, 90; poaching artists 34, 74–75; realising creative potential 1, 40; regulation 87–88, 90–92, 108–109; storytelling 66–68, 70–73, 80–81, 116
artists: *see* artist management; career development; creative industries; creativity; portfolio careers; uncertain futures; women in creative industries

Association of Artist Managers Australia 88, 108–109, 125–126
Australia 7, 44, 46, 51, 69, 112–114, 116
Australia Council 7, 46, 77, 112, 71
automation 118–120

Baker, Sarah 8, 32, 40, 70, 77, 106
Banks, Mark 8
Barthes, Roland 50
Bilton, Chris 8, 49–50
Bloom, Taryn 6, 28, 38
Book a Flash Mob 112–113
Bourdieu, Pierre 31
Bragg, Billy 34
Burnard, Pamela 8
business management 2, 9, 28, 47, 111

Cambridge Analytica 118
Card, Amanda 50
Carey, John 121
career development 1–2, 33–34, 69, 72–73, 76, 96
Carey, John 29–30
Catmull, Ed 47, 111
Cloonan, Martin 20–21
codes of conduct 74, 76, 79, 81, 88, 91–93, 108–109, 125–128
creative industries: in Asia 45–46; in Australia 46; career fragility/uncertainty 2, 6–8, 27, 31–32, 39, 45, 115; concentric circles model 15; crowdfunding 46–47, 71, 114; data collection 72, 115–117; funding 6–7, 44,

46, 70–71, 77–78, 112–114; gender imbalance 18, 31–32; increasing complexity 2, 105; and multiculturalism 46; *see also* dance industries, digitisation of creative industries, film industries, music industries
creativity 6, 8–9, 49; collaborative 10–11; dark side 5, 78–80, 95; environmental impact 5, 121; and geographic location 66; hard vs weak 6, 28, 38; 'high' vs popular 6, 31; and intrinsic motivation 35, 39–40, 52–53; social/economic benefits of 6, 31, 39, 116–117, 120–121; *see also* group creativity
Crowder, James 87
Csikszentmihalyi, Mihaly 7, 22, 66
consumer feedback 2–3, 28, 47–48
Crutzen, Paul 120
Culture Counts 115–117, 119
cultural capital 31, 71

dance industries: agents 51; agile management and effectuation method 27, 44, 51–55, 112; ballet 53–55; collaboration, power and democracy 10–11, 50–51, 55; cult of the choreographer 50; dance producers 39–40; funding 44, 113–114; project based 27, 44, 53–55, 112–113; self-management 51–53; social media and vlogs 112–115
data collection 72, 115–117, 118–119
Davis, Glyn 118
DeFillippi, Robert 61
Devriendt, Roel 8
digitisation of creative industries 2–3, 46, 72–73, 115, 121; effects on dance industries 114–115; film industries 56, 77; music industries 36, 76, 80, 89
Dissanayake, Ellen 121
Dylan, Bob 79

effectuation methods 26–28, 33, 36, 39
Elam, Chris 112–113
EMI 27, 94
Entertainment Act 1989 (NSW) 91
Evans, Mark 28

Fargher, Catherine 76–78
Featured Artists' Coalition 106–108
film industries 32, 76–78; agile management 55–57; effects of the digital age 56, 77; funding 77–78; group creativity and conflict 57–61; project based 57–58
Form Dance Projects 114

Friess, Shelli 87
Frith, Simon 20–21
Fuss, Diana 30

Gates, Bill 119
geographic mobility 54–55, 67
Gibson-Graham, J. K. 30
Gilfillan, Emily 10–11, 50–51, 102
Gino, Francesca 78–79, 95
global financial crisis 45–46, 117–118
Glow, Hilary 117
Goldberg, Danny 75
Goldbloom, Anthony 119–120
Google 58, 118
Gordon, Kim 75
GoSeeDo 112–113
Grabher, Gernot 61
Gratton, Emma Clark 31–32
Greenspan, Allan 118
group creativity 4–5, 9, 17, 57; conflict 58–61; group diversity 55, 59–60
group flow 4, 47, 57–58, 112

Hakstian, Ralph 52, 78
Henry, Colette 18
Hesmondhalgh, David 8, 32, 40, 70, 77, 106
Highsmith, Jim 3
Holden, John 117
Huberman, Michael 19
Hughes, Diane 28

IBM 118
impartiality of research 20–21
improv theatre 5
intellectual property 36–37, 71–72, 74, 89–91, 93, 110, 121
International Artist Organisation 107
International Music Managers' Forum 66–67, 76, 81, 88, 91–92, 107–111

James, Jefferton 4
Jenner, Peter 33–34
Jones, Candace 61
Jones, Susan 7

Kaggle 119
Kant, Immanuel 29–30
Keane, Michael 45
Keith, Sarah 28
Klein, Naomi 121
knowledge transfer 20–21
Kurtzberg, Terri 58–61

Landry, Réjean 20
lean startup method 3, 27–28, 35, 39, 45

Leary, Ruth 8, 49–50
Li, S. M. 45–46

Madden, Christopher 6, 28, 38
Maple, Peter 32, 55–61
McCrea, Jennifer 70
McGuigan, Jim 8
Medinilla, Ángel 47
Miles, Matthew 19
minimum viable product 3, 28, 35, 57, 114
Misnomer Dance Theater 112
Moore, Thurston 75
Mumford & Sons 76
music industries 5, 20, 67–69, 71–72, 75, 79–80, 88–89; agile management and effectuation method 3, 26–28, 33–36, 89; conflicts of interest 36–37, 93–97; festivals 67, 76; impact of the digital 3, 36, 72–73, 76, 80, 89; male dominated 18; new business models 3, 17, 36, 76, 80, 89; and political messages 70, 106; startup phase 33–37; youth orientation 69–70, 77; *see also* codes of conduct, Featured Artists' Coalition, intellectual property, International Music Managers' Forum, record labels, storytelling
Music Managers' Forum Australia 88, 108–109, 127–128

New York 54, 88, 112
Nirvana 75
Nix, Alexander 118

Ouimet, Mathieu 20

Pixar 47
portfolio careers 32–33, 35, 54–55
postmodernism 30, 50
psychology 4, 7–10, 17–18, 50, 57, 66, 87
Punch, Keith 19

qualitative research 16, 18–19

Radbourne, Jennifer 70, 115, 117
Radiohead 26–28
Ramsay, Kim 32
record labels 5, 26–27, 69, 71–74, 76, 93–96, 110
research methods 16, 18–19
research questions 17–18

Ries, Eric 21, 29
risk management 29, 33–35, 110
Robinson, Ken 8, 38, 49, 105
Rosenberg, Jonathan 58
Ryan, Bill 89

Saïhi, Malek 20
Sarasvathy, Saras 21, 28–29, 33
Sawyer, Keith 4–5, 10, 47, 49, 57, 111
Schmidt, Eric 58
Schramme, Annick 8
Scratchley, Linda 52, 78
Segers, Katia 8
self-management 1, 51–53, 55, 57, 60–61
Silva, John 75
social media 3, 36, 67, 71–72, 114–115
software industries 2–3, 46
Sonic Youth 75
South by Southwest 75–77
Spotify 89
Stein, George 68–69, 72
Stiegler, Bernard 118–120
Stitz, Tim 62
storytelling 66–68, 70–73, 75–77, 116; negative stories 80–81
Stromberg, Joseph 120
Swell, Pat 116
Sydney 32, 54, 78

Thornton, Sarah 31
Throsby, David 15
triple j 69

UK Music 106
uncertain futures 2, 6, 27–28, 31–32, 45, 115, 118–120
United States of America 46, 69, 71–72, 80, 112–114, 118
Universal Music 94, 97

Walker, Jeffrey 70
Wang, J. 45–46
Watkins, Kenneth 70
Watson, John 67–68, 71–73
Weber, Karl 70
Weisberg, Robert 8–9
Williamson, John 20–21
women in creative industries 18, 31–32

Yorke, Thom 26